To David & Ann,

I hope you enjoy
this short history of Denver.
Remember your family in Colorado.

Barbara & Virgil
1-26-03

DENVER
THEN & NOW

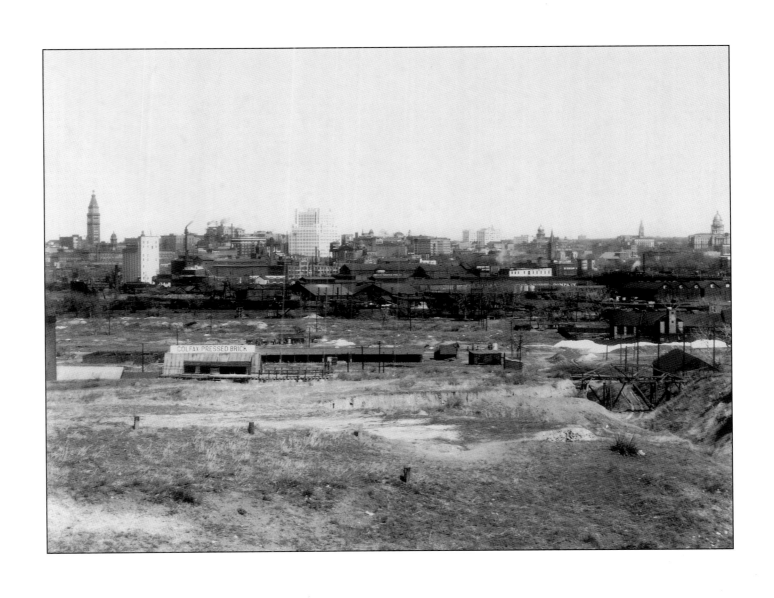

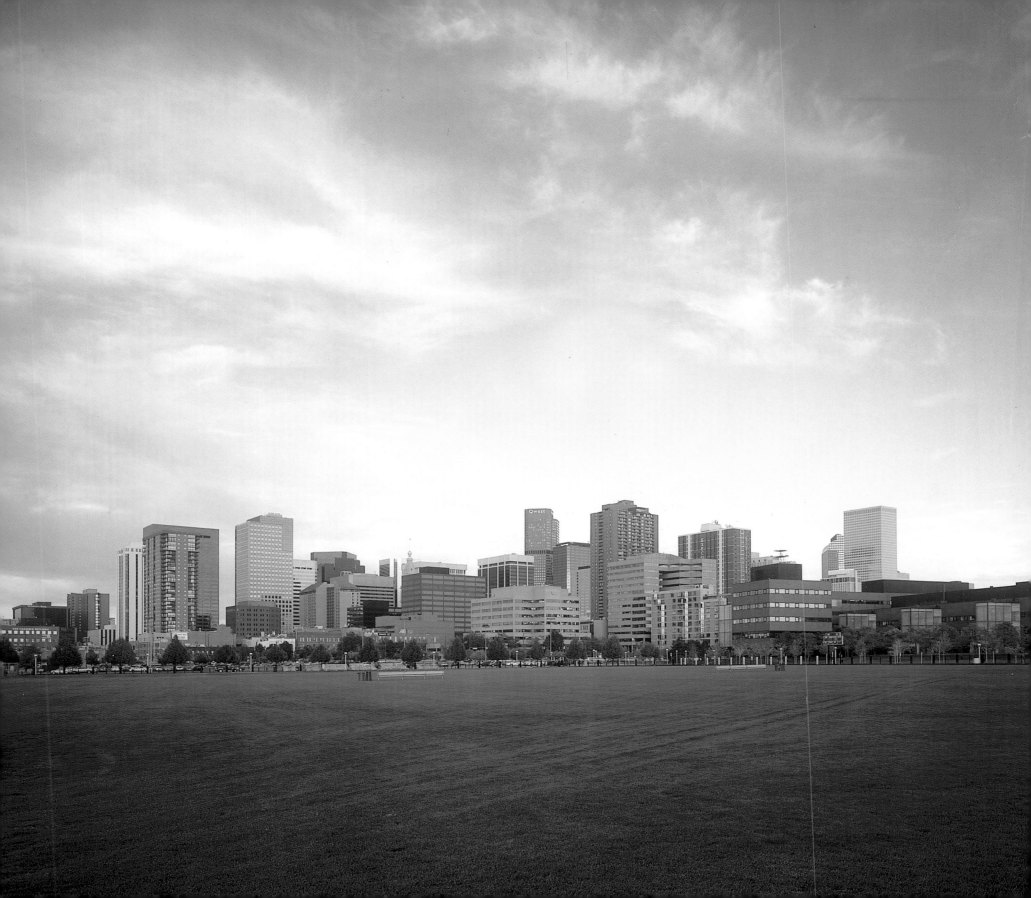

DENVER
THEN & NOW

JOSHUA DINAR

THUNDER BAY
P·R·E·S·S

San Diego, California

Thunder Bay Press
An imprint of the Advantage Publishers Group
5880 Oberlin Drive, San Diego, CA 92121-4794
www.advantagebooksonline.com

Produced by PRC Publishing Ltd,
64 Brewery Road, London N7 9NT, England
A member of Chrysalis Books plc

© 2002 PRC Publishing Ltd.

All notations of errors or omissions should be addressed to Thunder Bay Press, editorial department, at the above address. All other correspondence (author inquiries, permissions, and rights) concerning the content of this book should be addressed to PRC Publishing Ltd, 64 Brewery Road, London N7 9NT, England.

ISBN 1-57145-793-3

Library of Congress Cataloging-in-Publication Data available upon request.

Printed and bound in China

1 2 3 4 5 06 05 04 03 02

ACKNOWLEDGMENTS:

First and foremost, I would like to acknowledge the Colorado History Department at the Denver Public Library, whose vast archival collection is the source of the "Then" photographs in this book. The Colorado Historical Society's resources were also very useful. The works of several state historians, most notably, the prolific Thomas Noel, were invaluable during the research phase of *Denver Then & Now*. Rich Grant at the Denver Metro Convention and Visitor's Bureau, as always, was helpful beyond the call of duty. Photographer Phil Mumford was extraordinarily accommodating in tying up loose ends on several of the "Now" shots. No acknowledgment would ever be complete without thanking my parents, Richard and Nancy, for always offering more support than anyone deserves. And, of course, thanks to Katie for agreeing to put up with me, both for the time it took to complete this project and for all the time yet to come.

INTRODUCTION

I wasn't here, yet I remember them,
That first night long ago, those wagon people
Who pushed aside enough of the cottonwoods
To build our city where the blueness rested.

They were with me, they told me afterward,
When I stood on a splintered wooden viaduct
Before it changed to steel and I to man.
They told me while I stared down at the water:
If you will stay, we will not go away.
　　　　–from the poem, "Two Rivers," by Thomas Hornsby Ferril

The waters at the confluence of Cherry Creek and the South Platte River were slow and shallow, and there was no major port. To the east, the high plains were inhospitably dry and protected fiercely by the Native Americans. Treacherous and gravely unpredictable mountains swelled on the western horizon. Early pioneers cursed the land, and many of them turned back. Still, the dreams of fortunes in undiscovered gold were vivid enough to lure the adventurous to this stark country at the foot of the Rockies, and they began to build a city.

The birth of Denver, like the motivations of its earliest residents, was less than philanthropic. Settlers came for gold, and benevolence didn't get gold. William Larimer and his party came to the newly formed town of Auraria on the south side of Cherry Creek in the first week of November 1858, jumped an adjacent settlement, and founded the Denver City Town Company, naming it after Kansas Territory Governor James Denver on November 22. From its inauspicious beginnings, Denver was forced to struggle against its surroundings—the nature both of humans and the environment. Floods, fire, droughts, insects, blizzards, and the daunting task of navigating the mountains constantly challenged the pioneers. Martial law, debauchery, violence, and several shameful Native-American massacres dotted the city's early history, stigmatizing Denver as an outpost of the Wild West rather than a burgeoning city of the new frontier. It was a reputation not easily outgrown.

However, some of Denver's first prominent residents, through ingenuity and tenacity, began to steer the city in the right direction. Men like Walter Scott Cheesman, Horace Tabor, David Moffat, and John Evans set the foundation for a prosperous boomtown, beginning with the connection to the Union Pacific Railroad that literally saved Denver. Aside from the "spider web of steel" that linked Denver to the rest of the country, these men built banks, theaters, water facilities, ornate buildings, and great wealth, both for themselves and for the city in which they had invested their lives. Government was put on track by turn-of-the-century officials like Mayor Robert Speer, who envisioned a "City Beautiful," and, against all odds, allocated funds toward education, parks, theater and the arts, and the building of a grand civic center that would help to streamline Denver's administration.

The bridges and viaducts to which Thomas Ferril alluded in his poem allowed the formation of towns south of Cherry Creek and west of the South Platte. The advent of trolley cars allowed the convenient settling of these towns as "streetcar suburbs," which billed themselves as clean, quiet alternatives to life in the city. As the streetcar suburbs were annexed, the "Queen City of the Plains," with its bustling downtown surrounded by distinct residential neighborhoods, began to take shape.

Of course, the city's great booms were interrupted by several busts of devastating proportions. The regional economy was strongly dependent on outside factors, such as the market for precious metals; when prices hit bottom, so inevitably did Denver. Depressions in 1873, 1893, and, of course, 1929 challenged the city's resilience, and though the growth of the boom years all but disappeared during these difficult times, the spirit of resolve upon which Denver had been built still thrived, and the Queen City rebounded.

Denver has always evaluated itself against other cities. A determination to measure up to the nation's great metropolises brought the "Mile High City" into a new era in the second half of the twentieth century, although much of its historical character was lost in the process. In the 1960s, the Denver Urban Renewal Authority (DURA), in an attempt to clear the way for a modern skyline, began razing entire sections of the city with little regard for their historical context.

Many Denverites rallied against the leveling of their city, and though much of the damage had already been done, pockets of historic Denver were preserved and revitalized. These areas now stand as distinct reminders of Denver's pioneer past, and are all the more significant among the sharp towers of steel and glass and the modern shopping malls that represent Denver's present. Downtown is typified by this mingling of the then and now. Historic residences and sections of streets saved from DURA's bulldozers sit in the shadows of fifty-story behemoths. From vacant lots have sprung three brand-new, world-class sporting venues. The once popular Denver Auditorium has grown unrecognizably into the nationally renowned complex of theaters in the Denver Center for the Performing Arts.

Plenty has changed at the confluence of Cherry Creek and the South Platte River since William Larimer set up shop in 1858. Skyscrapers have sprouted as a man-made reflection of the mountains that brought people here in the first place. Commerce and technology serve as a substitute for the old economic motivators of mining and smelting. The rugged pioneer outpost has become a haven for those seeking the good life.

Even though the splintered wooden viaducts of Thomas Ferril's imaginings have long since been replaced by steel, the voices that spoke to the young poet were true to their word. The face of Denver has changed with each new generation, but the spirit of its origins continues to guide it. *Denver Then & Now* is a tribute to that spirit, a pairing of images from the nineteenth and early twentieth centuries with contemporary photos, a chronicling of the progression of a city that is both deeply rooted in where it has been and wholly invested in where it is going.

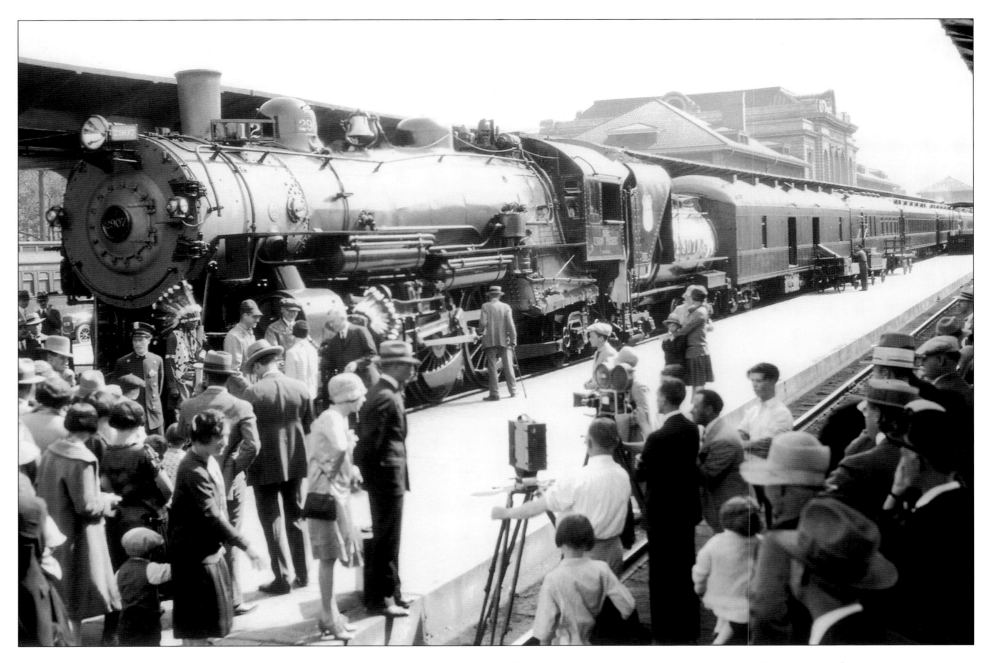

Were it not for railroads, Denver, an inland territory with no major river ports, would not be the city it is today. When it was decided in 1867 that the Union Pacific line would run through Cheyenne rather than Denver, the city was forced to improvise. Heavily invested entrepreneurs quickly built the Denver Pacific line to connect with the main line in Wyoming. The plan worked, and Denver's railway system, along with the city itself, thrived.

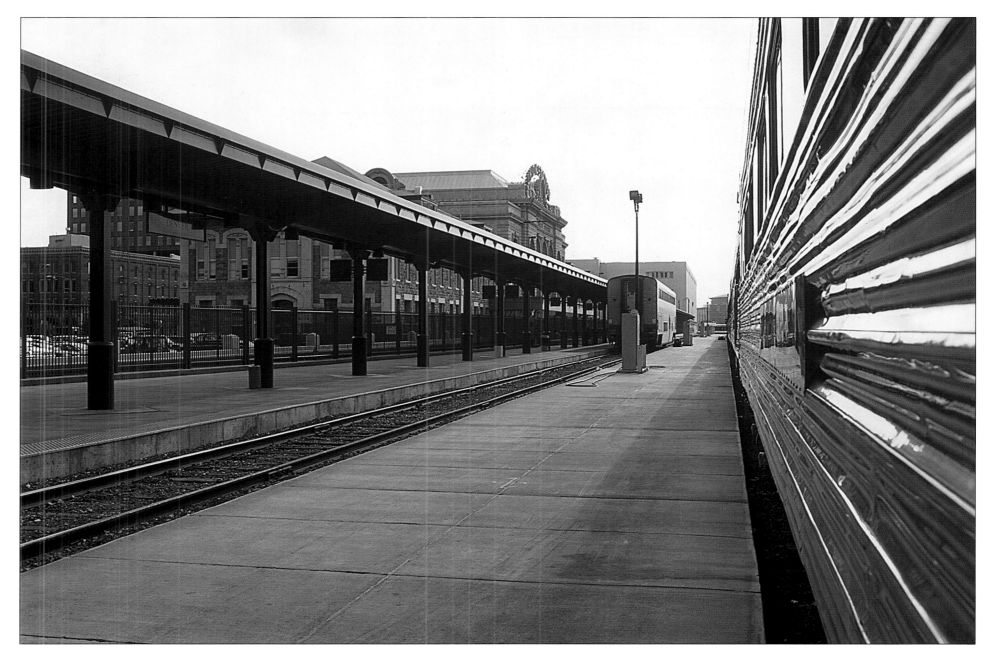

It is dining now, more than railways, which drives traffic into Union Station. Since World War II, there has been a steady decline in the demand for train transportation. Only a handful of Amtrak lines and the scenic Winter Park Ski Train still carry Denver's rail passengers west across the great divide or east through the plains. Still, the history of Denver's railroad has made possible the existence of the city as it is now.

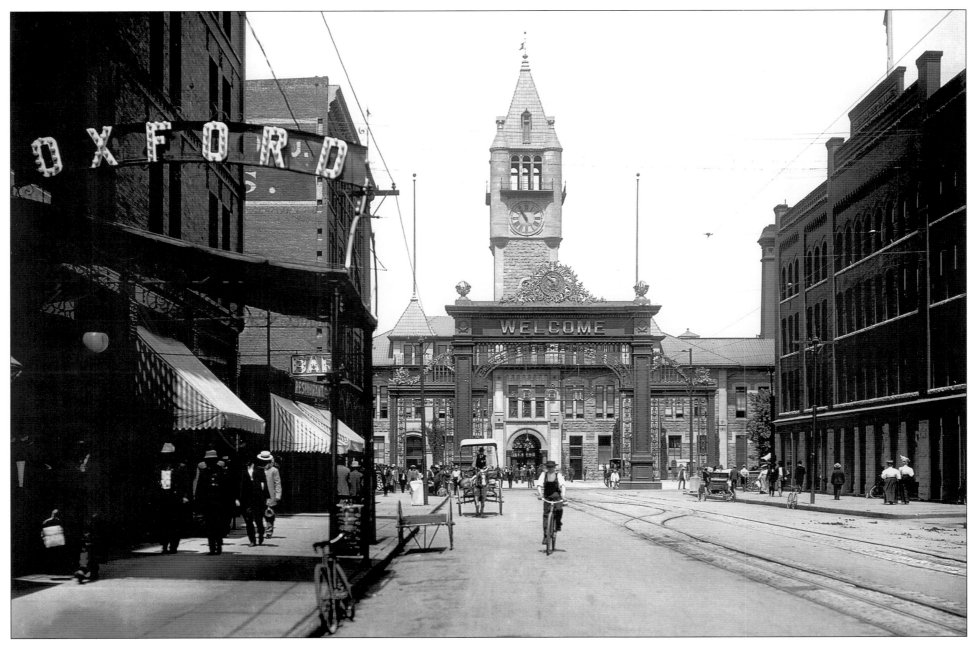

Within a decade of the railroad coming to town, it had become necessary to consolidate the various train depots within Denver. Thus, on May 13, 1881, Union Station was opened at the foot of lower Seventeenth Street. By the early 1900s, Union Station was Denver's busiest building and most important link to the rest of the country, seeing nearly eighty daily departures and one million visitors a year. The nearby Oxford Hotel accommodated many of the wealthier travelers.

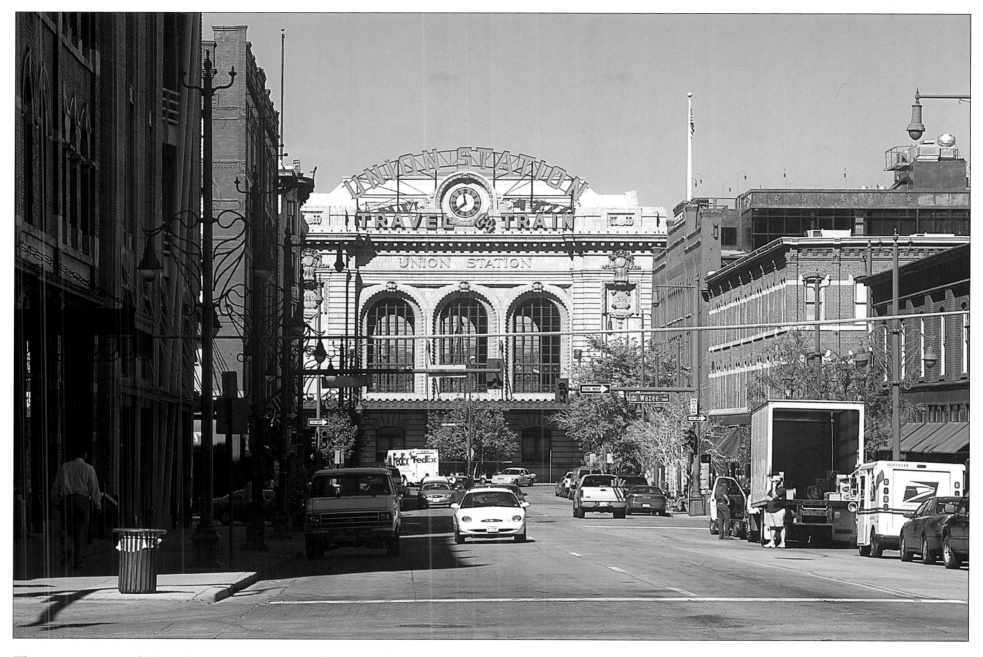

The center section of Union Station, as it stands today, was built in 1914, after the original structure was razed to make room for the growing demand for rail transportation. The eighty-six-foot-wide, sixty-five-foot-high, illuminated "Welcome Arch" that had been erected by Mayor Speer as "Denver's Front Door" was deemed a traffic hazard and removed in 1928. The Oxford, even without its glowing signage, remains Denver's oldest operating hotel, and one of its most charming and popular.

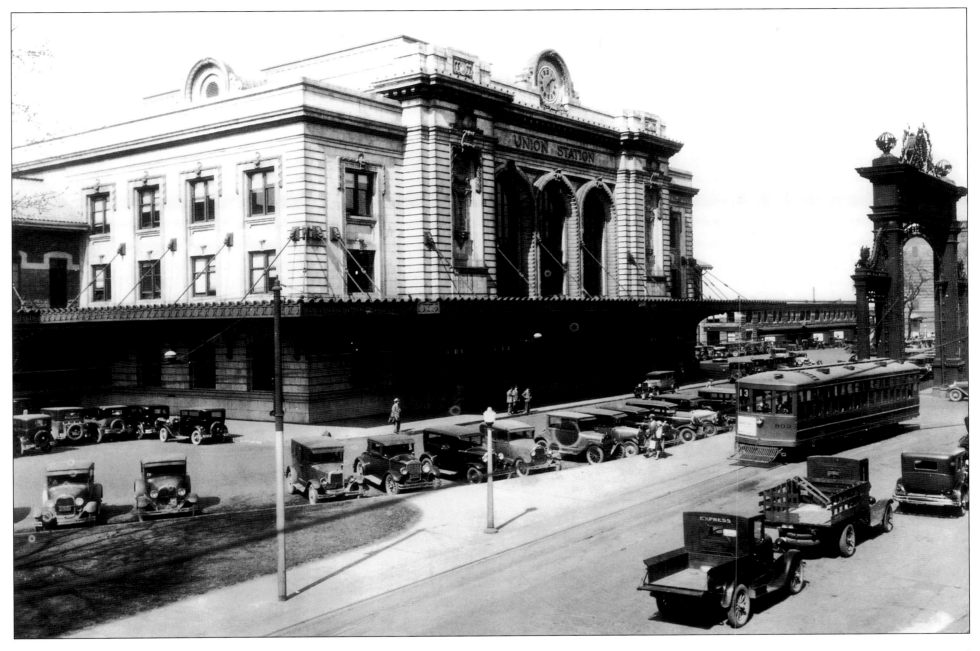

When it was built in 1881, Union Station was a symbol of Denver's coming of age, its initiation as "Queen City of the Plains." This shot, taken shortly after the main structure's second and final rebuilding in 1914, shows the simpler, more "modern" face of Denver's railway depot. Gone is the massive clock tower and Italianate architecture of the old building, replaced by the mammoth anchor of Seventeenth Street as it still stands today.

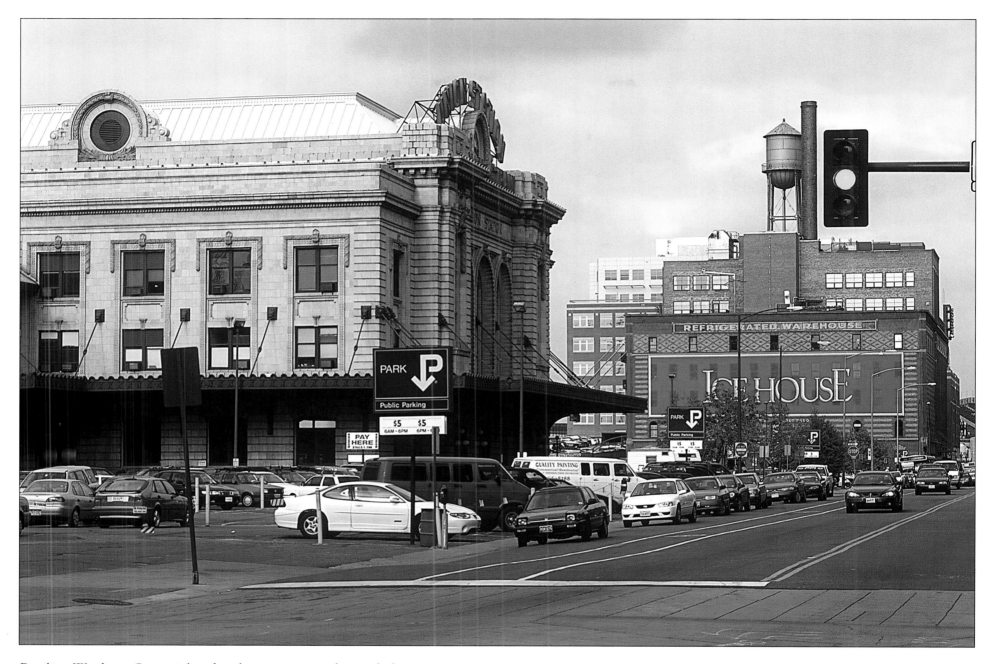

Bustling Wynkoop Street is lined with restaurants today, including one in
each wing of Union Station—wings that remain from the original 1881
structure. Although the station is virtually devoid of train traffic these days,
its great hall, sunlight streaming in from thirty-foot-high, arched windows, is a
proud reminder of the days when the building stood as the heart of Denver.

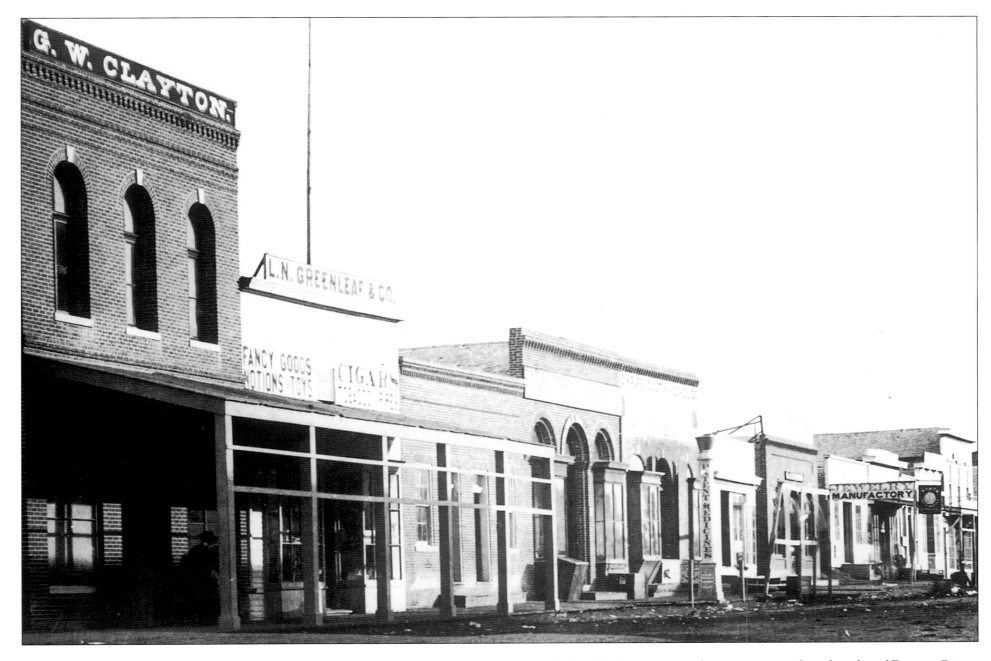

Named after William Larimer, the not-so-scrupulous founder of Denver City, Larimer Street was Denver's first real street and primary retail center. This shot, taken sometime in the 1860s, shows the slow move from wood frame to brick that reflects Denver's transformation from rural boom town to Queen City.

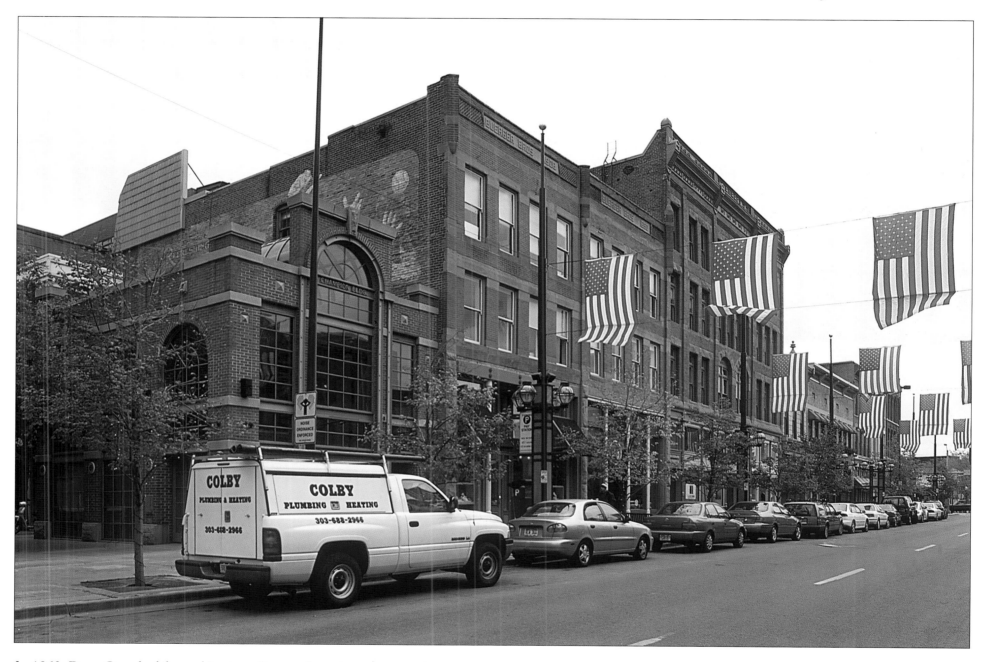

In 1963, Dana Crawford formed Larimer Square Associates, a group that successfully prevented the demolition of the 1400 block of Larimer Street by the Denver Urban Renewal Authority (DURA), a group dedicated to building an impressive skyline at the expense of many historical districts. The struggle was a success and one that led to several similar successes in Lower Downtown. Larimer Square became Denver's first historic district in 1971.

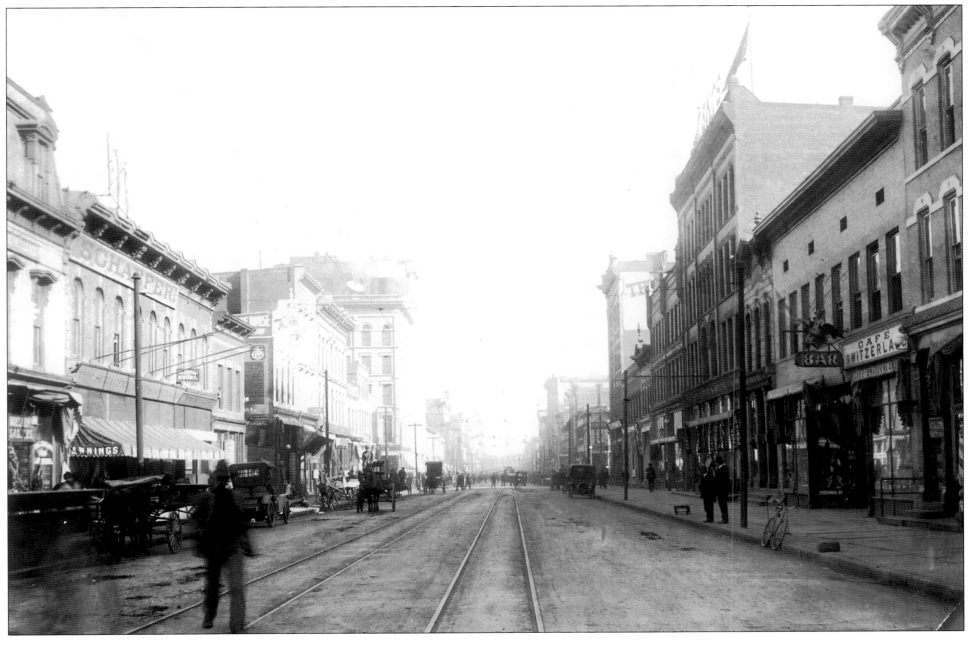

Although by the late 1800s Denver's commercial district had grown well beyond the small core that originally made up the city, Larimer Street was still a vital retail center. This photo, taken between 1905 and 1920, shows a host of stores and office buildings with the ruddy, brick complexion that still characterizes the historic districts of the city. The smelters of Denver's industrial section are in the distance.

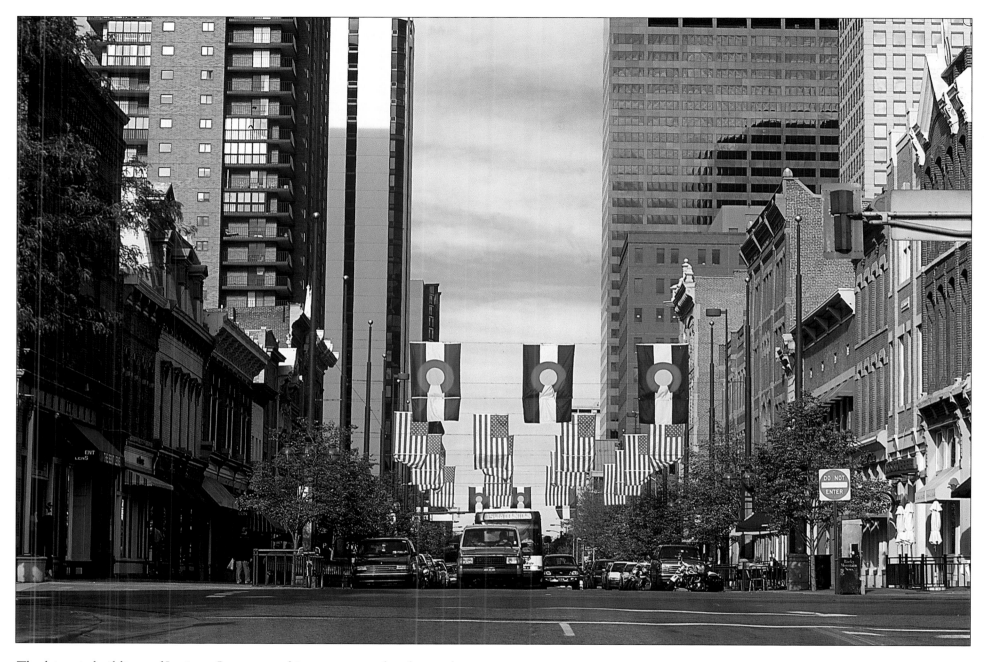

The historic buildings of Larimer Square stand in contrast to the glass and steel of many of the city's high-rises. The block, after being saved from demolition, was revitalized by architects who opened it up with arcades, courtyards, and open basements. Still a significant home for Denver's retail outlets and restaurants, Larimer Square, with its street fairs, summer concerts, and seasonal decorations, has come to shine as the face of downtown Denver.

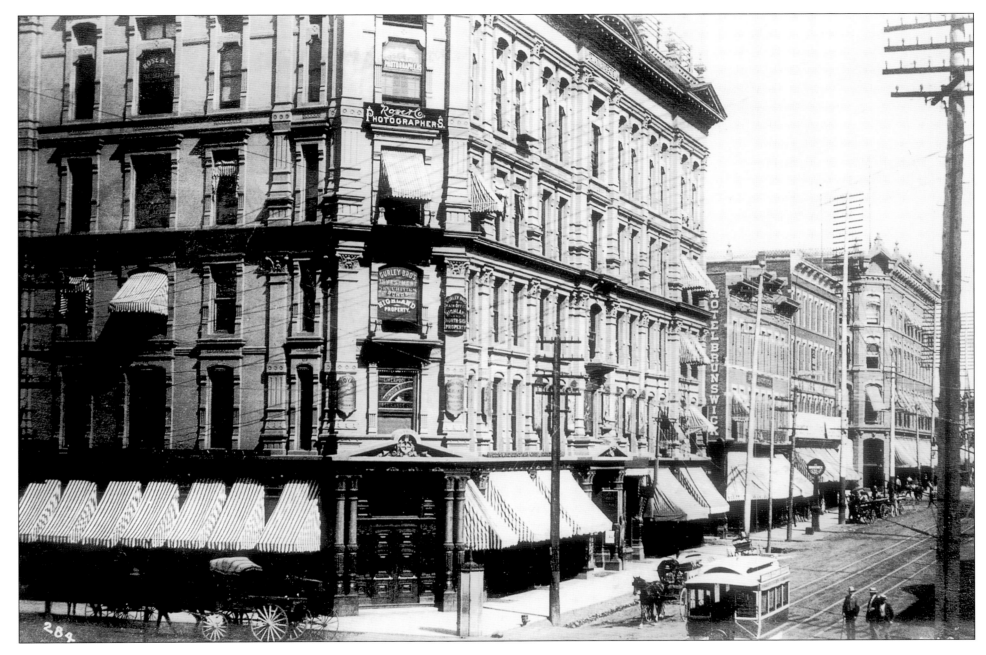

After he was elected lieutenant governor, Horace Tabor moved from Leadville, where he had made his fortune in silver, and permanently settled in Denver. The Tabor Block, an ornate five-story structure of retail and office space, was Tabor's first architectural testament in Denver to the good life. Architect brothers Willoughby and Frank Edbrooke designed the building, and Frank went on to become one of Denver's earliest preeminent architects.

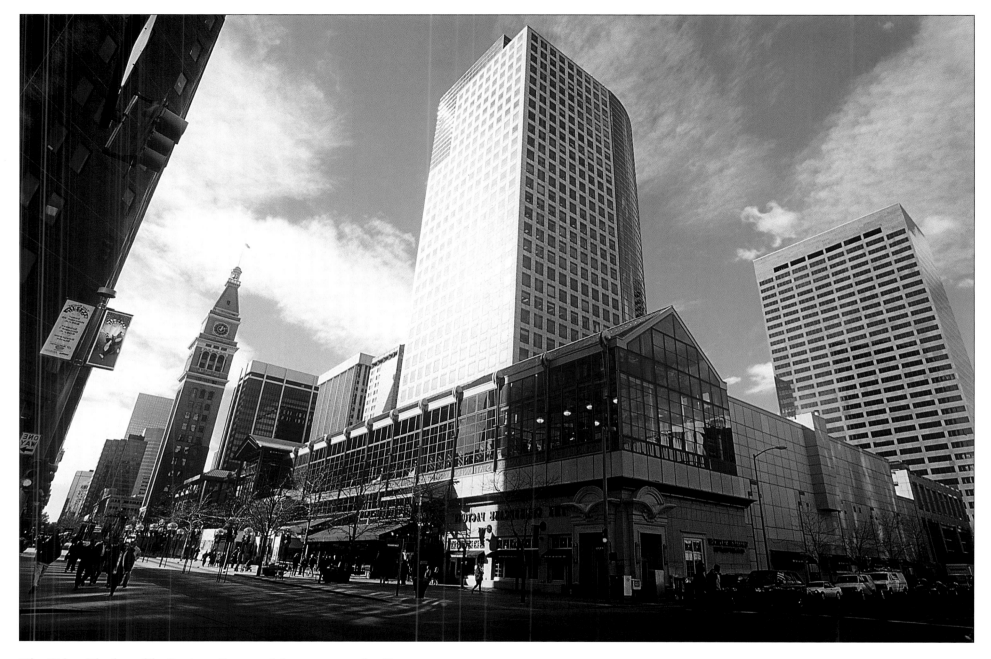

The Tabor Block, unlike Larimer Square, did not survive the Denver
Urban Renewal Authority's bulldozers, though Horace's name lives on in
the ultramodern, glass-abundant shopping mall that replaced the structure.
For years the Tabor Center, as the location is now called, housed many of
downtown's most upscale stores. Currently, the location is undergoing a major
expansion in an attempt to lure more traffic back to its position at the lower
end of the Sixteenth Street Pedestrian Mall.

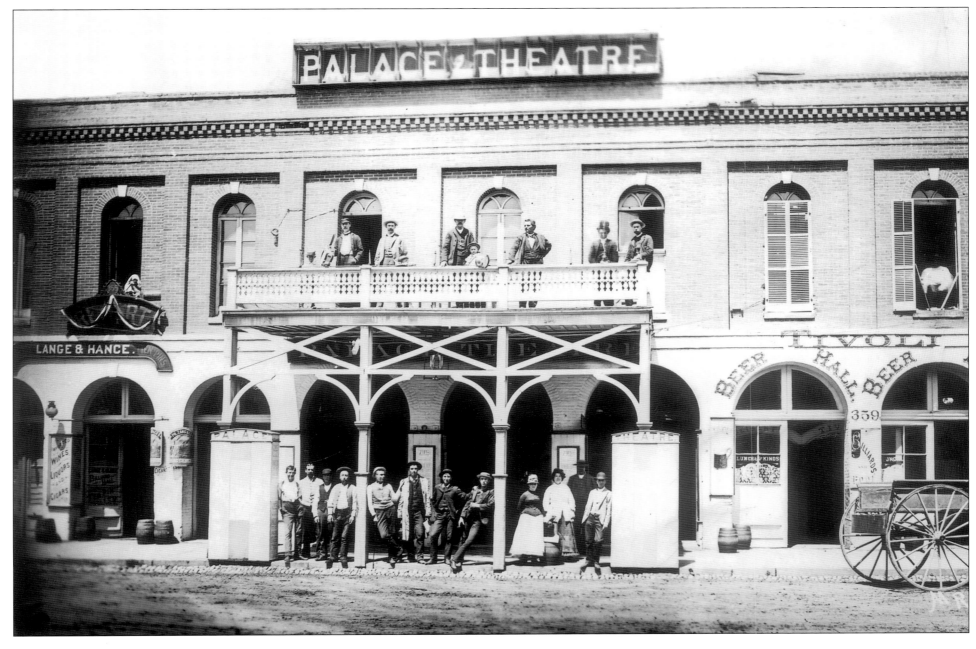

Opened by Edward Chase, one of Denver's most prominent gamblers, the Palace Theatre was a perfect example of the type of establishment that helped give Denver an unwanted reputation as a reckless, untamed town of the Wild West. Open to gambling, drinking, and burlesque, the Palace, and other establishments like it, was an embarrassment to a city desperate for national respect.

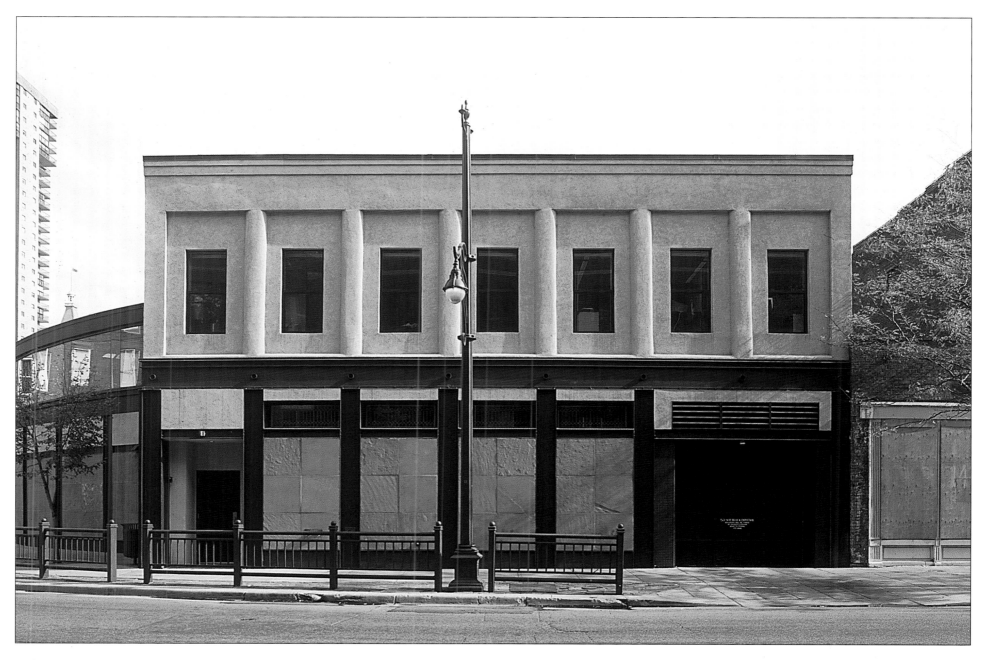

When it was announced that the main line of the Union Pacific Railroad would not run through Denver, Edward Chase, like many others banking on the growth of the railway, left town. Blake Street, which, along with Market, was once the seat of Denver debauchery and ill repute, is now lined with offices, like the one pictured here, as well as stores, restaurants, and other respectable places.

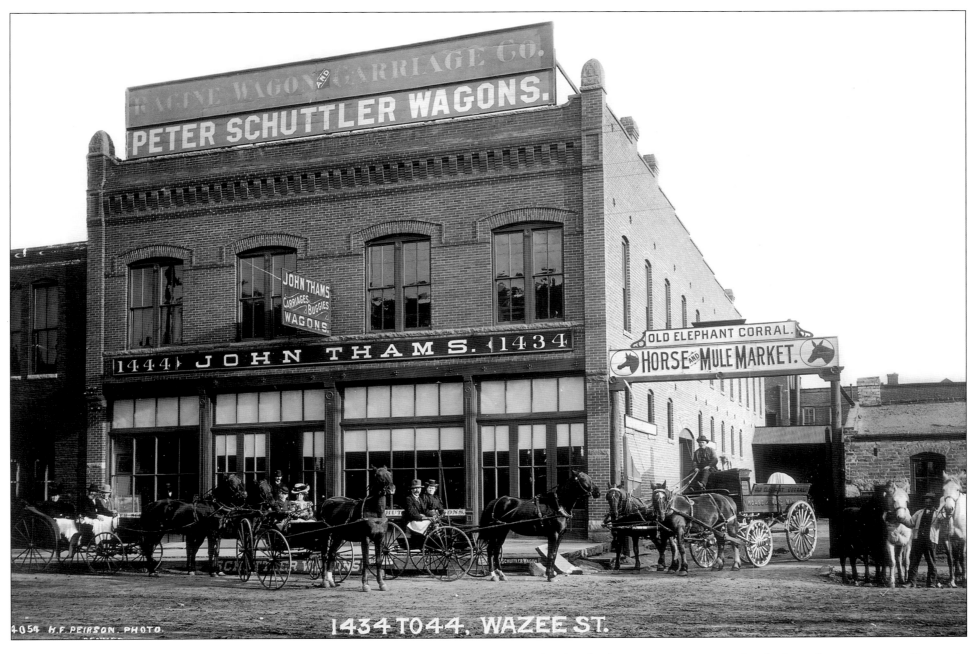

Though it has had its name since it was first built in the same year as Denver's founding, the name "Elephant Corral" is somewhat of a mystery. The original structure burned in the Great Fire of 1863, was rebuilt, subsequently torn down, and then rebuilt again in 1902. Livestock was bought and traded here continuously into the 1930s (though elephants were not among the four-hoofed commerce). Some claim that the site was the source of what is now the Western Stock Show.

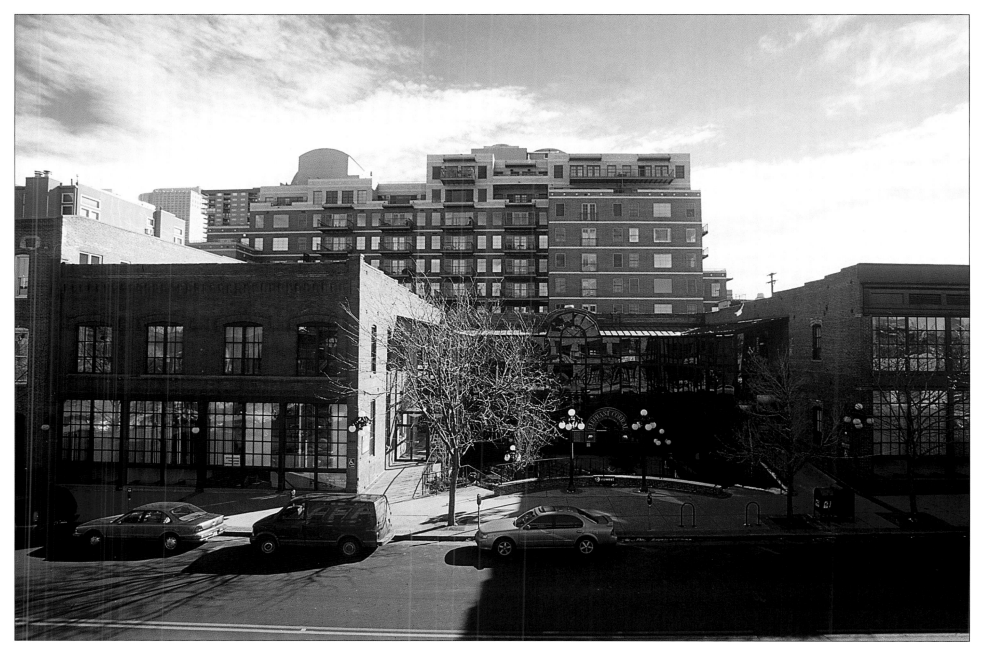

Modern commerce has replaced the horse-trade industry at the corral, where in 1981, the most recent renovation was completed. The courtyard was added where the corral itself once stood. A wall of glass now encloses the offices housed on the property, making the original structure difficult to discern, but preserving the history of the building without sacrificing modern amenity and appeal.

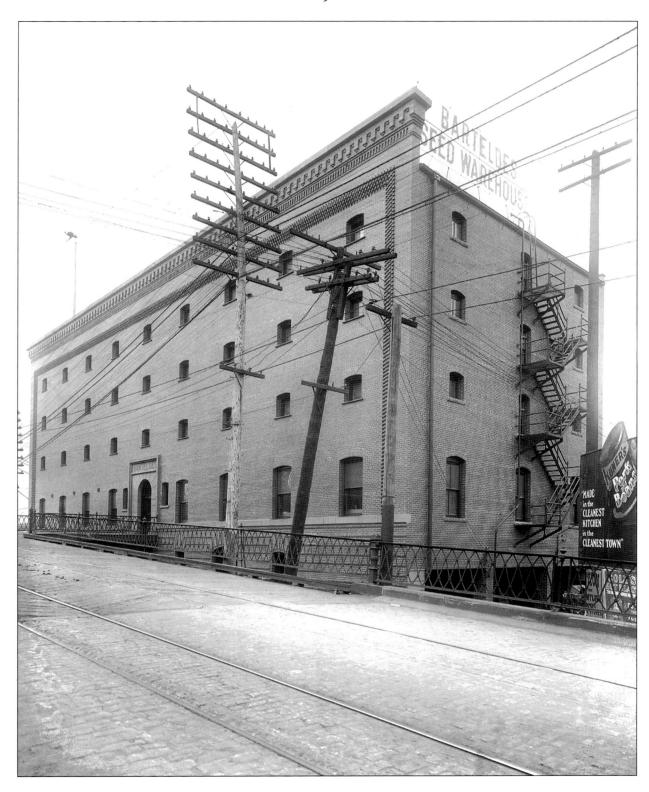

Like many early Denver businesses that started in small buildings, Barteldes Seed Company quickly outgrew its original home. The company, after changing partners several times, finally moved into this warehouse on Wynkoop and Sixteenth Street in 1908. This photo, taken between 1910 and 1920, shows the viaduct that once stretched from Wazee Street across the Platte River. A small footbridge connects the viaduct to the Barteldes Warehouse.

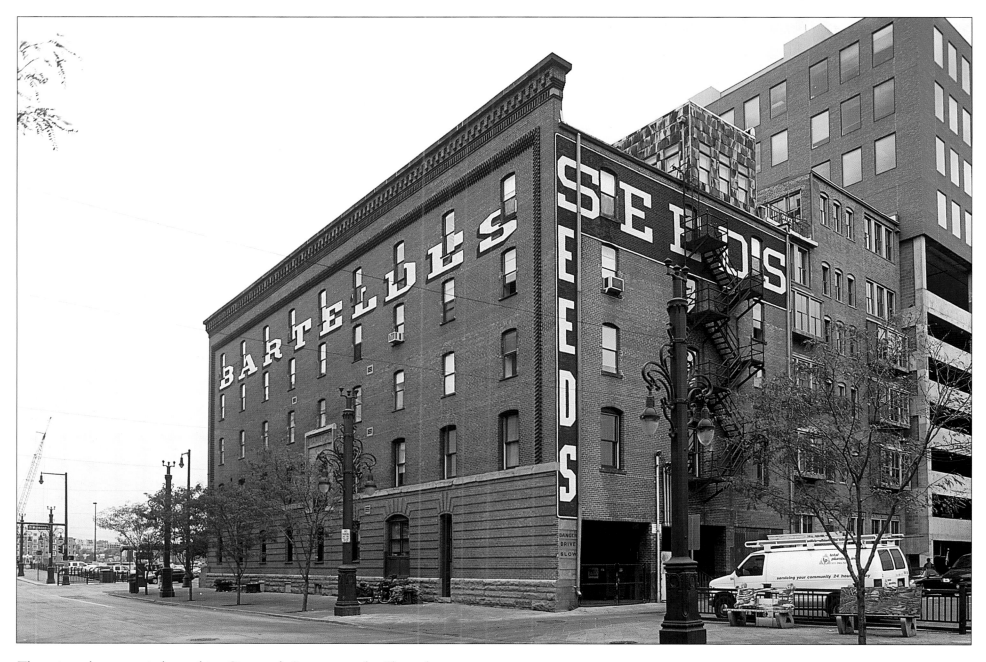

There is no longer a viaduct taking Sixteenth Street over the Platte, but it is interesting to note the second-story doorway that once served as the main entrance to the building. The sign on the textured brick wall was a popular means of advertising from the mid-1800s to the mid-1900s, and though this is a much younger example, original signs dating back as far as 1883 can be found around downtown Denver.

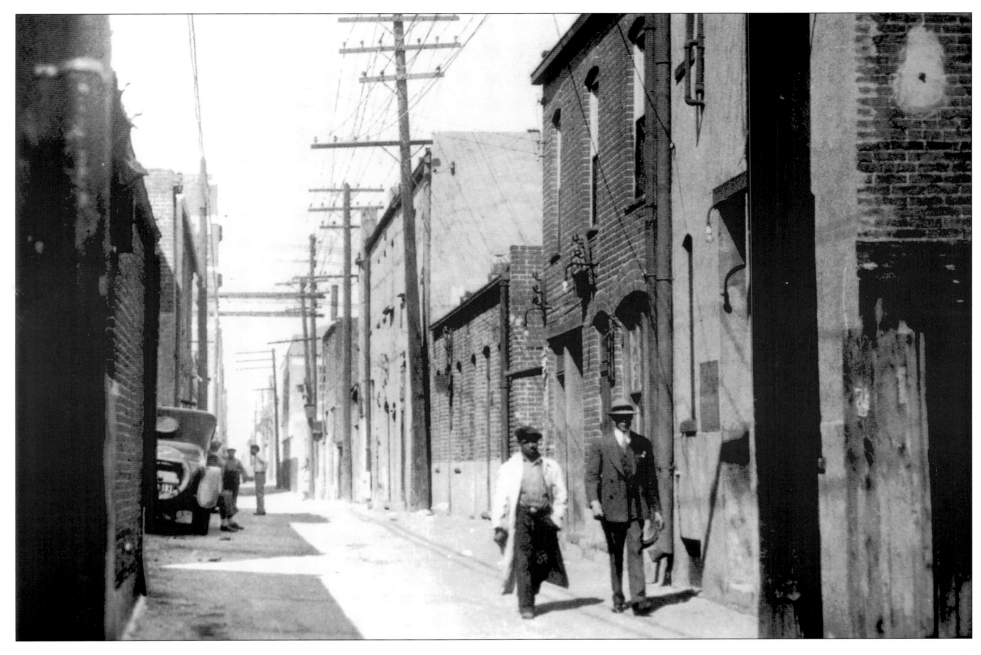

In the early 1900s, Denver wasn't exactly a bastion of ethnic acceptance, and many of the city's minority groups found it much safer to remain in specific pockets of the city. Hop Alley, pictured above, was Denver's "Chinatown," though by 1929, when this picture was taken, the Chinese population in the city had seen such violence and persecution that its numbers had shrunk from over 1,000 in the 1890s to just over 200 in 1920.

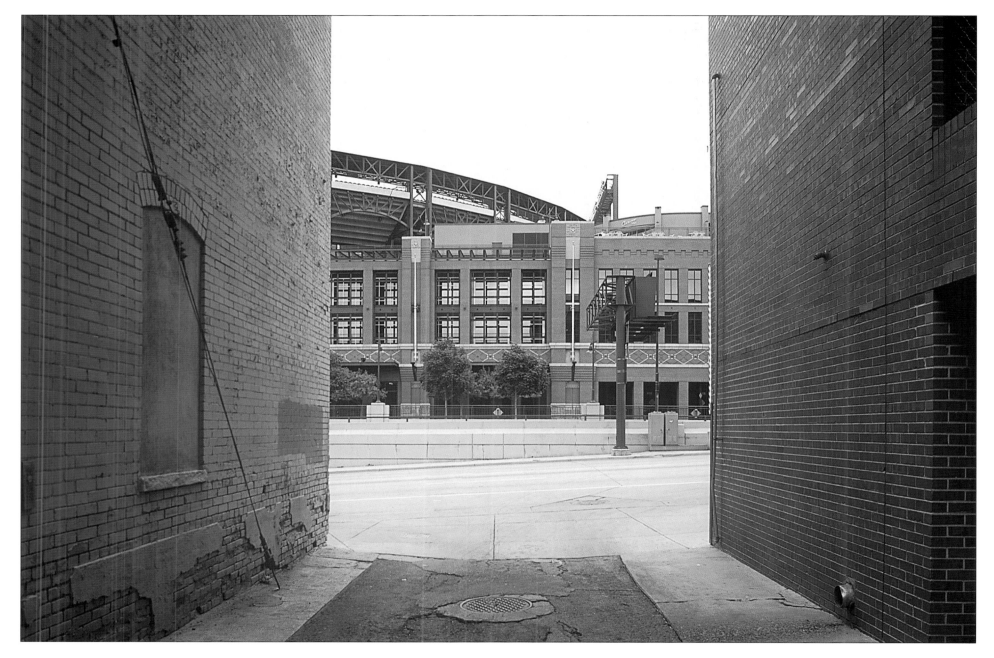

These days, Hop Alley is just an alley near Coors Field (seen above), home of the Colorado Rockies baseball team. Completed in the mid-1990s, the beautifully designed stadium is a symbol of a city constantly striving to come of age as a modern metropolis. Likewise, Denver's Asian population, which once unceremoniously populated Hop Alley, grew rapidly throughout the latter half of the twentieth century. Hints of Asian culture can now be seen, felt, and tasted throughout Denver.

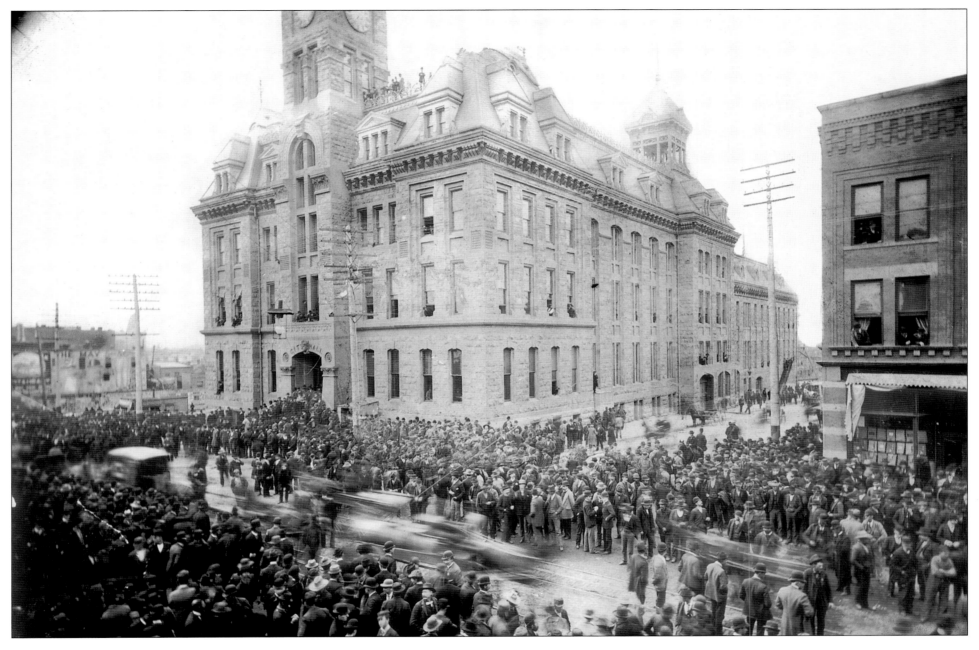

The City Hall building was never very well respected, either for its architecture or the politics that went on within. In March of 1894, Governor Davis H. Waite attempted to remove several corrupt city commissioners from duty. The commissioners barricaded themselves inside the building, and for several hours the city stood on the brink of riot. From its birth, Denver's government was plagued with corruption; unfortunately, City Hall stood as a pillar to that old government.

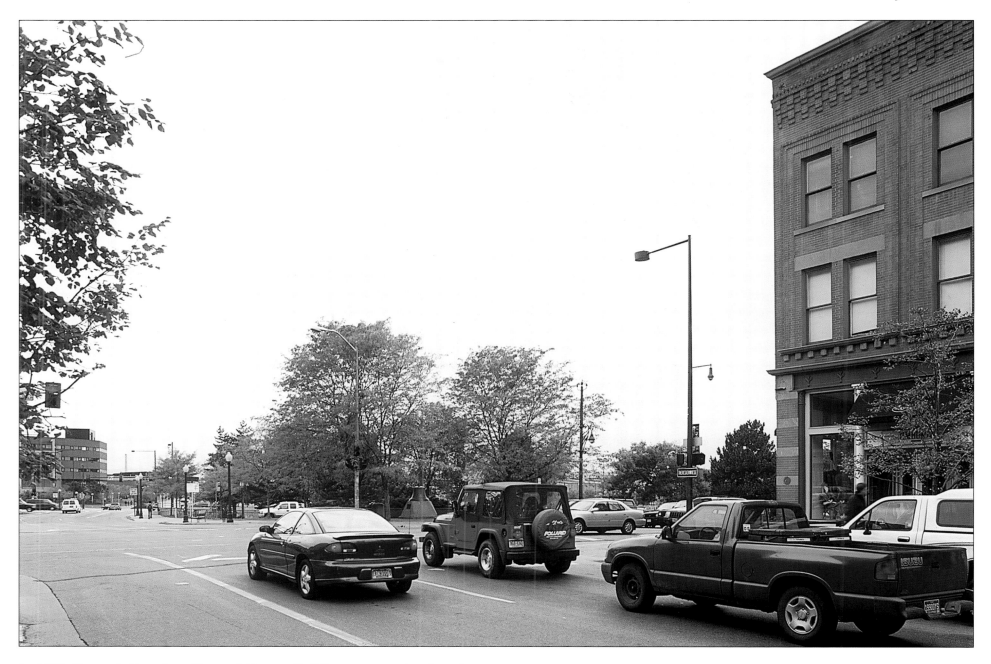

In 1932, Denver's illustrious City and County Building was completed, and city officials abandoned their offices at City Hall. Today the south end of Market Street is more a retail hub than a political one. As is evident in this photo, the old City Hall was later demolished, and this was one historical reminder that many Denverites were happy to see go.

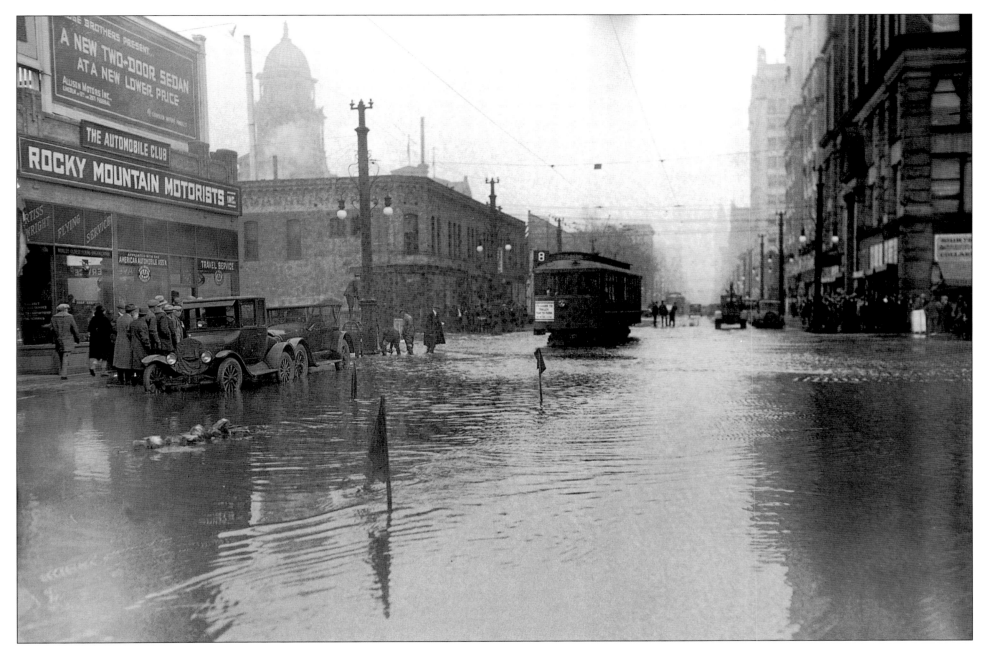

Several years after the chartering of Denver as a city, a lesson to future planners was learned, as the waters of Cherry Creek rushed over their banks, virtually wiping out the earliest buildings in the town of Auraria. Though Denverites quickly learned how to live with the two rivers that bordered their city, floods, including the one pictured here at Sixteenth and Cleveland Street, which was caused by the Castlewood Dam collapse of 1933, have dotted the city's history.

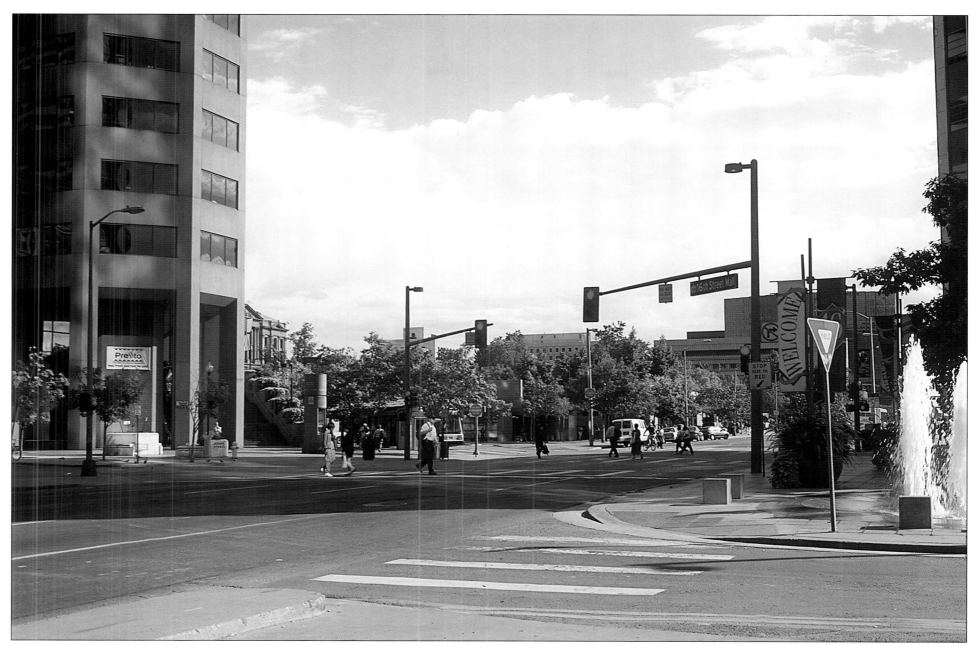

The walling of Cherry Creek, as well as technological advances in the design of dams, has helped prevent any major downtown floods in recent years. This photo shows a dry version of the top of Sixteenth and Cleveland Street, looking toward the Capitol Building, which is now obscured by the Petroleum Club Building.

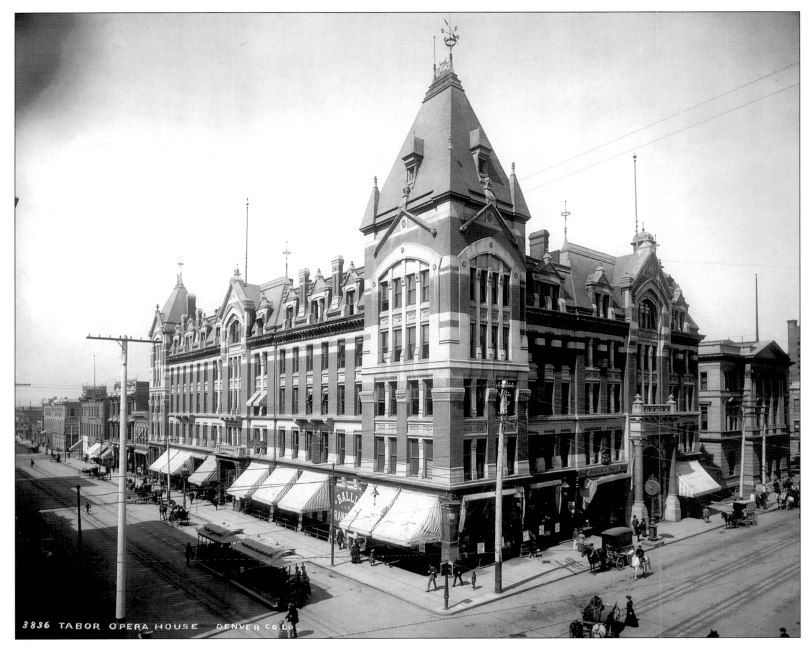

3836 TABOR OPERA HOUSE DENVER COLO.

Once considered the finest building in the city, the five-story Tabor Grand Opera House, like Tabor's other great architectural achievement, the Tabor Block, was built by renowned architects Willoughby and Frank Edbrooke. The building's completion in 1881 signaled a new era in Denver building and a huge step forward in the cultural relevancy of Denver. The Opera House, the crown of Theater Row at Sixteenth and Curtis, even boasted Denver's first elevator.

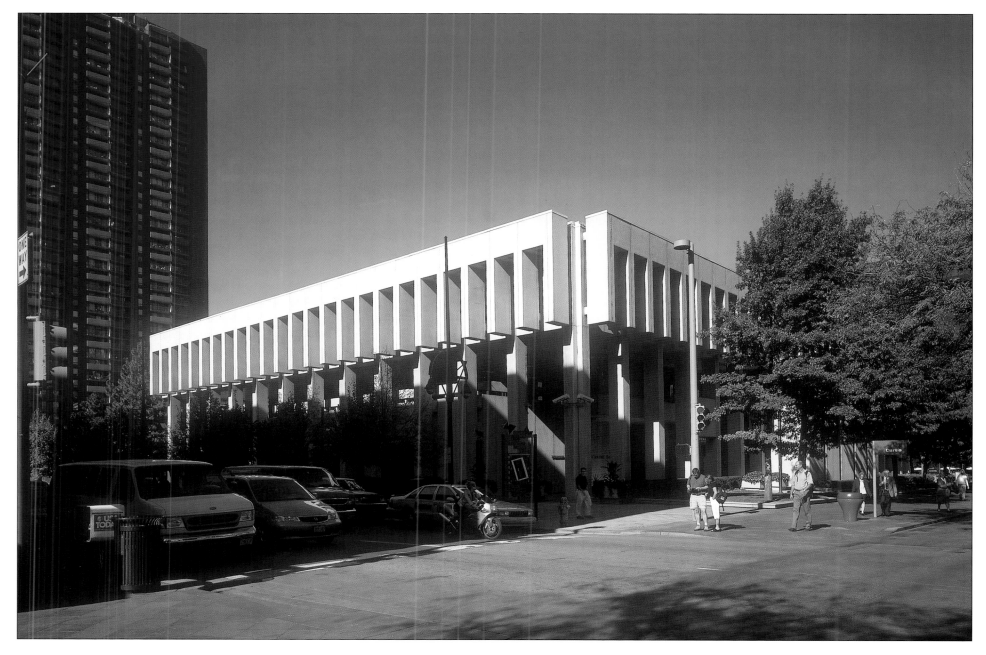

Many of Denver's greatest historical structures were demolished before the era of preservationists. This is unfortunately the case with the Tabor Opera House, a structure that certainly would have been worthy of the national register for Denver landmarks. Instead, this less-remarkable, two-story office building lines the pedestrian mall on Sixteenth Street where it intersects with Curtis.

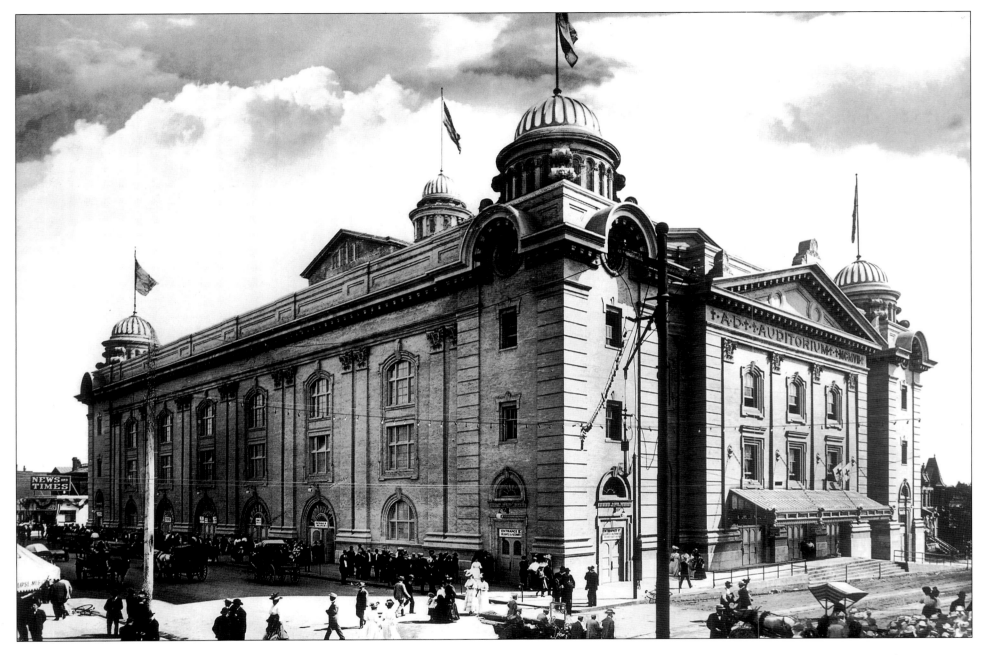

Opened in July of 1908 to coincide with the Democratic National Convention and the inauguration of Mayor Robert Speer, the 12,000-seat City Auditorium was, at the time, second only to Madison Square Garden in size. The auditorium, which hosted music, theater, conventions, and expos of all kinds, stood illuminated at Fourteenth and Curtis, flags flying from each of its domes, as a proud accomplishment of the city.

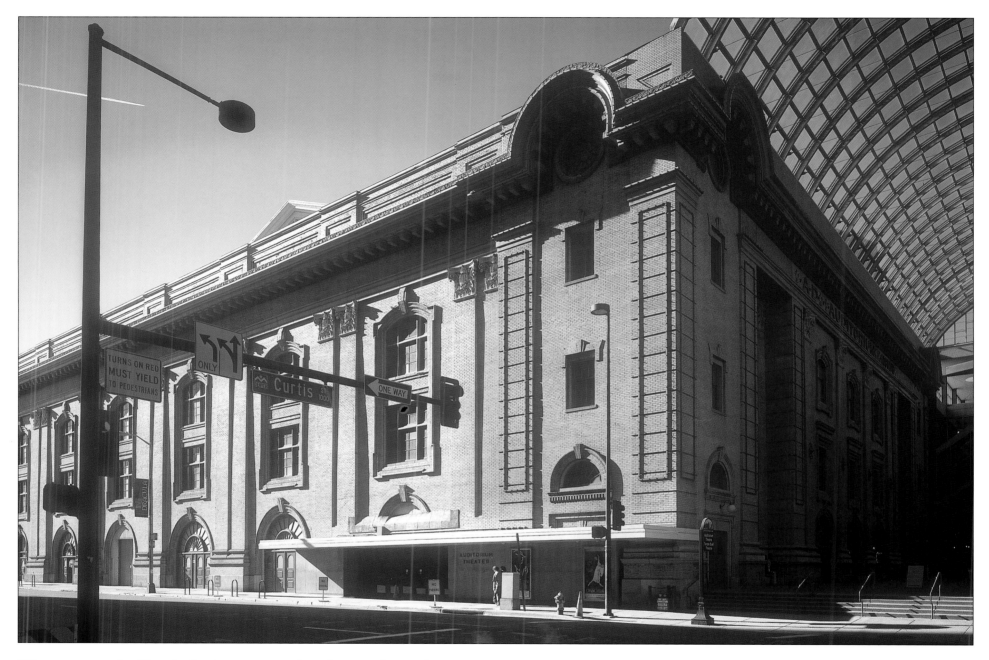

What was once the City Auditorium now stands with a new face as the foundation of the impressive Denver Center for the Performing Arts (DCPA), a huge, ever-expanding complex of theaters. The DCPA, which boasts the nation's second largest seating capacity, is connected by a galleria under a glass vault. The complex, as was the intention, attracts many of the nation's top theater tours and musicians, and is a cornerstone of Denver's cultural scene.

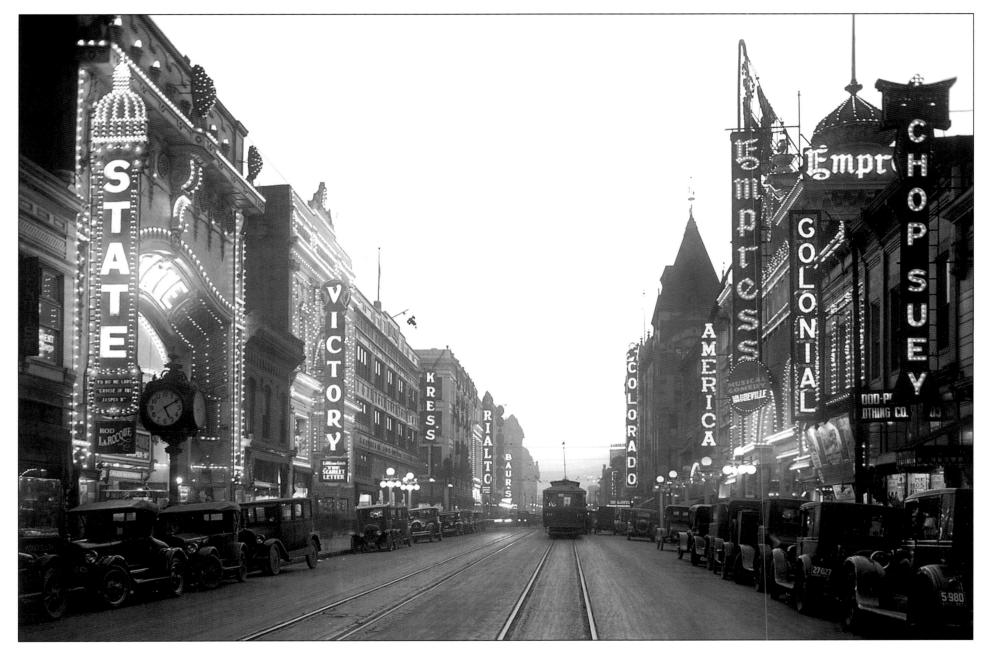

Bookended by the City Auditorium at Fourteenth Street and the Tabor Grand Opera House at Sixteenth, Curtis Street was Denver's Theater Row. Little light bulbs had become a signature of the city, and in a place that proudly called itself the "City of Lights," Curtis Street was Denver's "Great White Way." By 1930, there were forty-eight theaters shining 10,000 bulbs on Denver's streets, prompting the claim that Curtis was the brightest street in America.

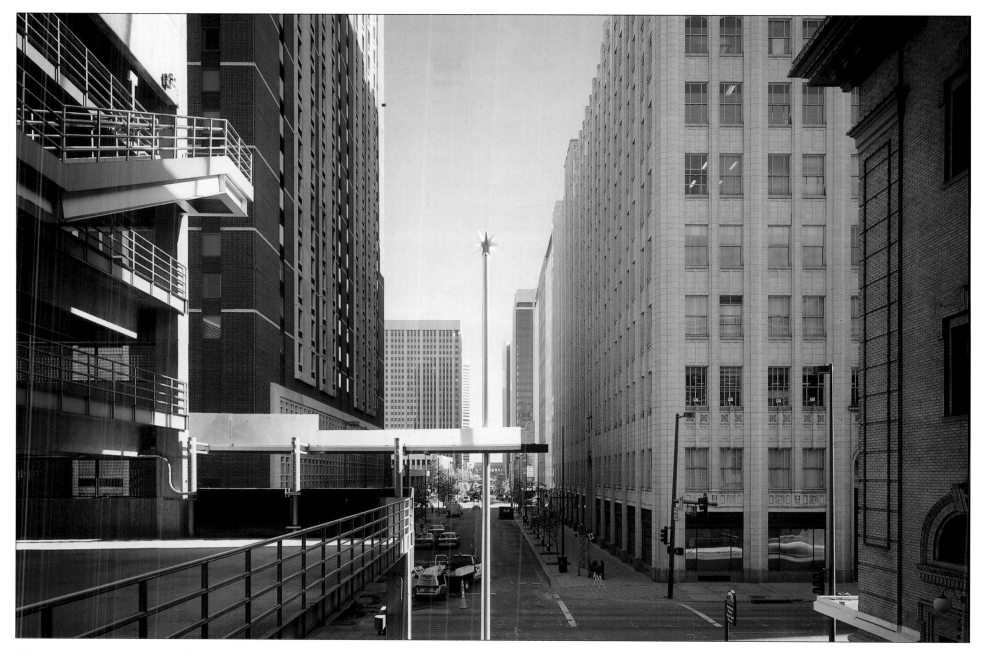

The Great Depression brought the lights down on many of Curtis Street's theaters. Stage shows were largely replaced by movies, and the battered economy didn't leave much room for recreation. Eventually, the Denver Urban Renewal Authority razed the entire street of its theaters, consolidating the city's stages into the DCPA Megaplex. Offices and loft high-rises have since taken the place of the Great White Way.

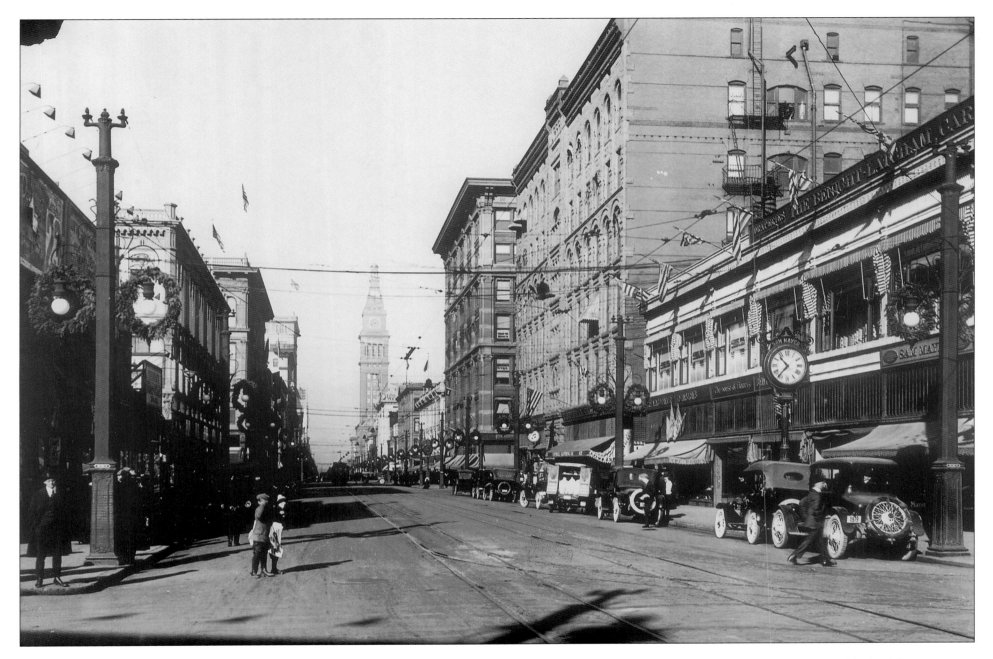

By the late 1800s, Sixteenth Street was the primary retail hub of downtown Denver. Drawn by the abundance of shopping and theaters, Denverites flocked to the thirteen-block, one-mile stretch that connected what would soon be the Civic Center and state buildings to lower downtown.

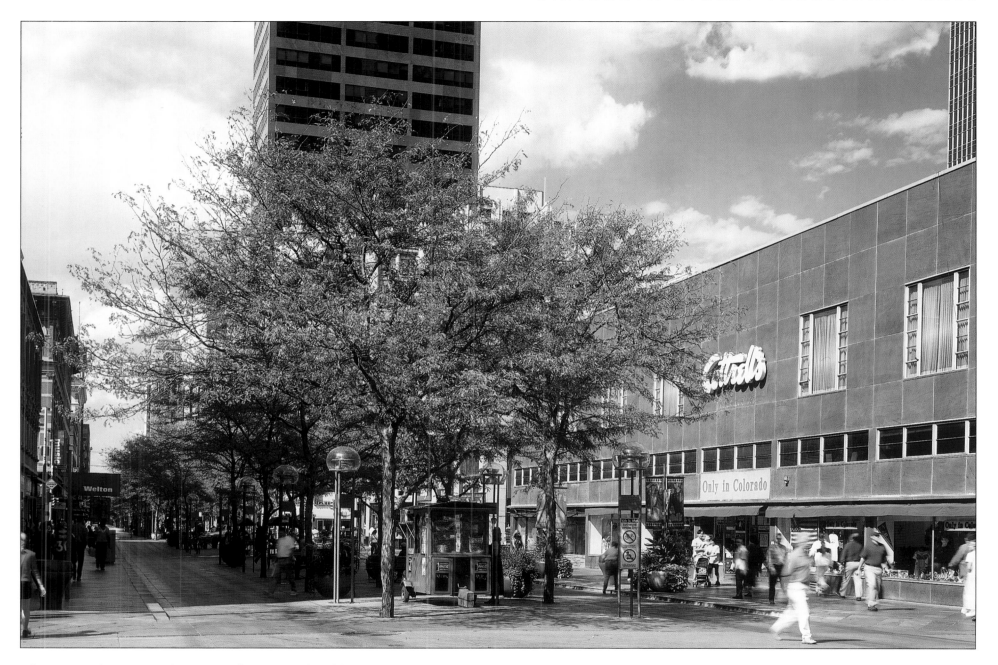

The Sixteenth Street Pedestrian Mall was completed by IM Pei's office in
1982, in an effort to return retail dominance to an area that had slumped in
the preceding decades. It took several years, but the trees, fountains, and
outdoor sculptures on the new mall eventually did see the beginning of a new
downtown economic boom.

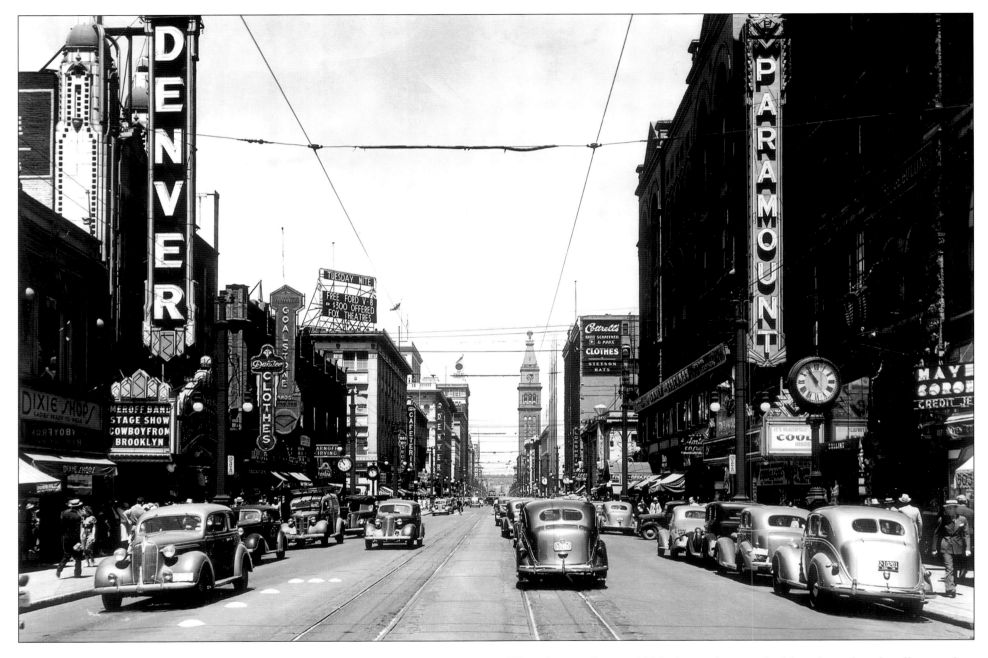

This photo, taken in 1938, shows that cars had largely replaced trolleys as the primary means of transportation in post-Depression downtown Denver. As the city continued to evolve, structures like the Paramount Theater, designed by renowned architect Temple Buell, with its grand lobby and 2,100 seats, was a shining example of the good life for which Denver was striving to achieve.

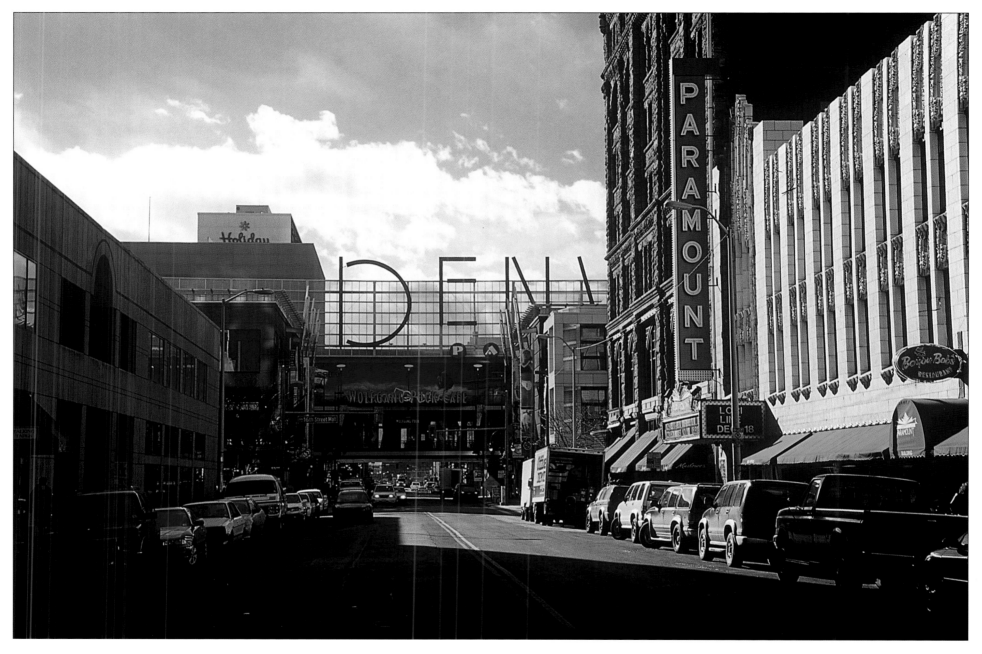

These days, the free shuttle buses are the only motorized transportation allowed
on the thirteen blocks of Sixteenth Street between Market and Broadway. The
Paramount Theater, though built during the Depression, was a grand model of
art-deco design and remains on the mall as the sole movie palace to survive the
Sixteenth Street renewal. The new face of Denver is nowhere more evident
than in the Denver Pavilions mall, which is seen here in the background.

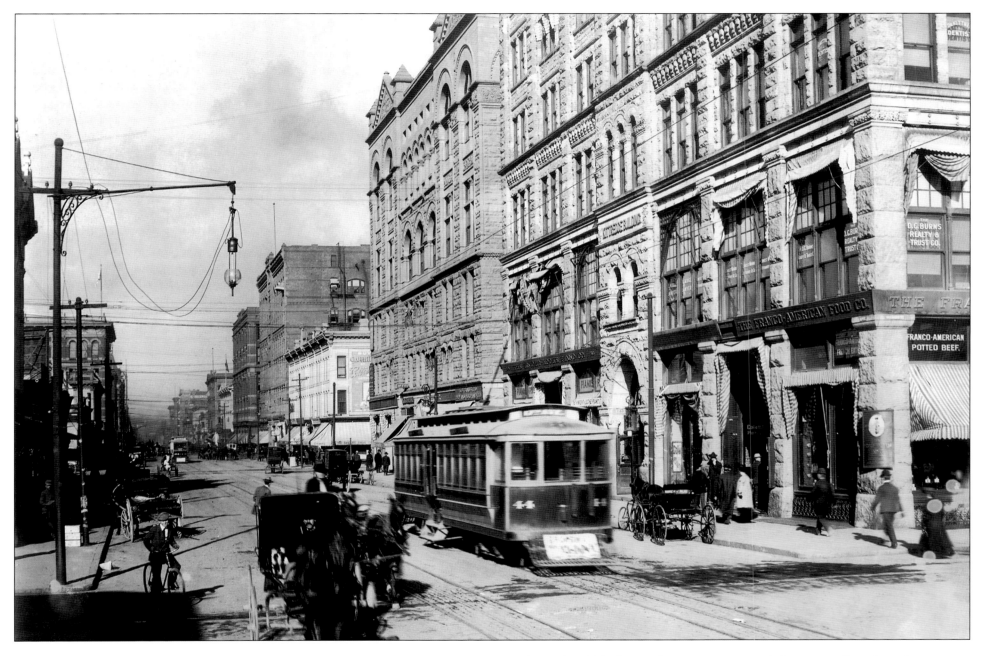

In the early 1900s, horse-drawn carriages and electric trolleys shared Sixteenth with pedestrians who shopped and strolled on this street to "see and be seen." The seven-story Kittredge Building, in the foreground on the right, is considered by many to be Denver's first modern skyscraper, complete with an elevator. True to the spirit of Sixteenth Street, the Kittredge Building offered retail space at street level.

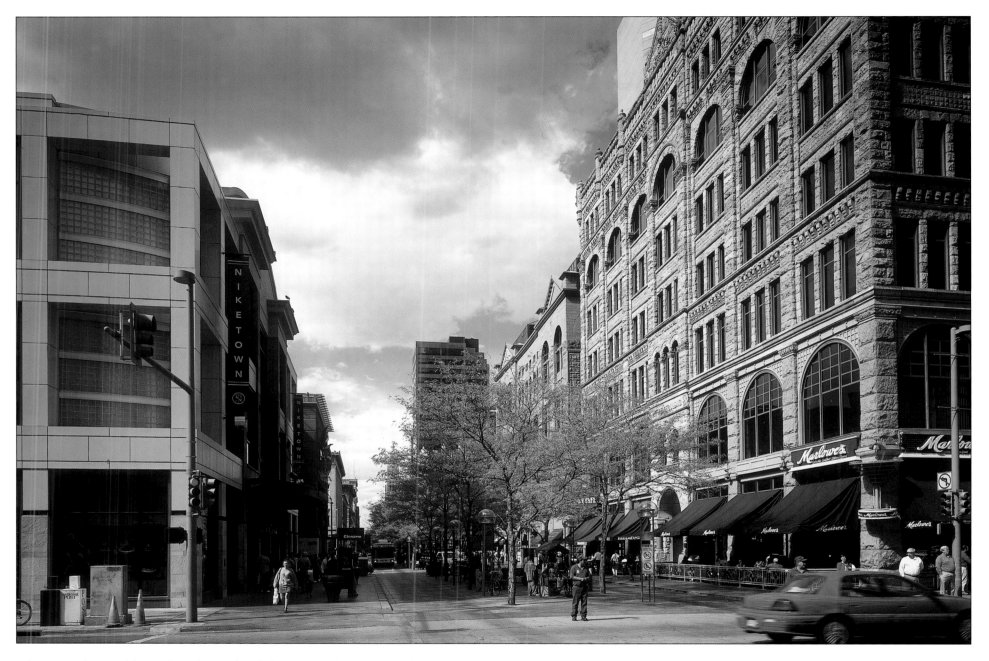

The Kittredge Building, though overhauled in the early 1990s, still stands in historical contrast to its neighbor across the street, on the left of this photograph—the brand-new Denver Pavilions, a structure converted in the last years of the twentieth century from a two-block stretch of parking to an ultramodern shopping gallery, brimming with national retail outlets and upscale stores and restaurants.

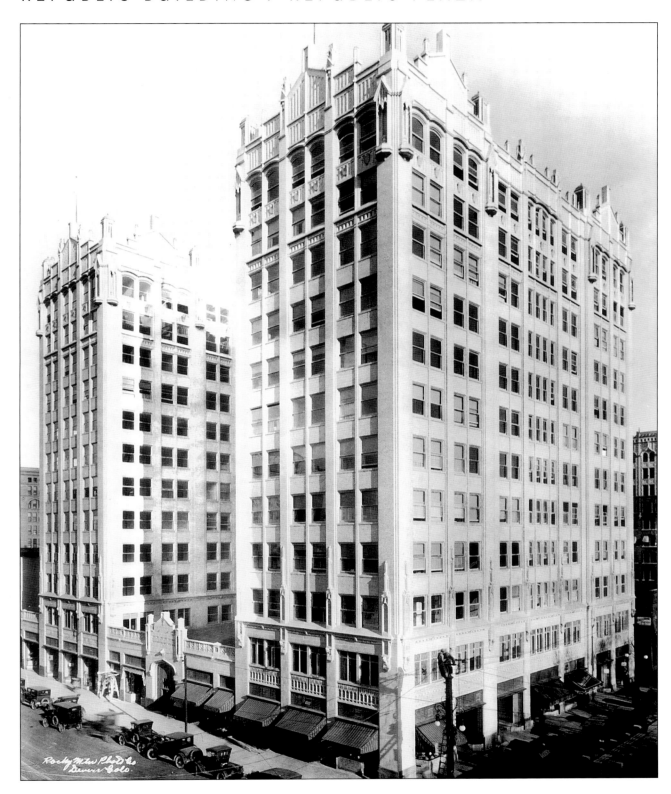

Shortly after the time that Denver began erecting buildings toward the sky, a height restriction barred the design of any building over twelve stories tall. Until 1953, when the restriction was repealed under pressure from developers, the well-admired Republic Building, as pictured, was as tall as it got in Denver.

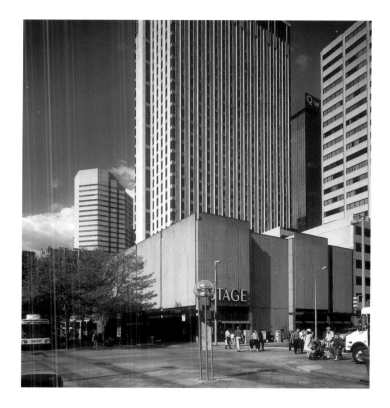

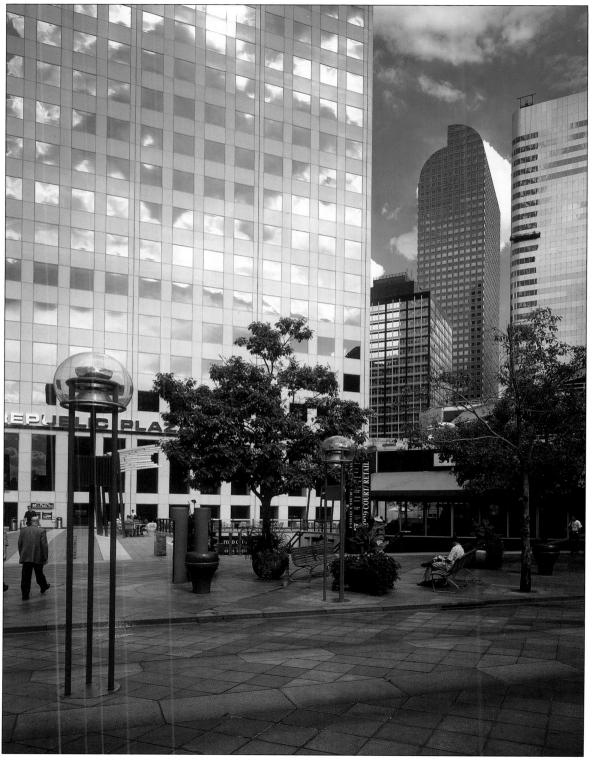

In 1981, the Republic Building, despite protest, was demolished. Today, Denver reaches way beyond twelve stories into the sky, as can be seen at the fifty-six-story Republic Plaza, built in 1983, and in the structures that surround it. The straightforward Republic Plaza is currently the tallest building in Colorado and appreciated more for its incredible reflective capabilities than for its architectural achievement.

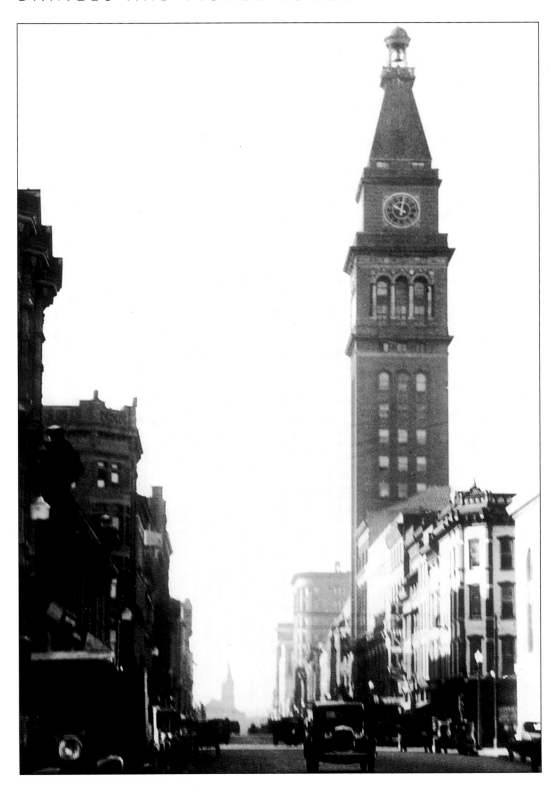

William Daniels, co-owner of Denver's finest department store, Daniels and Fisher, envisioned a retail outlet that sported a tower fashioned after Saint Mark's in Venice. Thus, in 1911, the 372-foot Daniels and Fisher Tower was erected, connecting to the department store itself. It did not resemble Saint Mark's, and it is questionable whether it was actually the third-tallest tower in the world as was claimed, but the Daniels and Fisher Tower certainly made a respectable mark on Denver in its own right.

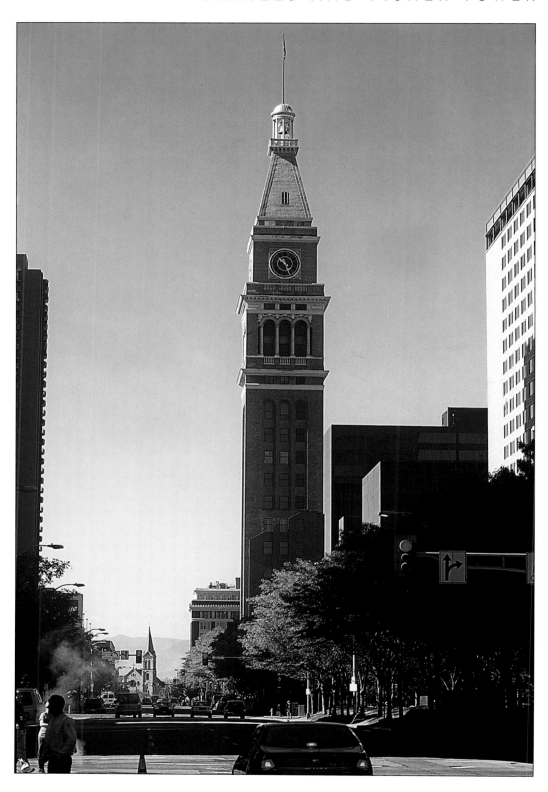

The Daniels and Fisher Tower no longer dominates Denver's skyline as it once did, but it certainly stands as a survival story in the long list of historical casualties caused by the Denver Urban Renewal Authority's renovation of Denver. While the attached Daniels and Fisher department store did not fare as well, the tower, now used as full-floor offices, remains one of Denver's most elegant landmarks.

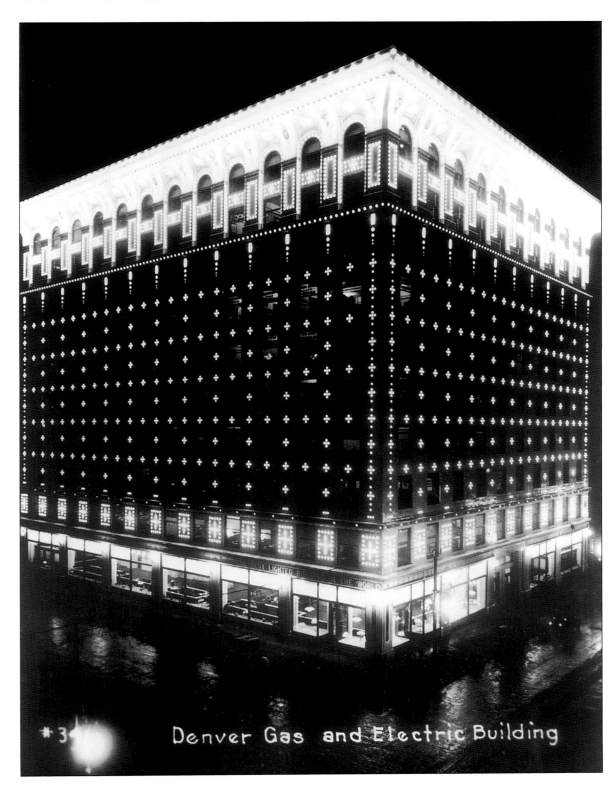

Denver Gas and Electric Building

The Denver Gas and Electric Building at Fifteenth and Champa was built during Denver's era of lights. Unfortunately, the DG&E Building shined much brighter than the ethics of the company itself. While the company was often enshrouded by scandals involving monopolistic practices and election fixing, Denver marveled at the glow of the 13,000 bulbs which could, at the time, be seen for miles.

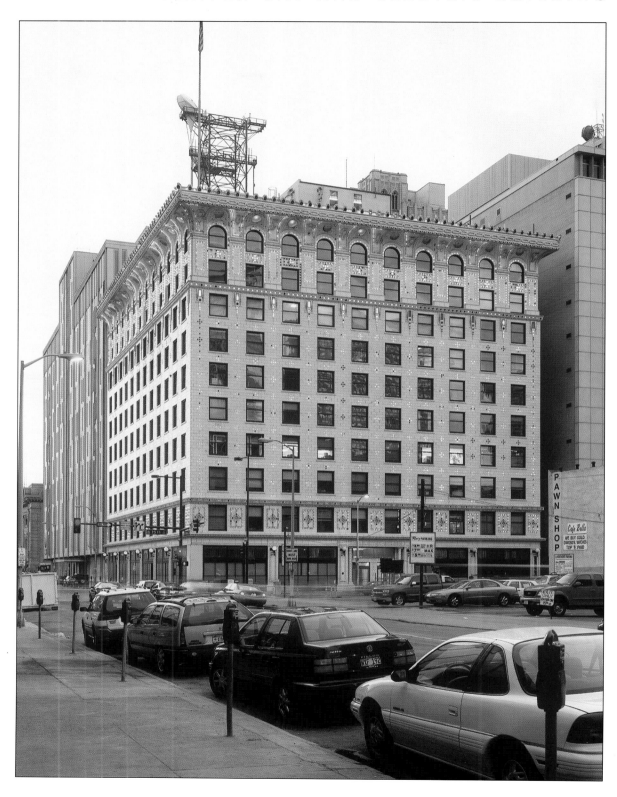

DG&E eventually became Public Service Company and moved out of the building, which was bought and renamed the "Insurance Exchange." For a number of years, the lights on the Insurance Exchange, like most of Denver's other bulbed structures, were out, but in 1983, with a nod to the past, the owners of the building turned the lights back on. The Insurance Exchange is once again Denver's brightest building.

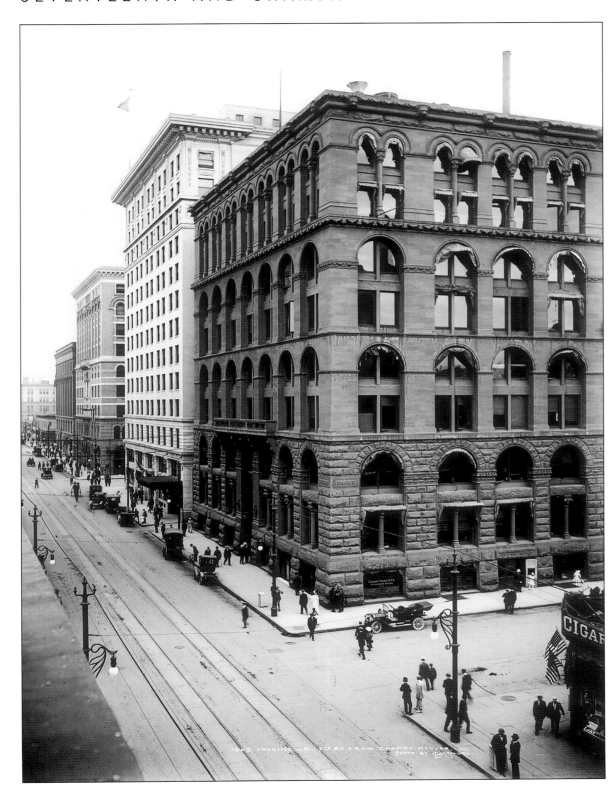

With Union Station at one end and the Brown Palace Hotel at the other, Seventeenth emerged as the most popular street for expensive offices. The Boston and Equitable buildings, which sandwich the National Bank building, were both financed by out-of-state investors, but represented the city's premier office space in the late nineteenth century.

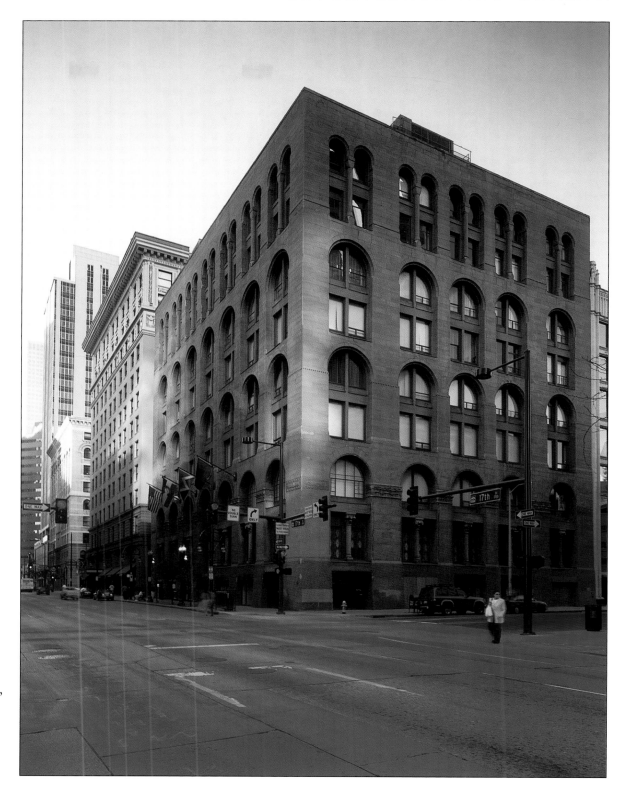

The facades of these buildings appear much as they did over one hundred years ago. Much of Denver's office space, however, has since moved to the more modern skyscrapers of downtown, while buildings like the Boston and Equitable have been converted to lofts to help accommodate the ever-growing residential population in downtown Denver.

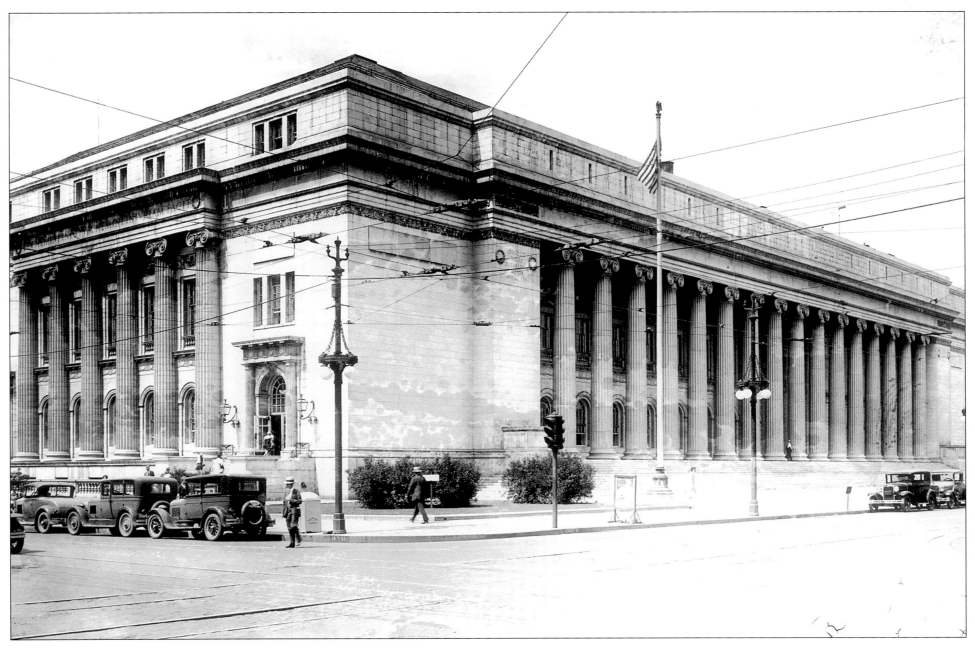

Built in 1910 (though not completed until 1916) to replace the old post office at Sixteenth and Arapahoe, the new post office was an architectural marvel of the neoclassical style. The building, which consumes an entire block, boasts sixteen ionic columns, marble walls, and a grand marble staircase that ascends to the entrance above street level. Denver was especially proud of the new post office during the Depression era; the bold, ornate design of the building reminded people of a more prosperous time.

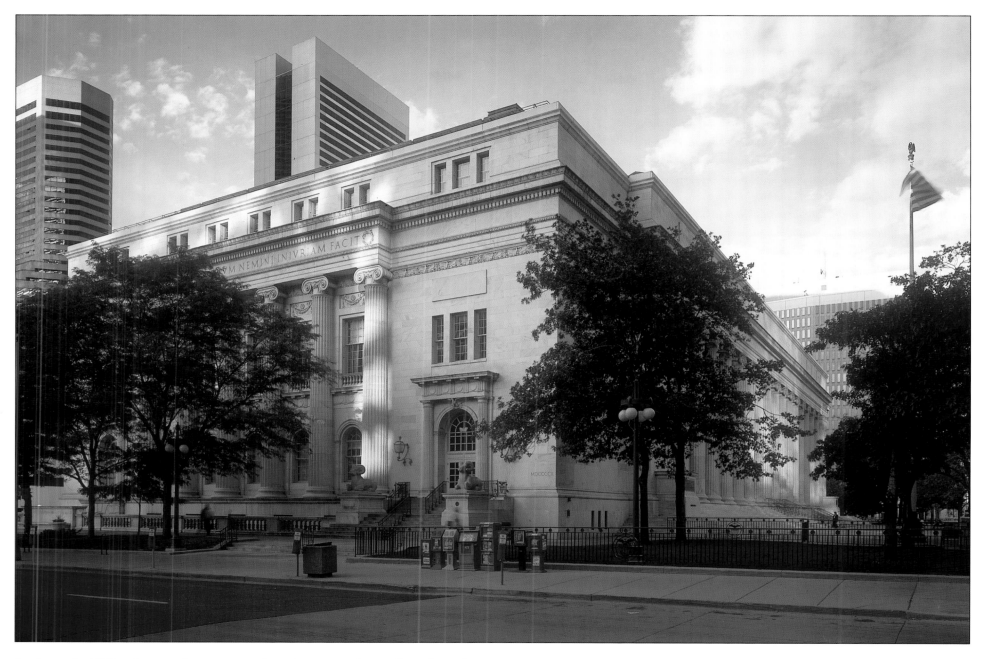

In the early 1990s, the postal service was forced to move their offices from the premises of the main post office when the Federal Court of Appeals granted millions for a massive restoration project. Now called the "Byron White Courthouse," after a Colorado University football star who was eventually appointed to the U.S. Supreme Court, the structure has been returned to its original glory.

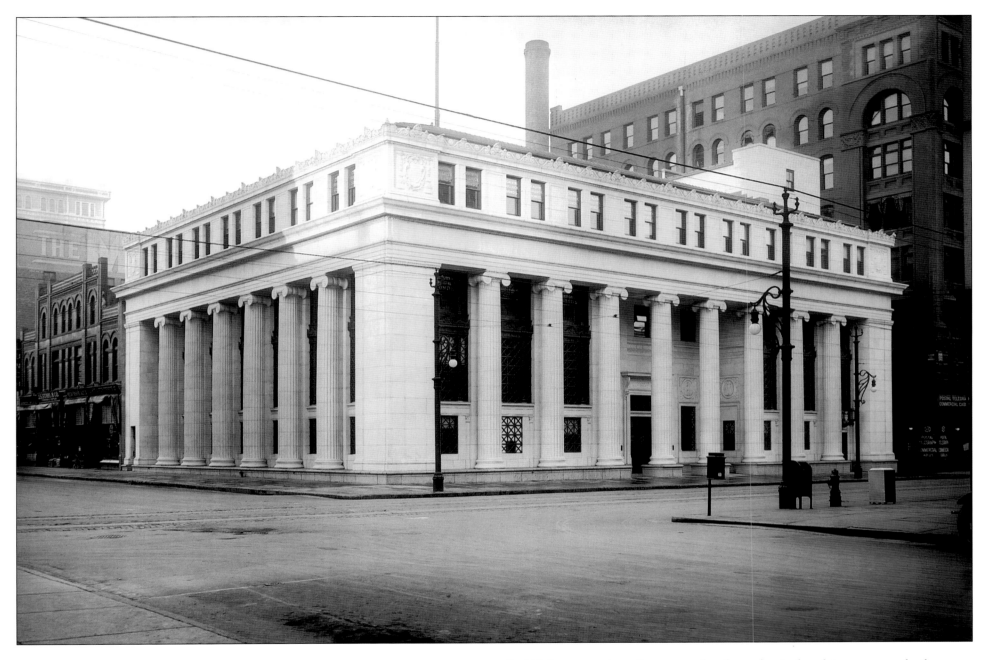

In 1915, a second sterling example of neoclassical architecture was built at Seventeenth and Champa to house the bank founded by Denver entrepreneurs and brothers, Charles and Luther Kountze. The bank struggled through the Depression, but survived as a family institution, investing fortunes in Colorado enterprises, until control left the Kountze family in 1962.

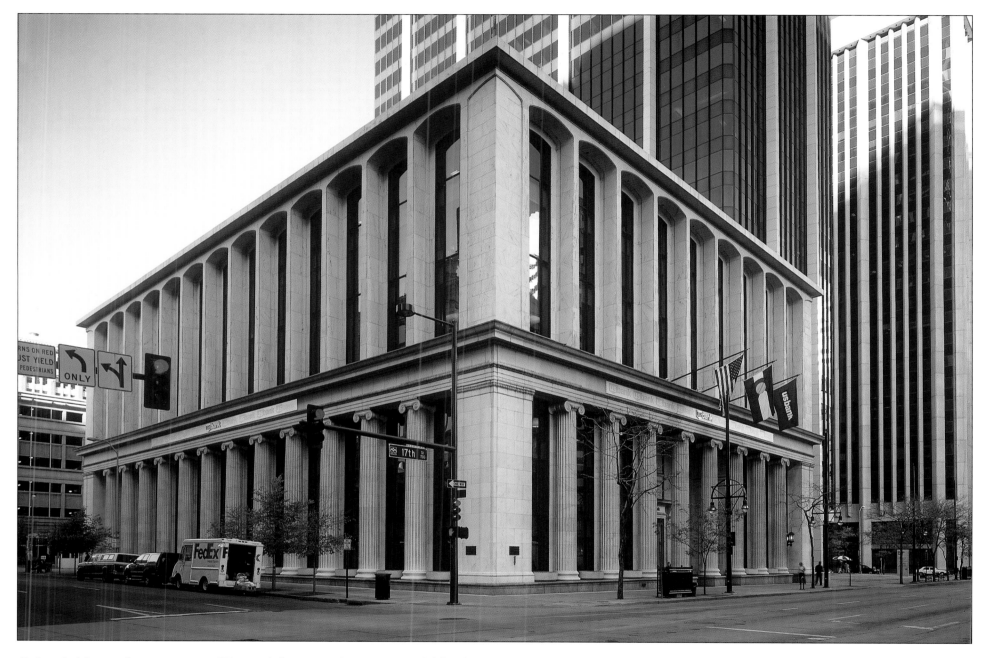

Colorado National remains one of Denver's largest and most successful banks.
In 1965, an additional two stories were added to the original building, which
had already seen a smaller, less dramatic addition in 1926. The adjacent
twenty-six-story tower, which houses CNB's offices, was built by Minoru
Yamasaki—who also built New York City's once-mighty World Trade
Center—to match the original bank building without crowding or
overshadowing it.

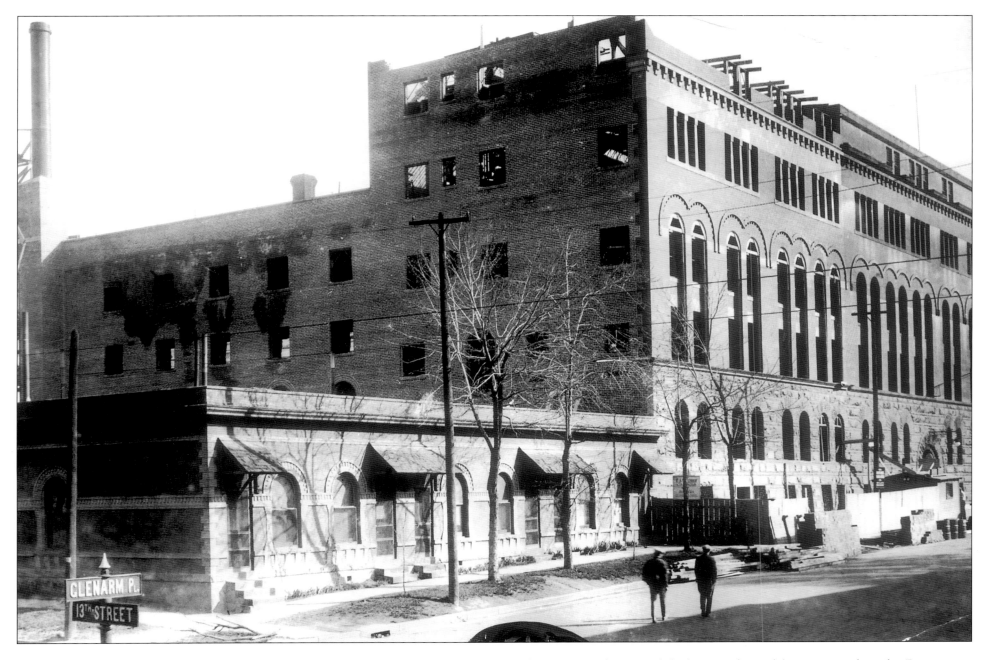

Built in 1889 to house a club that was formed five years earlier, the Denver Athletic Club offered Denverites a host of physical and recreational activities. This photo, taken in 1926, shows the first addition to the building, which added a swimming pool, billiards room, and lounge, among other amenities. In the 1890s, it was the DAC that introduced Denver to football, as its successful team defeated a number of collegiate teams.

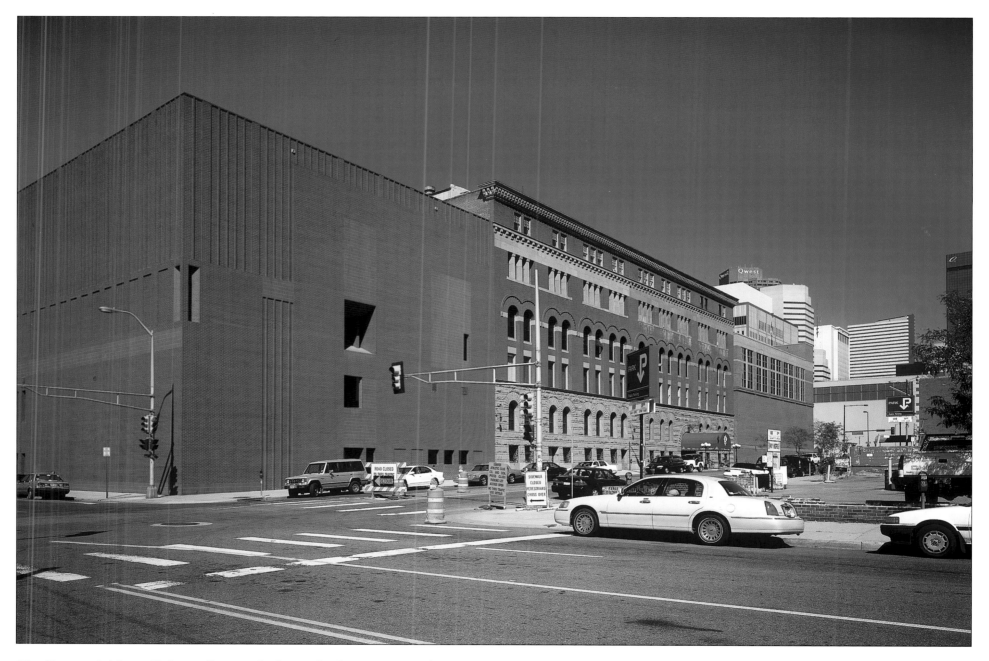

The Denver Athletic Club is still a popular haunt for Denver's sports lovers. Since the late 1800s, the building has undergone several additions and unabashedly sports the various architectural styles of each addition's respective time period. The last add-on was built in 1996 and included a rooftop patio with tennis courts and an expanded fitness center.

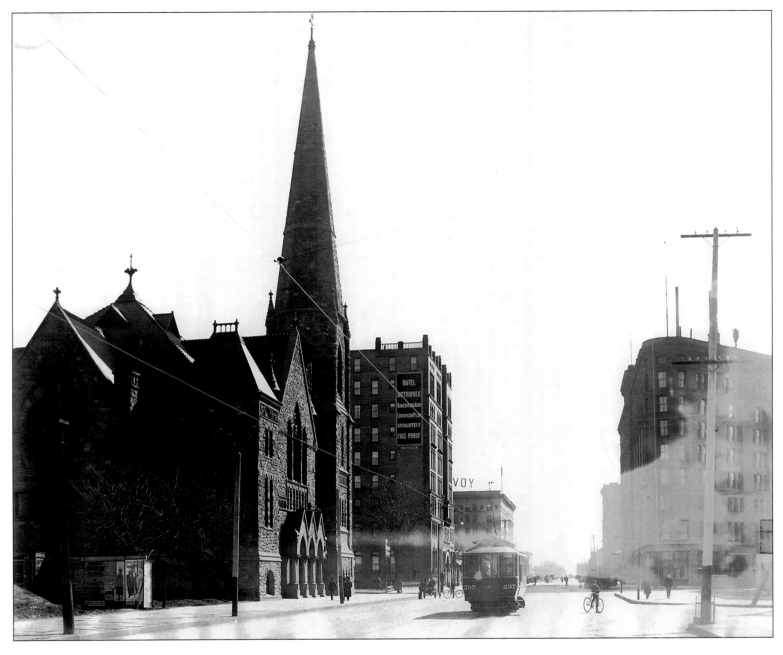

Broadway was the main north-south artery in Denver, with Denver Tramway Company (DTC) trolleys taking passengers from the city south into the suburbs of Capitol Hill, Baker, and Washington Park. The Trinity Methodist Church, Brown Palace Hotel, Savoy Hotel, and Hotel Metropole were some of the proudest landmarks in the first years of the 1900s, when this photo was taken.

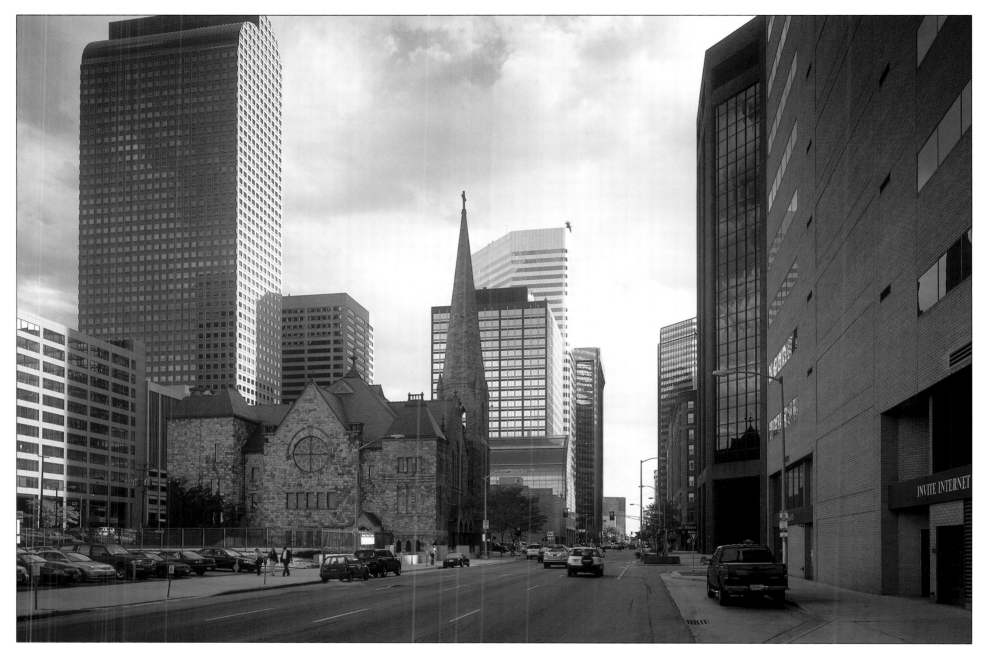

The Brown Palace and Trinity Methodist are the last historical buildings remaining in the area, though they are now somewhat dwarfed by surrounding towers. IM Pei's first project in Denver and the first building to exceed the old twelve-story height restriction, the Mile High Center is adjacent to Trinity Methodist. In 1983, the MHC was modified to attach to the fifty-story, cash-register-shaped structure behind it and renamed the "United Bank Tower."

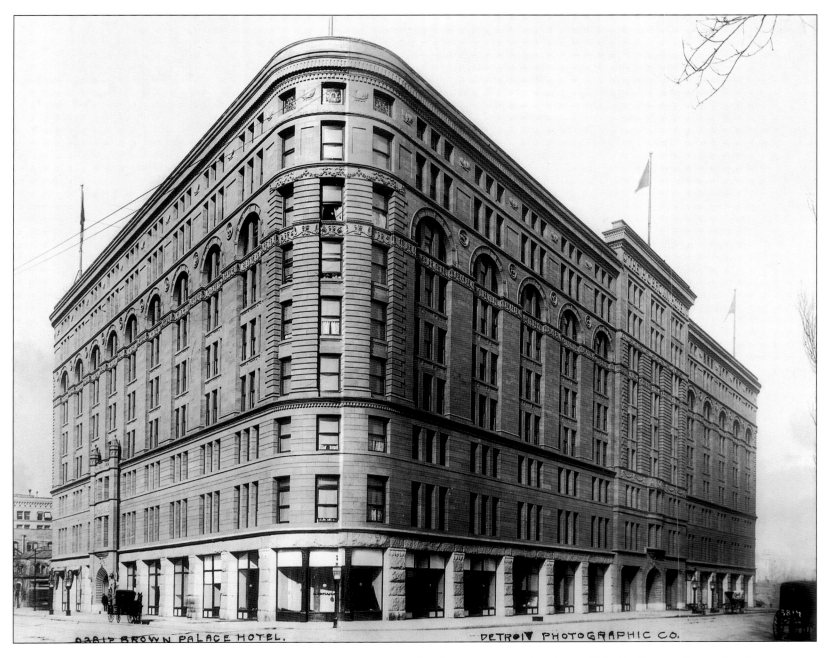

BROWN PALACE HOTEL. DETROIT PHOTOGRAPHIC CO.

From the day it was completed in 1892, the Brown Palace has been Denver's finest hotel. Conceived by Henry C. Brown, a primary developer of the Capitol Hill area, and built by Denver's foremost architect, Frank Edbrooke, the Brown, with its challenging triangular lot, was a stylistic marvel. The nine-story, skylighted lobby atrium, the fireplaces in each room, and the building's steel frame impressed people almost as much as the elevator, telephones, hot showers, and flush toilets.

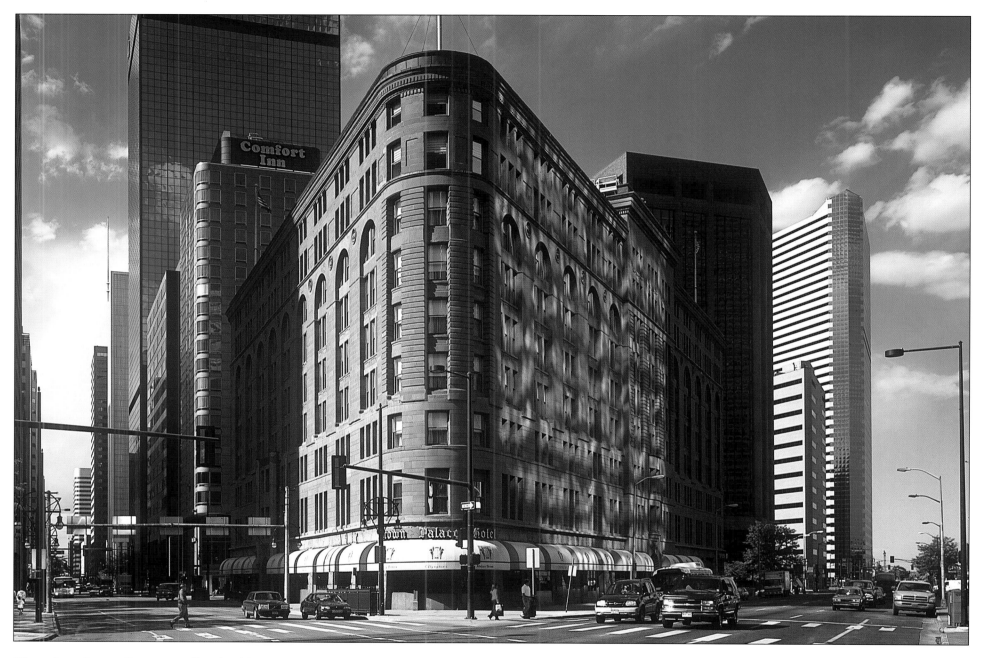

Though no longer Denver's tallest building, the Brown nonetheless remains one of the city's most important landmarks and elegant hotels. The fireplace system ingeniously became a central air system, the top floors are now residential suites, and a walkway leads to the adjacent tower addition, but the hotel retains its historical charm. Structures like the Anaconda Tower (now the Qwest Communications Building) may have taken over the skyline, but the Brown is still emblematic of Denver's character.

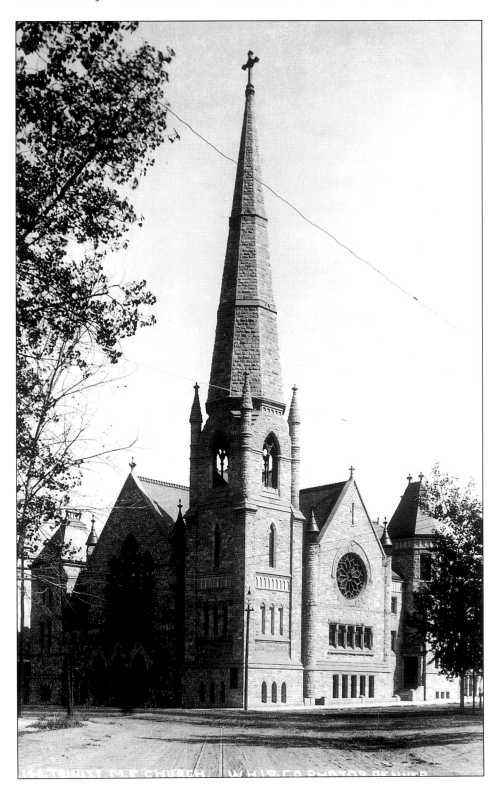

Built in 1888, Trinity Methodist was downtown's first church, and with its ornate, 181-foot steeple, 1,200-seat sanctuary, huge 4,000-pipe organ, and intricate interior woodwork, it was the height of accomplishment for Robert Roeschlaub, Denver's first licensed architect.

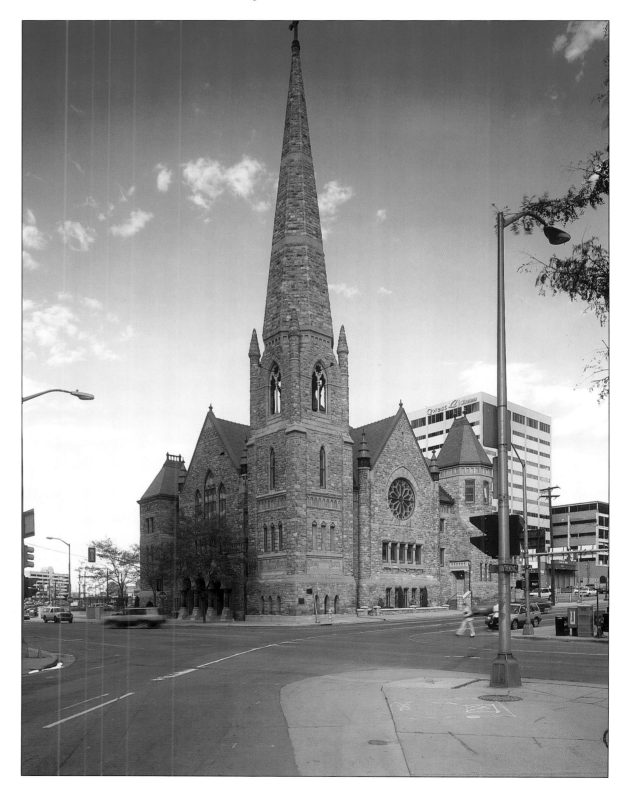

Trinity Methodist is still considered the most striking church in Denver. It is also one of the best-preserved historical structures in the city. In 1982, the church set a precedent by selling its development rights. The resulting restoration left the building with an underground office, education center, and parking complex, but it was largely unchanged aboveground.

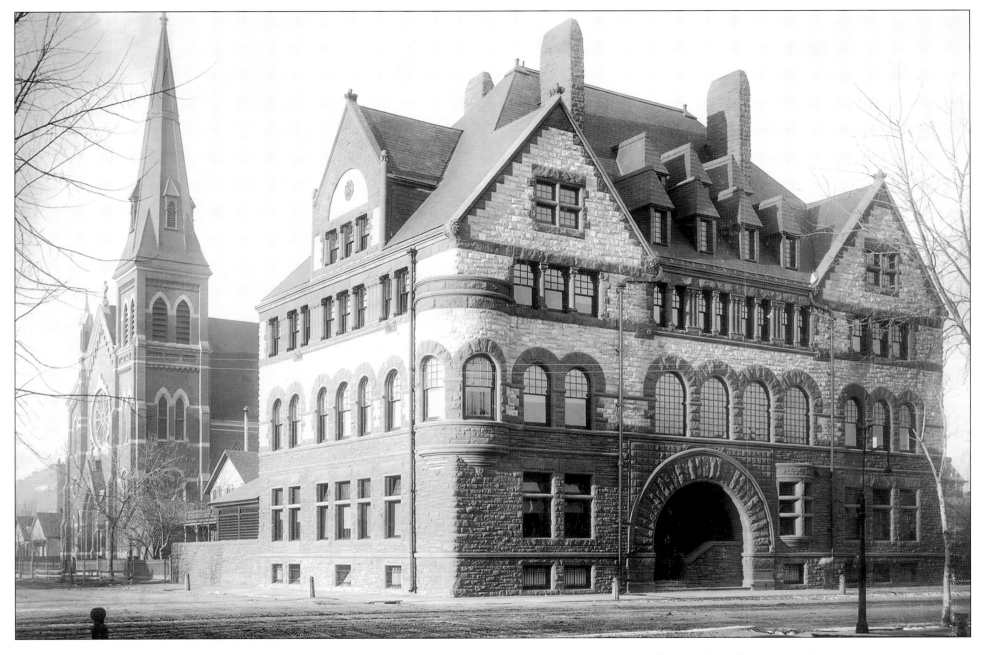

The most influential gentlemen of the day, provided they were not minorities, were members of the highly exclusive Denver Club, which was founded in 1880. The edifice that housed the club was completed in 1889; it was the first building to be completely designed, inside and out, down to the furniture, by an architect. The Denver Club, like its members, was meant to inspire awe in those outside, and often succeeded.

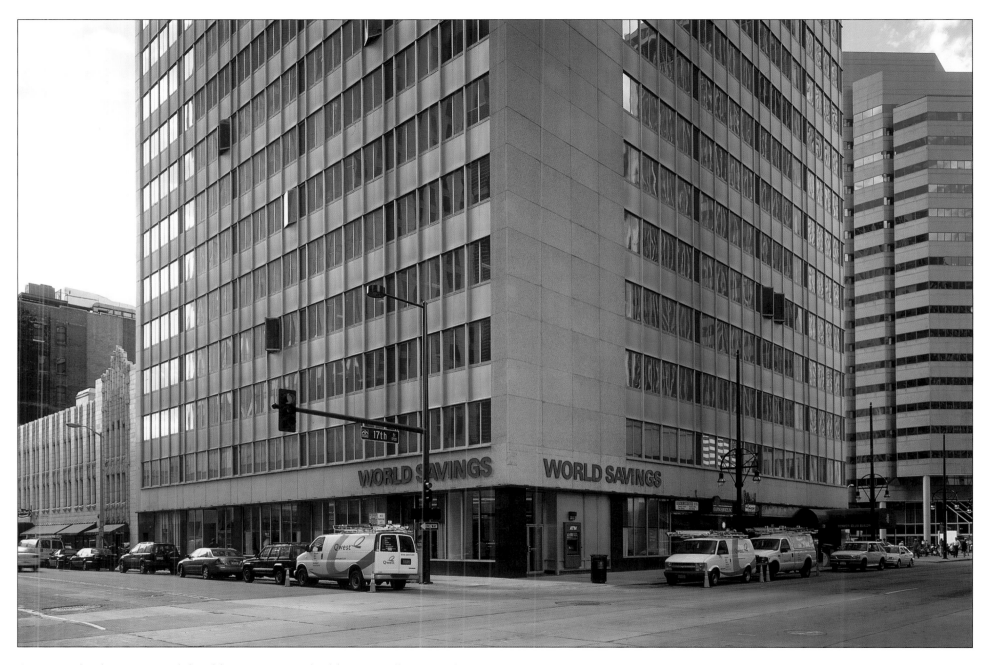

Surprisingly, the Denver Club sold its impressive building to millionaires from
Texas in 1953. The original structure was demolished, and a new Denver Club
sprang up in its place. Much taller, but much less stylistically interesting, the
twenty-one-story high-rise continued to house the club on its top four floors.
The Denver Club today remains a bastion for the city's elite.

The town of Auraria, named after its founder's hometown in Georgia, was organized on November 1, 1858, just a few weeks before William Larimer jumped an adjacent site and chartered the Denver City Town Company. There was great competition between the neighboring towns before the two consolidated. The absorbed Auraria became an industrial suburb when the railways came to town; early residents moved out and the original pioneer town fell into an unenviable state of disrepair.

Much of Auraria was leveled in the late 1960s. The several historic edifices that still stand have been incorporated into the conglomerated higher education center, the Auraria Campus. A few of the city's oldest residences have been restored into Ninth Street Park and are now used commercially. In the background, the tip of St. Elizabeth's Catholic Church, built in 1898, can still be seen from its place on campus.

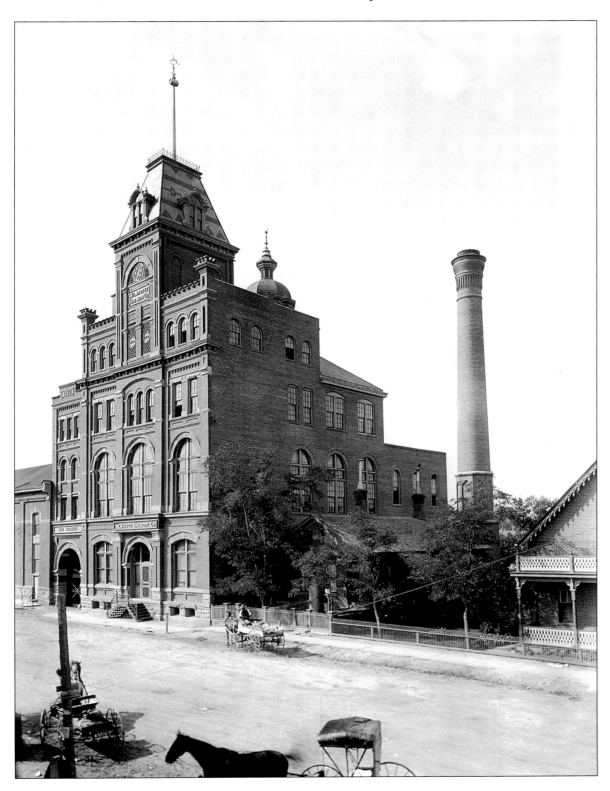

Soon after its establishment in 1859, the Milwaukee Brewing Company was sold and renamed after Copenhagen's Tivoli Gardens. After a merger, the company became Tivoli-Union Brewery and was one of the few beer manufacturers to survive prohibition. The plant shown here, located in Auraria, Denver's oldest neighborhood, operated as a brewery for more than sixty-five years.

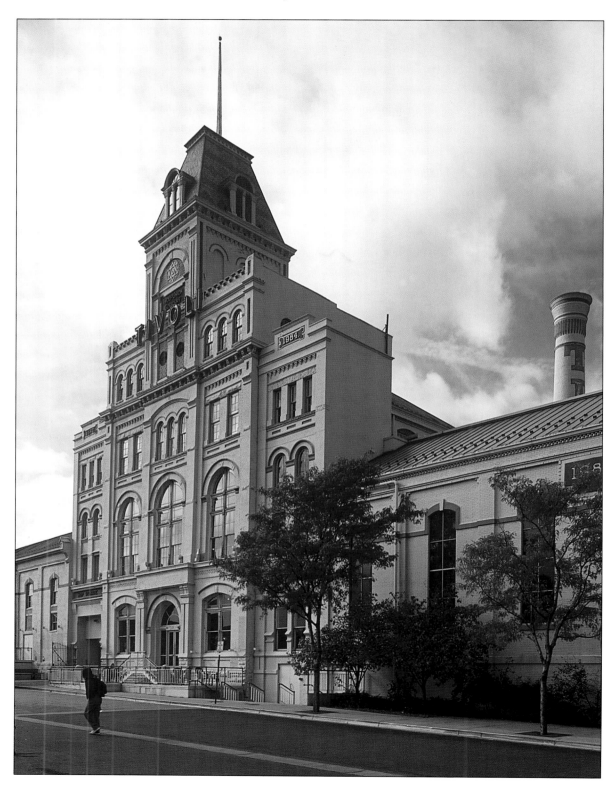

By the mid-1970s, most of historical Auraria had been razed by the Denver Urban Renewal Authority. An experiment in higher education rose up in its place. The Auraria Higher Education Center—a campus shared by three local colleges—opened in 1977 and quickly gained the largest student body in the state. The Tivoli, one of only a few remaining buildings, became the Auraria Campus's student union, filled with shops, bookstores, food stands, and lounges.

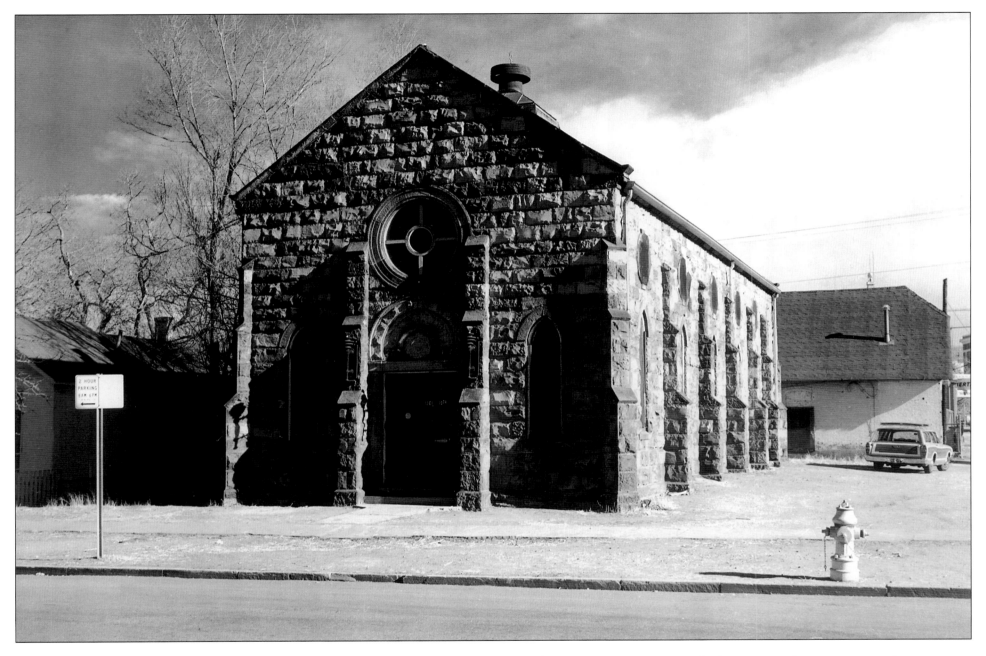

Prejudice against minorities was fairly commonplace in nineteenth-century Denver, and many groups were relegated to areas on the outskirts of the city. There was an influx of Eastern-European Jews in the late 1800s, many of whom settled in the old Auraria neighborhood. This temple, originally built in 1876 as an Episcopal church, was purchased in 1902 by Sherith Israel, a small congregation.

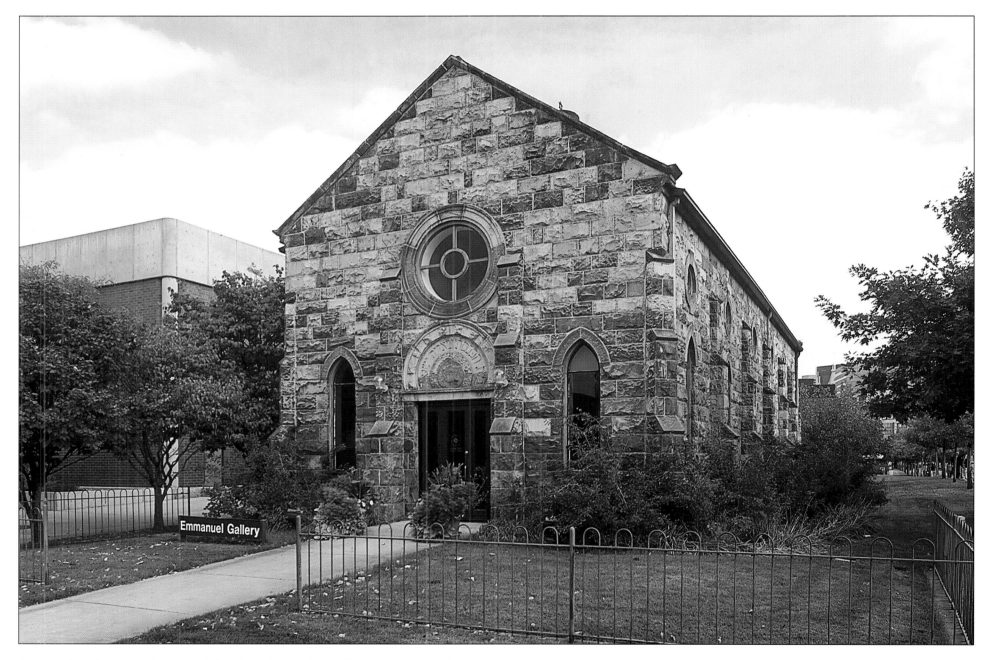

Sherith Israel managed to avoid the demolition that rolled over much of the Auraria neighborhood and functioned as the synagogue for Denver's "Little Israel" community for many years. A Star of David on the roof and Hebrew inscription on the door are a testament to this use, though the building is now used as an art gallery on the Auraria campus.

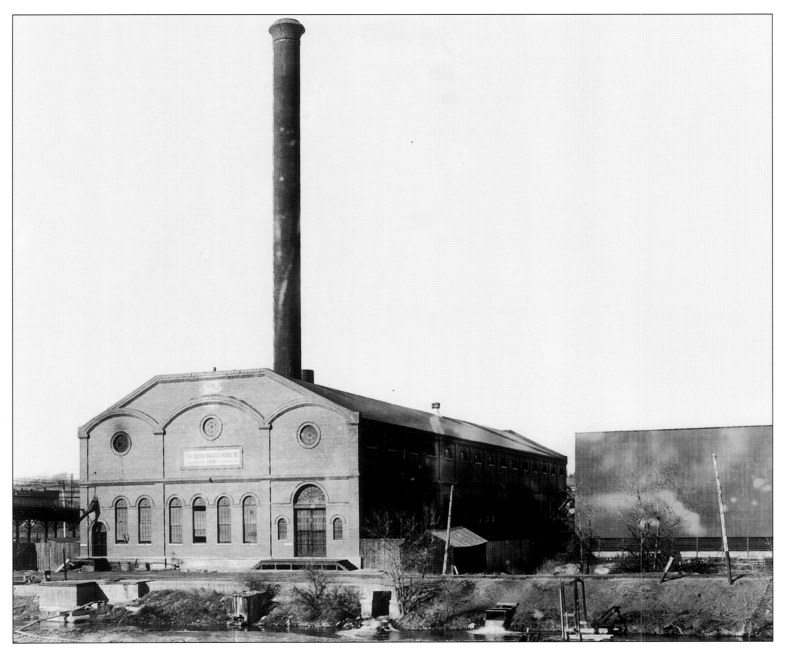

Shortly after it was founded in 1886, the Denver Tramway Company (DTC), created one of the country's most extensive network of cable cars, making the old horse-drawn streetcars obsolete and forever changing life in Denver. The DTC Powerhouse, pictured above, was built to harness the energy of the Platte River, on whose banks it was built in 1901. The powerhouse supplied electricity to the company's fleet of cable cars and trolleys.

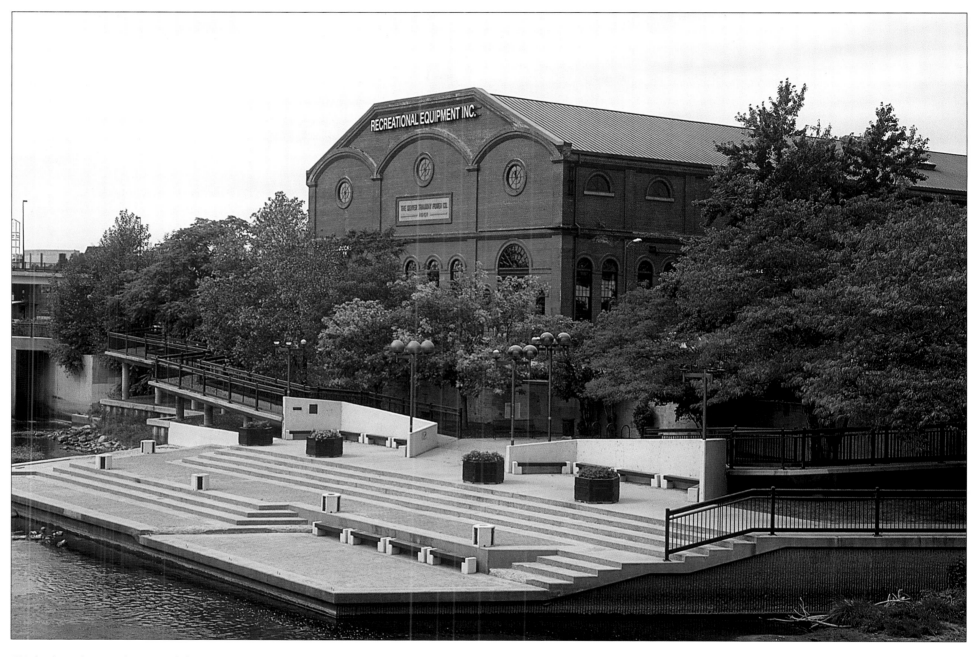

With the advent of automobiles, the DTC struggled, but managed to remain in business until 1970, when it was replaced by the Regional Transportation District (RTD), which revived mass transit in Denver. The powerhouse was converted for a short time to the Forney Museum, which housed over 400 pieces of historical transportation. A lack of public support eventually pushed the museum out; the renovated space is now home to the Recreational Equipment Inc. (REI) flagship store.

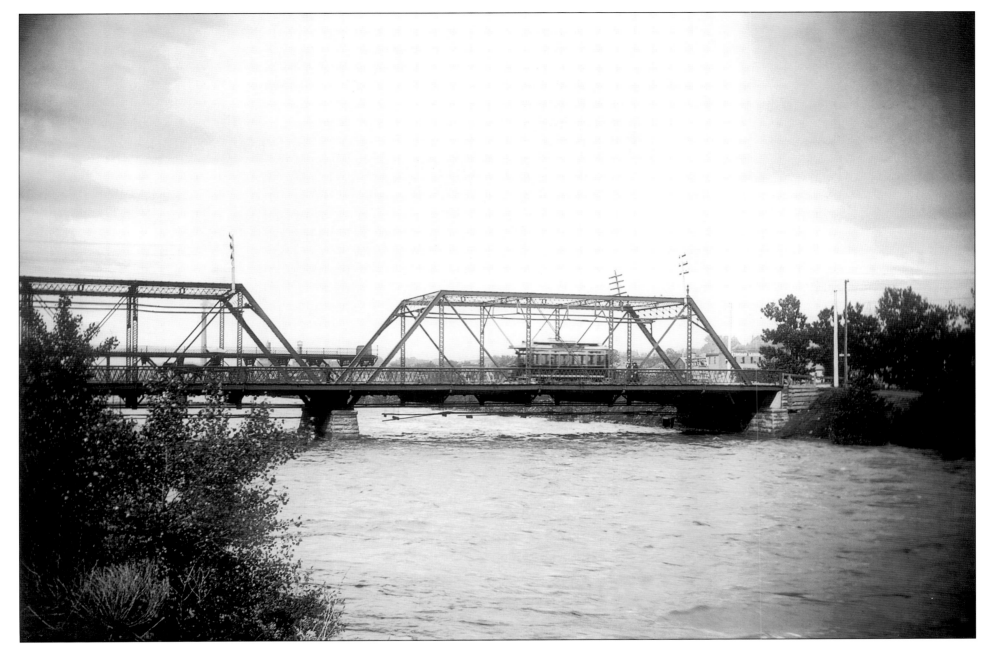

As early as the 1880s, the city began constructing bridges and viaducts over its rivers and train lines. Denver, unlike other burgeoning cities of the plains, could not count on its waterways, the South Platte and Cherry Creek, to bring wealth or transportation. Instead, these small rivers served as barriers to expansion. By 1900, there were eleven bridges over Cherry Creek. The Fifteenth Street Bridge, seen here in 1892, spanned the South Platte.

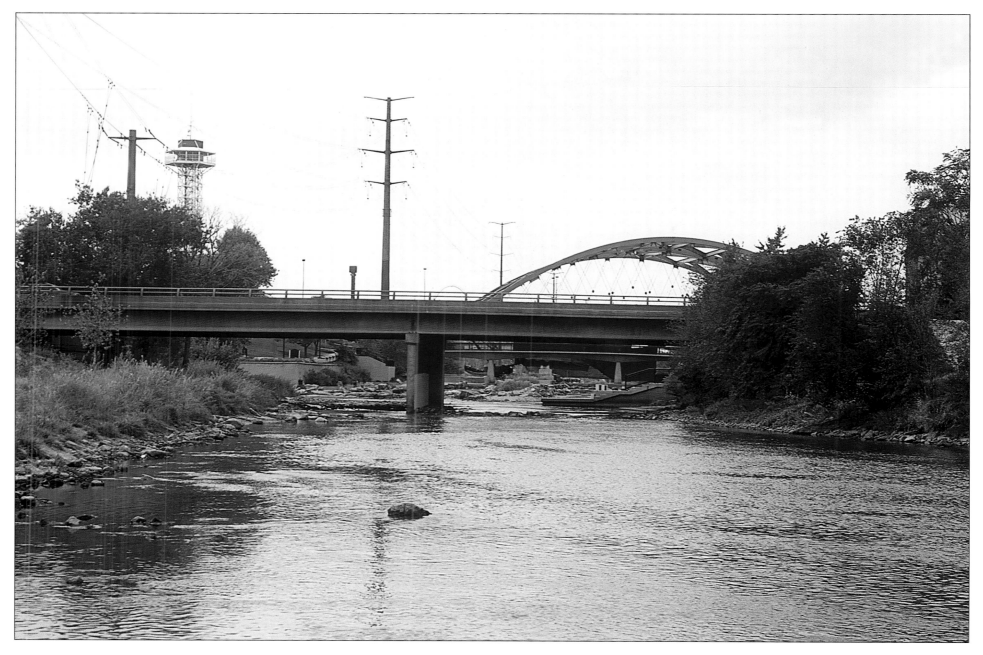

The face of the Central Platte Valley, through which flow the South Platte and Cherry Creek, has continuously shifted over the years. Old bridges and viaducts have come down while new ones have gone up. Confluence Park, adjacent to the old DTC Powerhouse, has helped to beautify the traditionally industrial banks of the Platte. Architectural genius was not necessary to build these connectors, but the connectors themselves were essential to the growth of Denver.

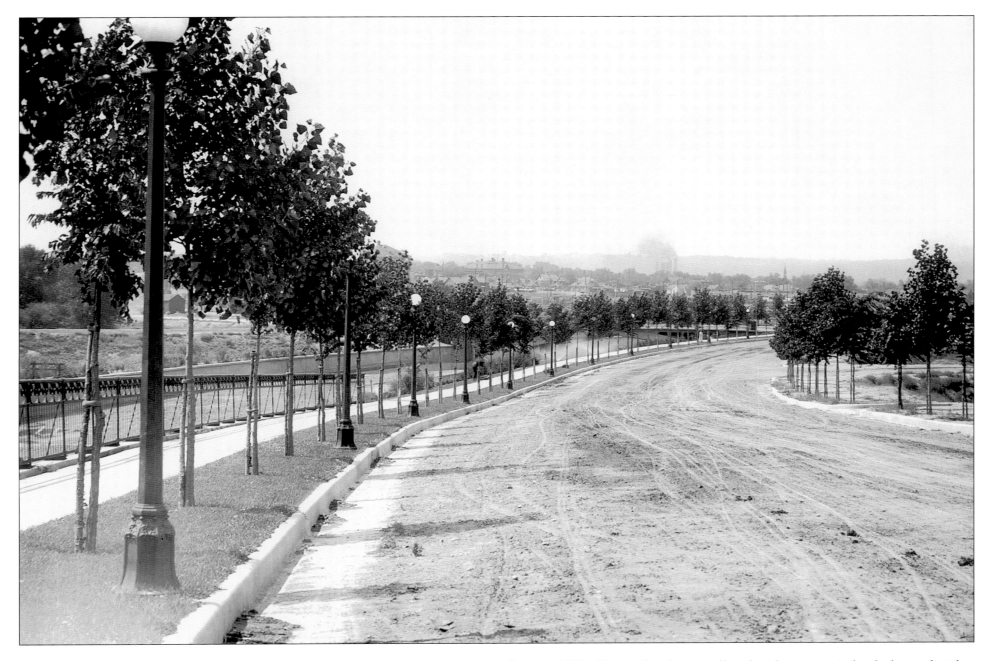

Prior to 1904, Cherry Creek was polluted with sewage, its banks littered with makeshift dumps. Mayor Robert Speer, whose grand vision of the "City Beautiful" had already seen many successes, set his sights on cleaning up the waterway. To that end, he proposed walling the creek and building a street lined with trees, lamps, parks, and open spaces parallel to it. The result was the above scene, photographed between 1910 and 1920.

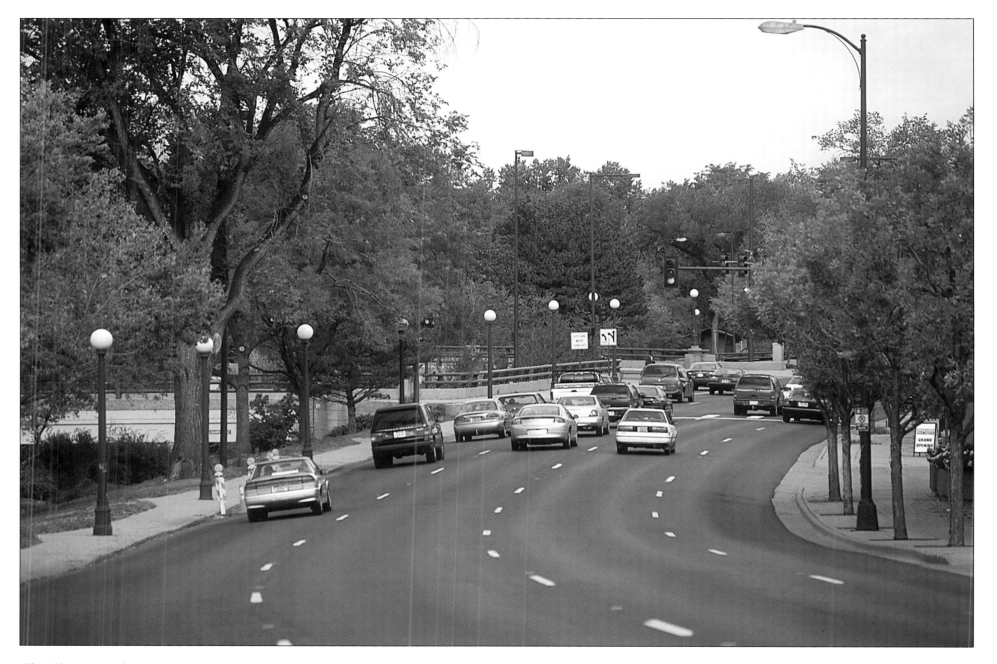

The Cherry Creek project was a success back then; today, Speer Boulevard, which was named after the visionary mayor, is both a National Register and Denver landmark. The street runs parallel to the creek from University to its junction with the Platte River, where it continues into northwest Denver. As can be seen here, the old lighting has been reinstalled and the original saplings have matured quite a bit over the past ninety years.

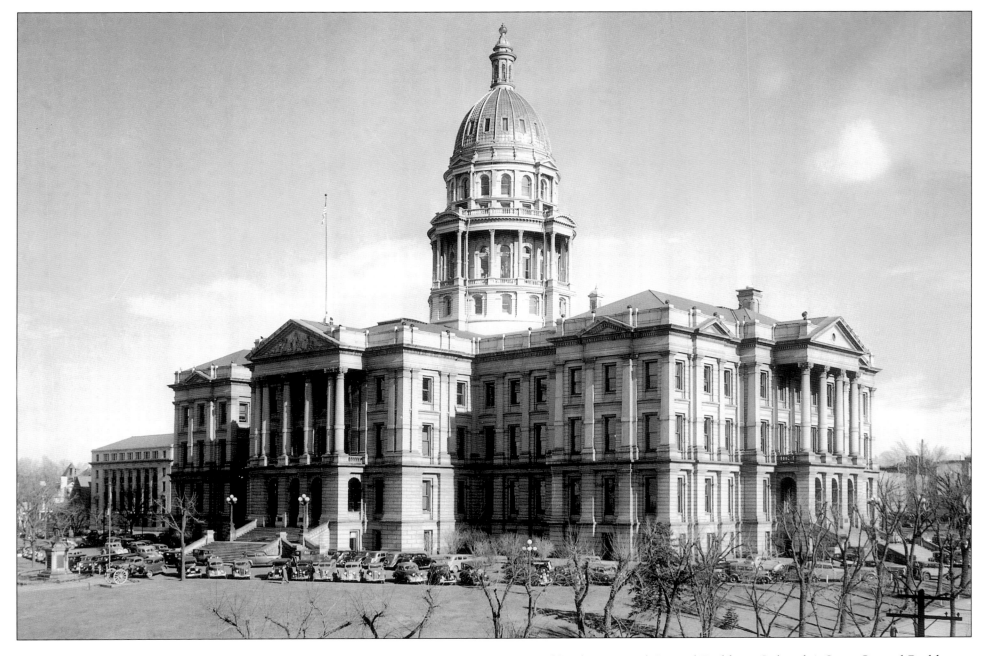

Inspired by the national Capitol Building, Colorado's State Capitol Building took its time on the way to completion. Land was donated in the late 1860s, ground wasn't broken until 1886, and the finishing touches—not including the gilded dome, which took another four years—weren't put on until 1904. It was well worth the wait, as the finished structure was the grandest in town.

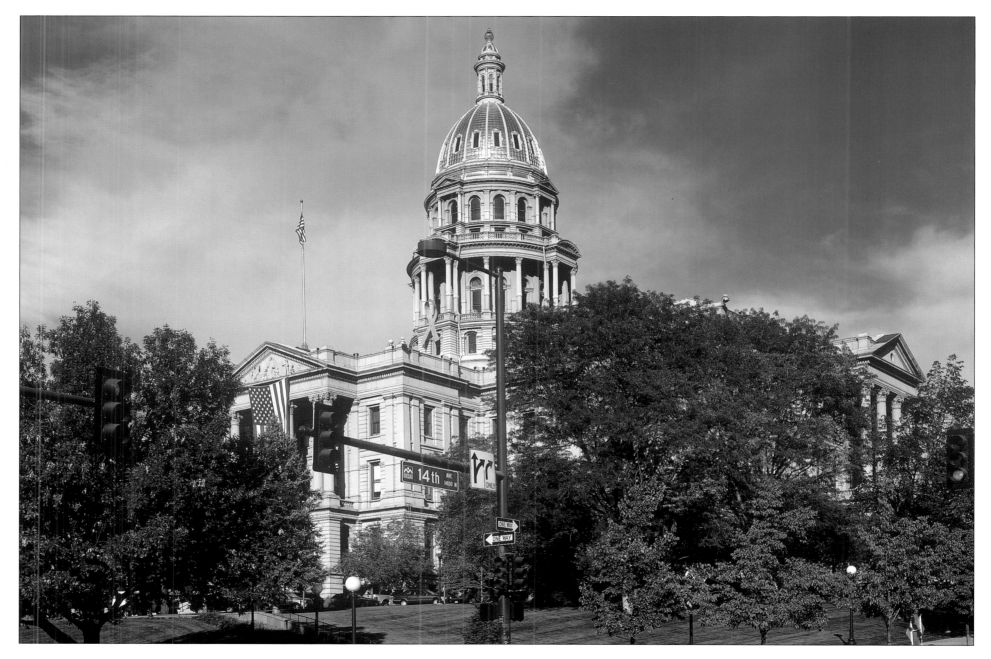

The State Capitol Building now sits at the east end of Denver's Civic Center. Despite the removal of the city's height restrictions, which were designed, in part, to prevent skyscrapers from dwarfing the most important structures, the neoclassical complex, which now also includes the State Capitol Annex and the State Office Building, retains its prominence in the heart of the city.

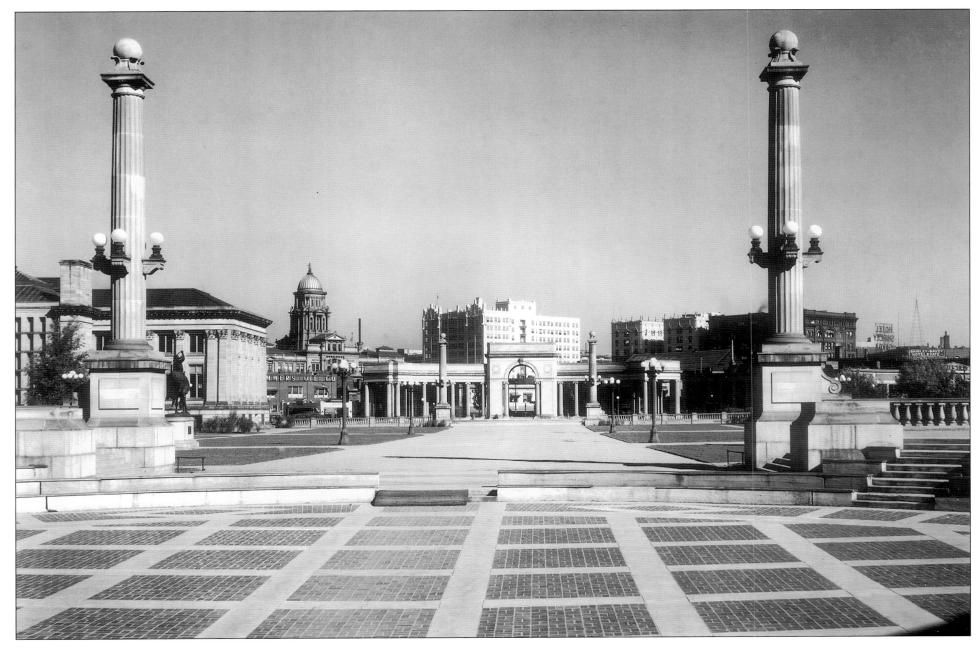

Mayor Robert Speer's grand vision for his "City Beautiful" included an elaborate park that would accentuate the State Capitol and link it to other government buildings. Many different plans were drawn up for what would eventually become Civic Center Park, photographed circa 1930. The Voorhies Memorial, seen here at the northwest corner of the park, was built in 1922 to honor a local businessman who contributed funds toward the park's completion.

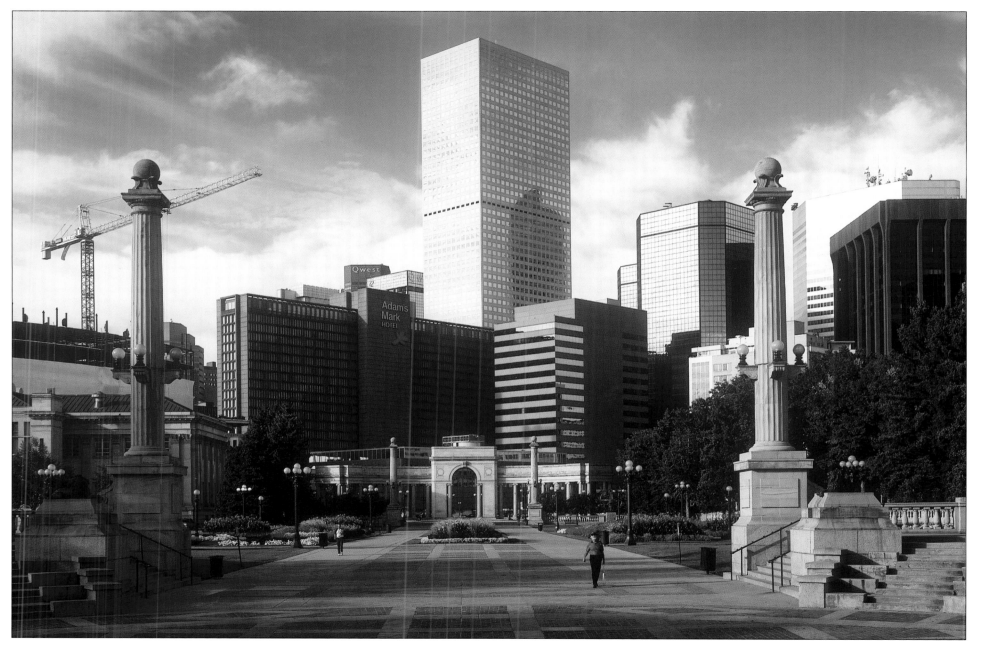

Skyscrapers, including IM Pei's Mile High Center and Colorado's tallest building, the Republic Plaza, which here shows the reflection of the cash-register-shaped United Bank Tower, now loom heavily over Civic Center Park. Still, with its open feel and perimeter of ornate structures like the Voorhies Memorial, the Civic Center is a proud legacy of Mayor Speer's era of the "City Beautiful."

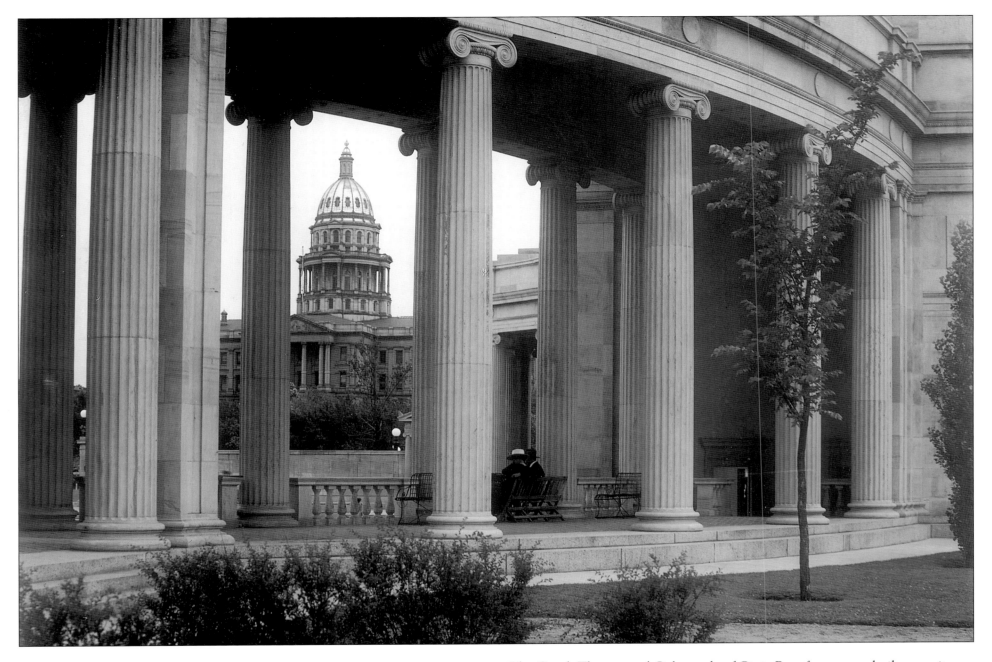

The Greek Theater and Colonnade of Civic Benefactors was built opposite the Voorhies Memorial, on the southwest end of Civic Center Park, in 1919. The two memorials were meant to create a sense of symmetry, and with matching columns and facing curves, they did. The sunken amphitheater was designed to seat 1,200 people and was decorated with the prized murals of Allen True.

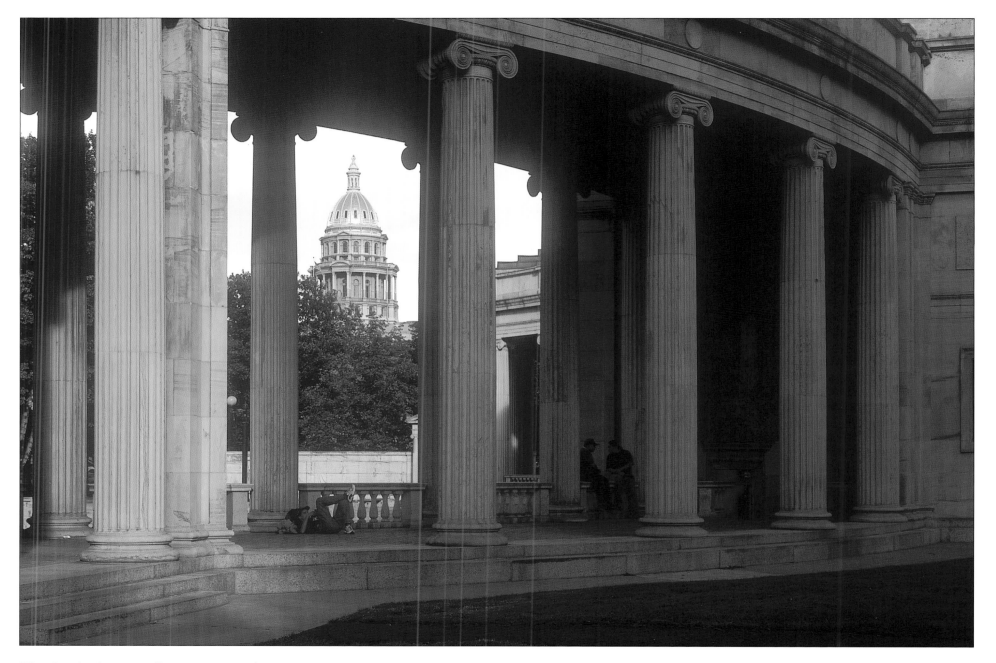

The Greek Theater still serves as a southern entrance to Civic Center Park
and a reminder of the great achievements of those who molded the city. Many
Denver events, including the city's oldest festival, the Festival of Mountain
and Plain, are still held here. Appropriately, this view, which includes the
State Capitol Building, hasn't changed much since the building of the theater.

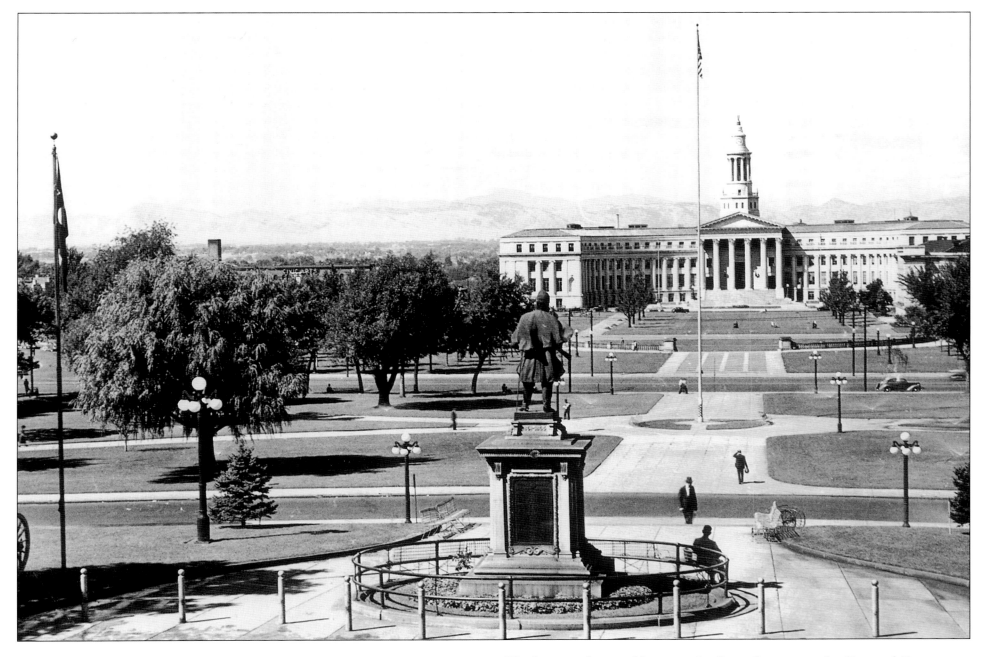

The last significant addition to the Civic Center was the City and County Building, which was built in 1932 at the southernmost end of the park, facing the capitol. The clustering of government buildings was designed to make Denver's administration more efficient. Ironically, there was debate for nearly two decades over the design and materials of the building before an association of nearly forty architects finally completed it.

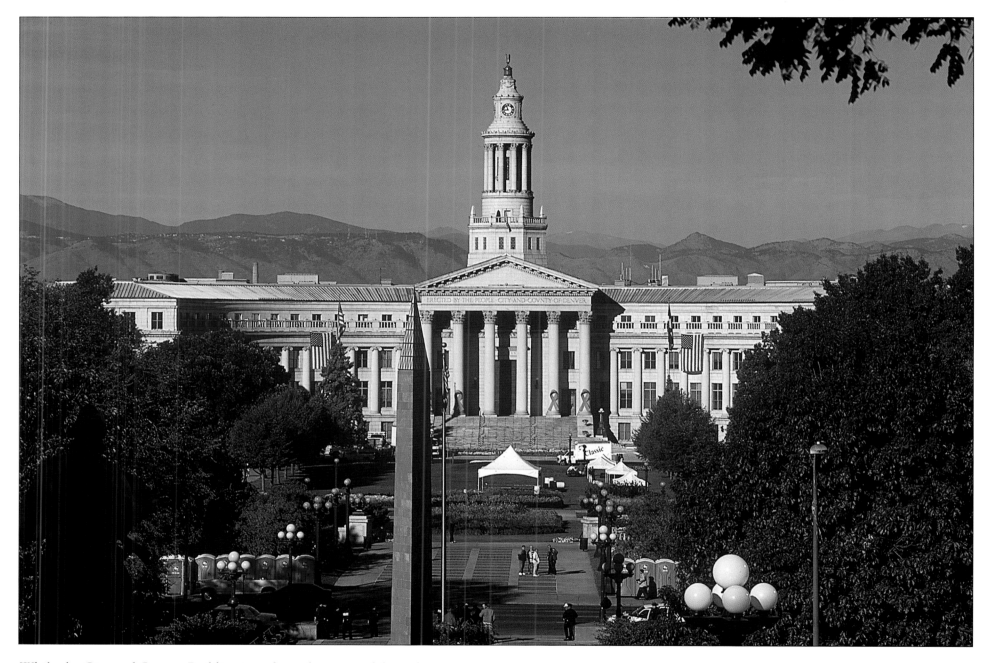

While the City and County Building is perhaps the most celebrated testament of Mayor Speer's "City Beautiful" vision, the mayor himself, who died in 1918, never got to see that vision complete. The full-block structure, which underwent a massive interior refurbishing in the early 1990s, has been decorated with holiday lights each year since it was built, making what is already one of the city's most dominant buildings even brighter.

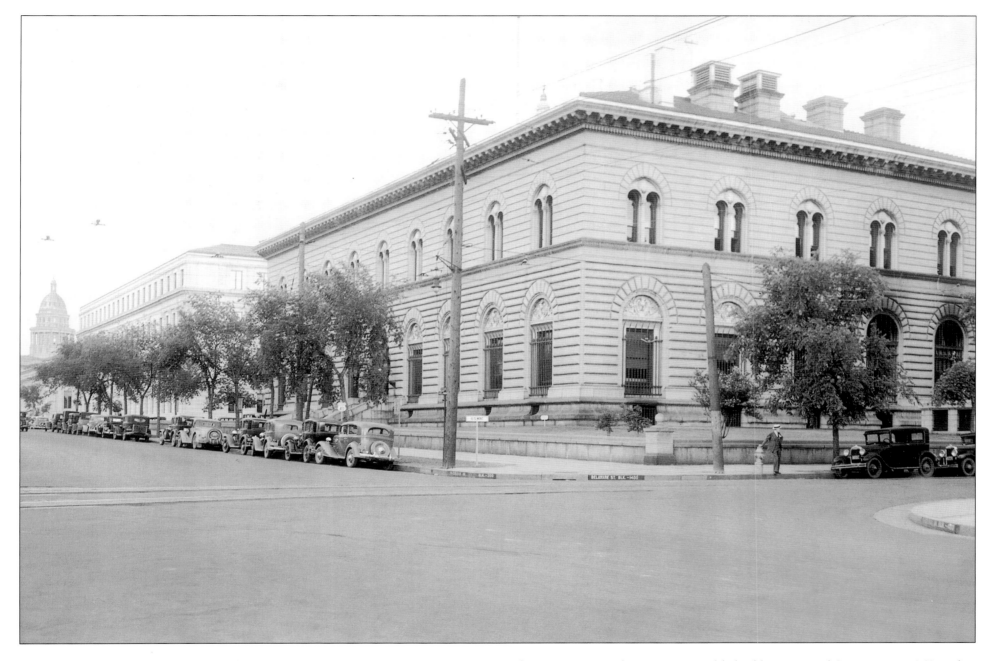

The Denver Branch Mint was established by an act of Congress in 1862 and was originally housed in an unassuming structure at Sixteenth and Market. The stately structure pictured here, reportedly inspired by the Palazzo Medici-Riccardi in Florence, was built on West Colfax in 1906 to replace the old building. The original design of Civic Center Park encompassed the mint, though in the final revision, it did not.

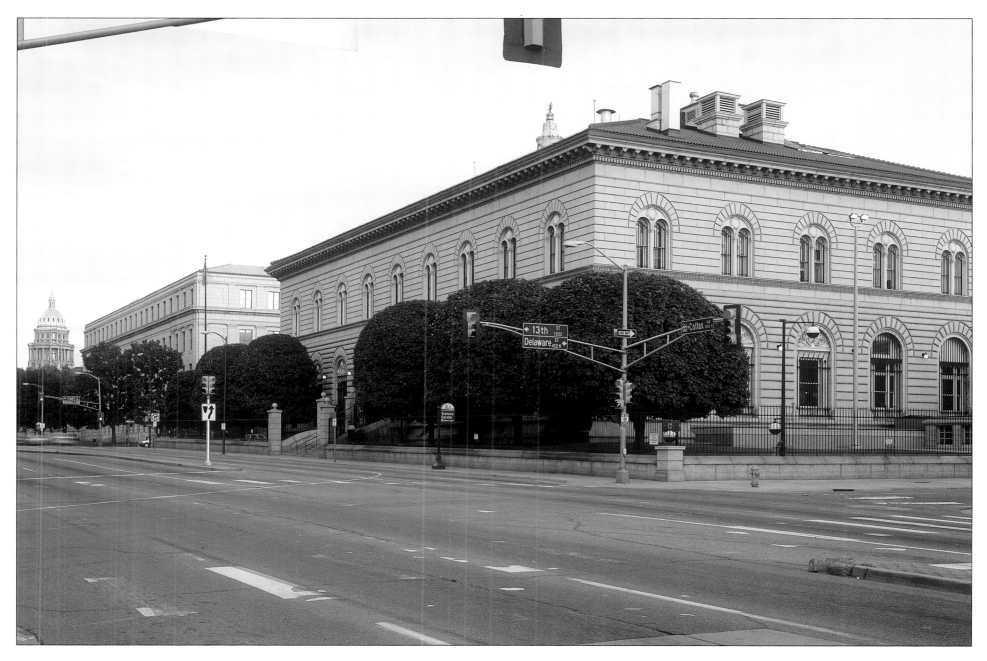

Denver's mint remains one of only two U.S. mints west of the Mississippi
River. A number of minor additions have altered the facade and original
intention of the building's design, but the mint remains one of Denver's most
popular attractions and is a powerful reminder of the city's pioneer past.

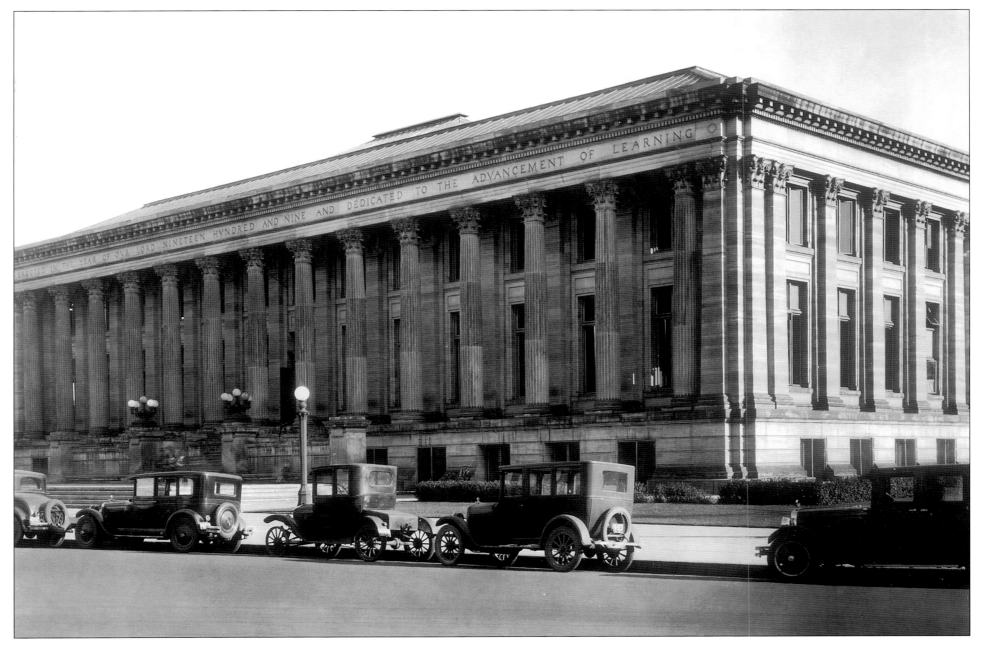

Andrew Carnegie donated almost half of the funds that went to build the Denver Public Library in 1909. The building, like many in the Civic Center district, was built in the neoclassical style. It housed 300,000 volumes that had previously been stored in various public buildings. The consolidated library headquarters, because of the cynicism it met on the road to completion, was a great step forward for Mayor Speer's "City Beautiful" project.

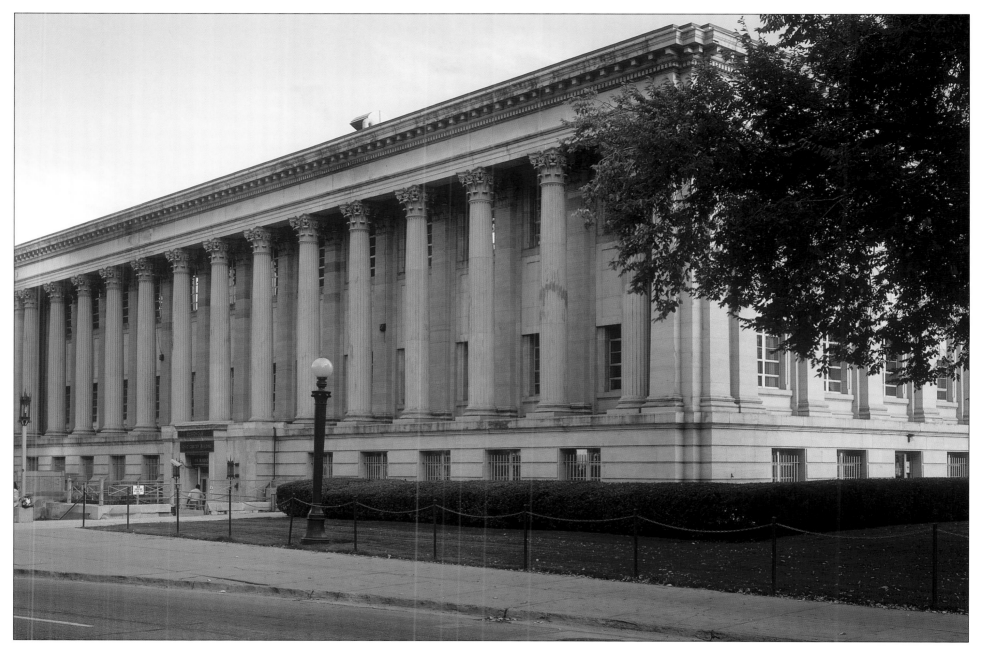

In 1955, the library moved its headquarters to its current location on Fourteenth Avenue, just down the block from this location. The new library building, which was massively renovated in 1995, is intricate both in geometry and color, and with four stories that consume an entire block, it is much larger than its old home, which now houses the Board of Water Commissioners and several other city offices.

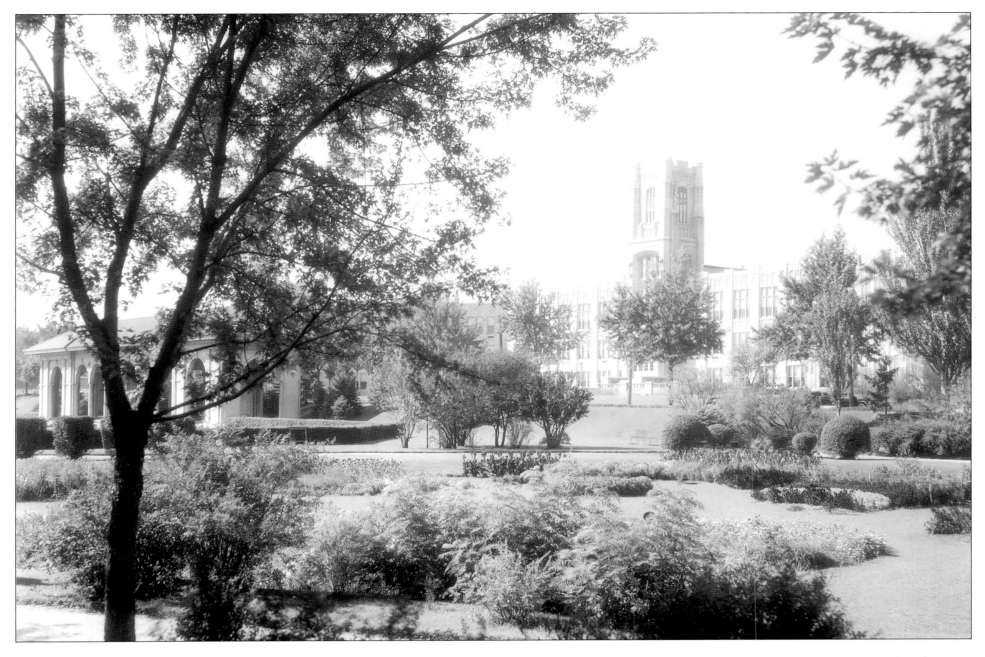

While education took precedence over parks in the early vision of modern Denver, the two quickly became intertwined. By 1932, a twelve-million-dollar expansion built four schools to replace the old Denver High School at Nineteenth and Stout. The new schools were aesthetically incorporated into Denver's overall scheme, each with its own architectural style and park setting. Above is the Gothic-style West High School, built in 1925 on the perimeter of the manicured Sunken Garden.

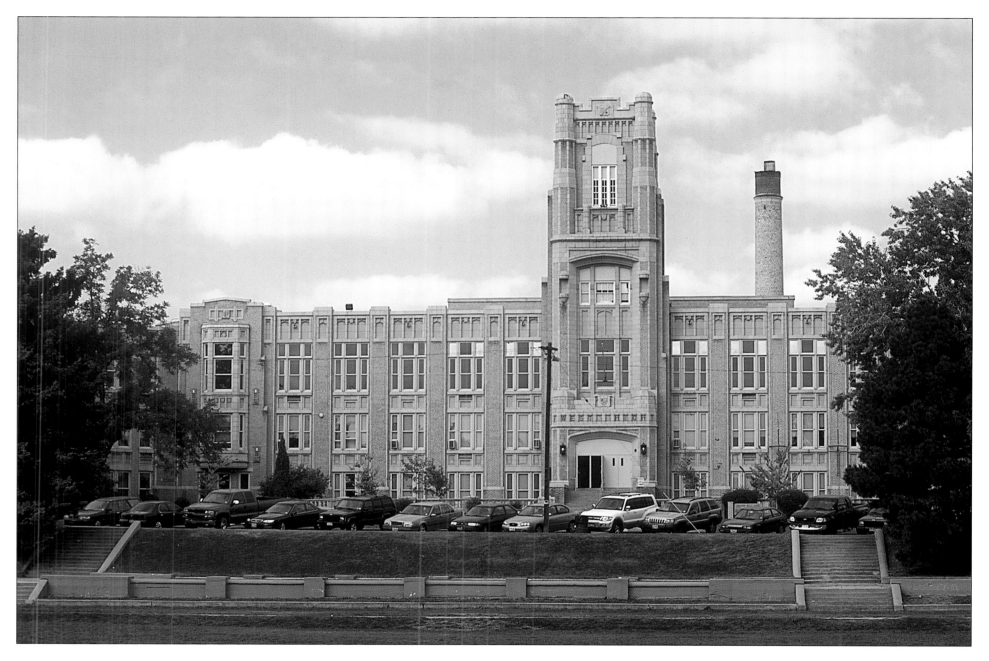

West High School—along with the three other "compass point" high schools—is still educating Denver's youth. While the school system is commonly lauded for its academic distinction, the inclusion of minority students has long been an issue, culminating in a three-day walkout that led to riots in 1969. Social issues aside, Denver's high schools are a great monument to the vision of an educated "City Beautiful."

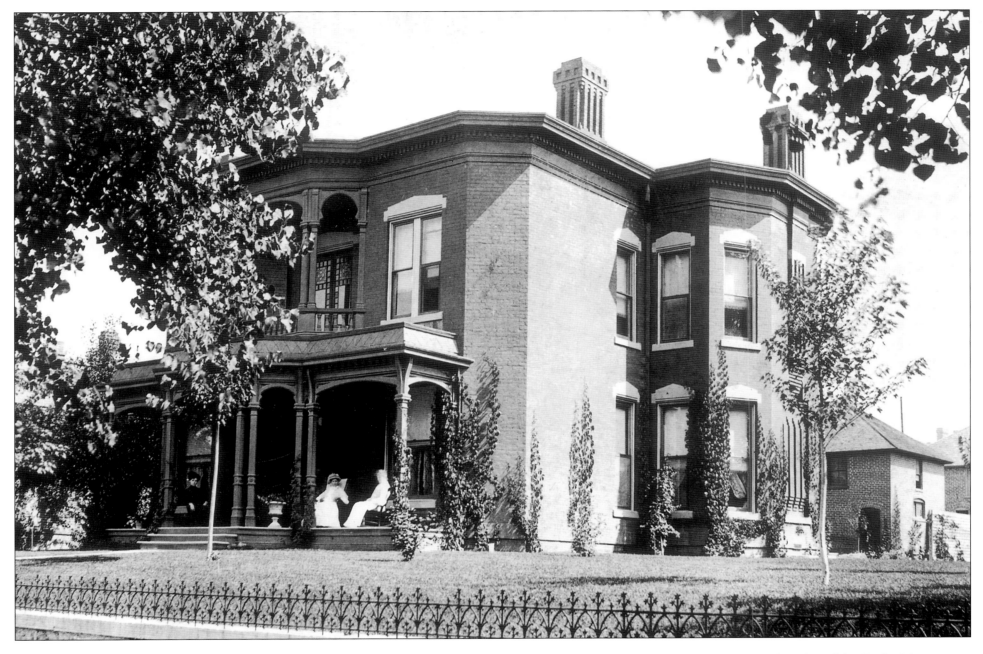

After securing his fortune, William N. Byers, founder of the *Rocky Mountain News*, built and moved into this home in the Civic Center area in 1883. In 1889, William Evans, the son of Colorado's second territorial governor, John Evans, moved himself and his family into the house. This photo, taken circa 1887, shows the house prior to its three additions.

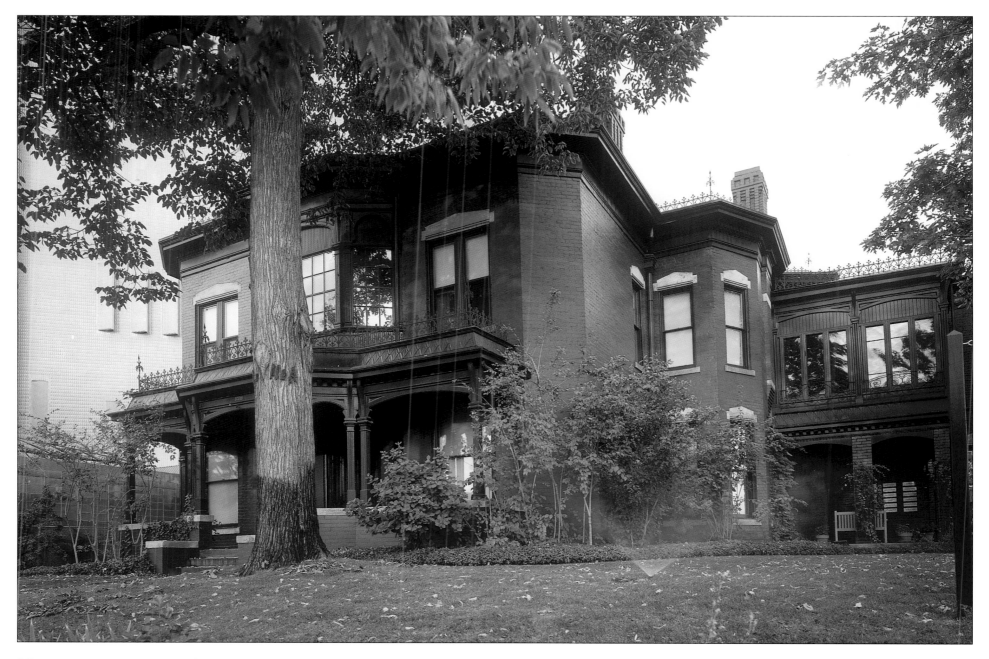

The Byers-Evans House, as it has come to be referred, has been converted into a museum run by the Colorado Historical Society. John Evans built additions in 1898 and 1910, and renovations by the CHS were completed in 1990. The museum, which includes interactive displays and exhibits, concentrates on the history of Denver in general, and on the specific stories of the house's famous occupants.

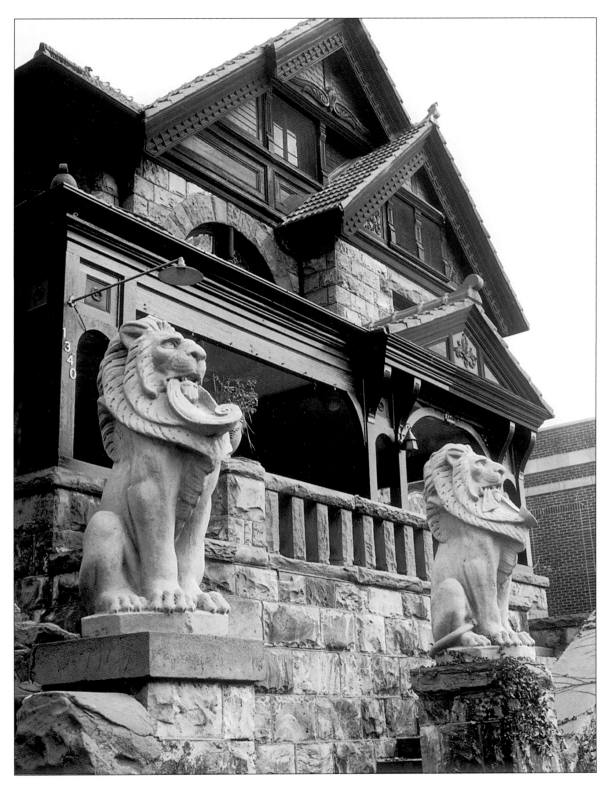

Margaret "Molly" Brown and her husband, who earned his fortune in the mines of Leadville, moved to Denver in 1894. Molly struggled to fit in with the Denver socialites, but her husband's wealth and this mansion in Capitol Hill were not enough to gain her acceptance. After Molly achieved national fame as the "Unsinkable Molly Brown" who saved a lifeboat full of *Titanic* survivors, her Denver circle opened up quite a bit.

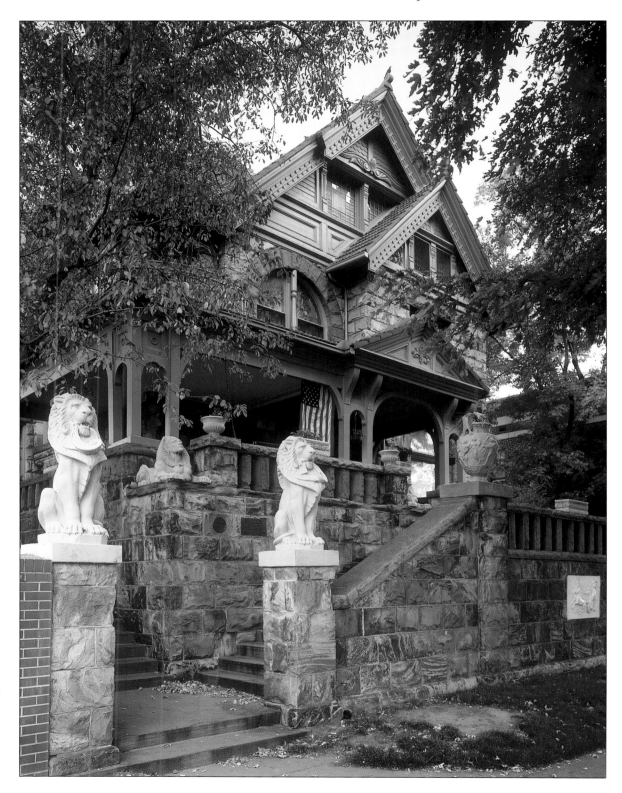

After Molly Brown's death in 1932, her house was converted into a shelter for wayward girls for a short time. Like many other historic houses, this one faced demolition in the 1960s, but was saved when Historic Denver, Inc. purchased it and turned it into a museum. The Queen Anne style dwelling has been fully restored to its original condition and remains one of Denver's most popular historical museums.

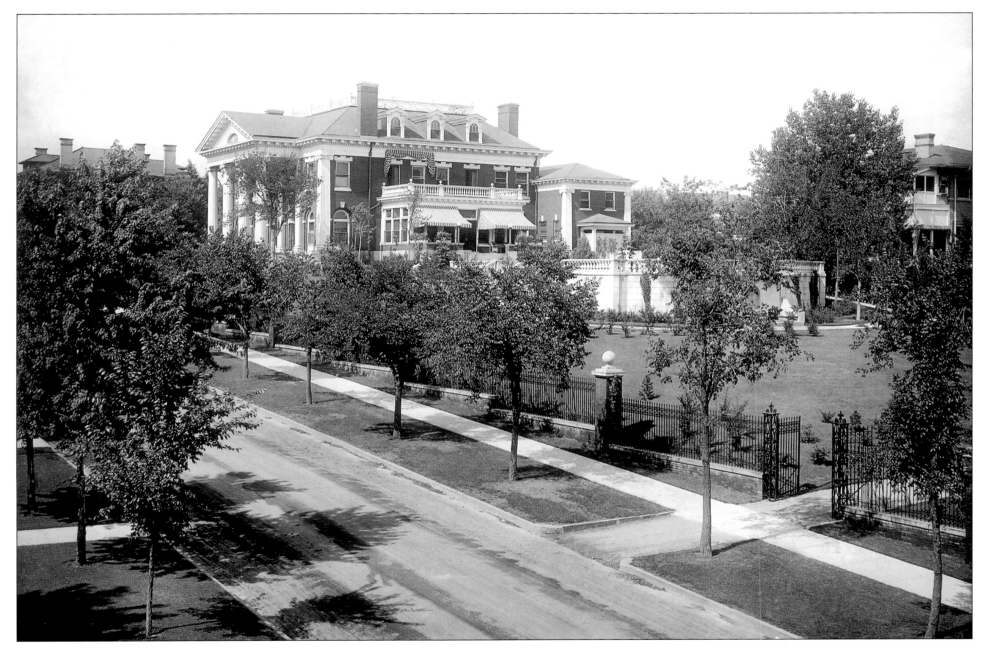

Walter Cheesman, one of Denver's most prominent entrepreneurs and active city builders, commissioned this Capitol Hill mansion but died before it was finished. The residence was completed in 1908 and housed Cheesman's widow, as well as the son of Governor John Evans, who married Cheesman's daughter, for more than a decade. In the late 1920s, the property was purchased by another prominent Denver capitalist, Claude Boettcher.

The Boettcher family resided in this home through the 1950s, when Boettcher's trust offered the house to the city as a residence for the governor. Located in the still-affluent neighborhood of Capitol Hill, the mansion overlooks Governor's Park. Quite a bit of restoration work has been done on the property, including a very recent half-million-dollar updating of the home's private quarters.

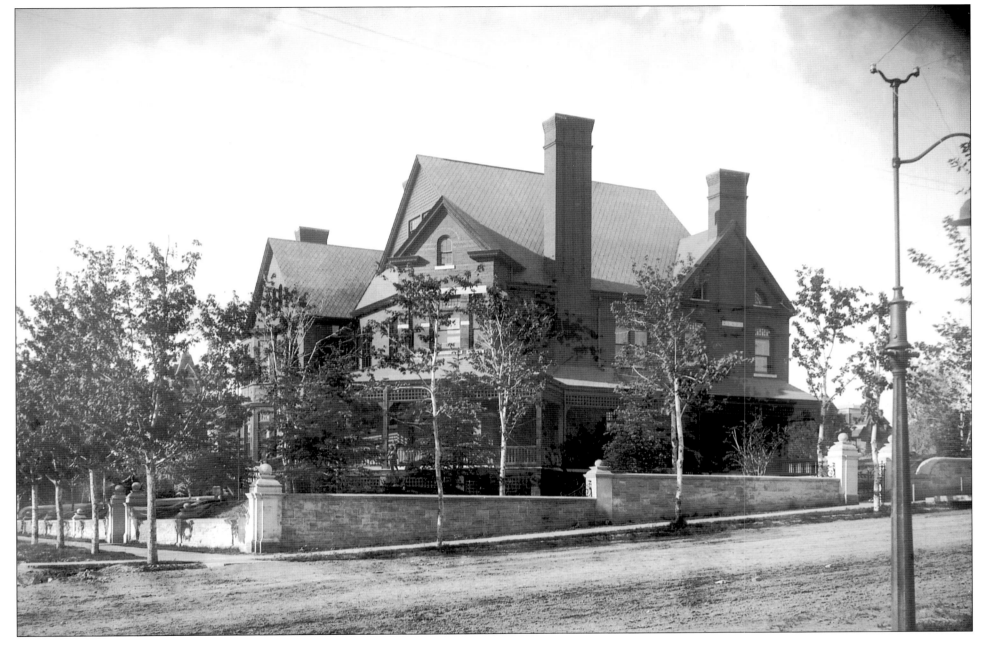

David Moffat, like many of Denver's pioneer entrepreneurs, moved to the elite Capitol Hill area by the 1880s. He lived in this mansion on Seventeenth and Lincoln until a grander home—which included Tiffany windows, crystal chandeliers, and heated sidewalks—was completed. Moffat was perhaps the most prolific of his peers, with significant dealings in banks, railroads, water, and real estate. The house pictured here was typical of wealthy Capitol Hill estates.

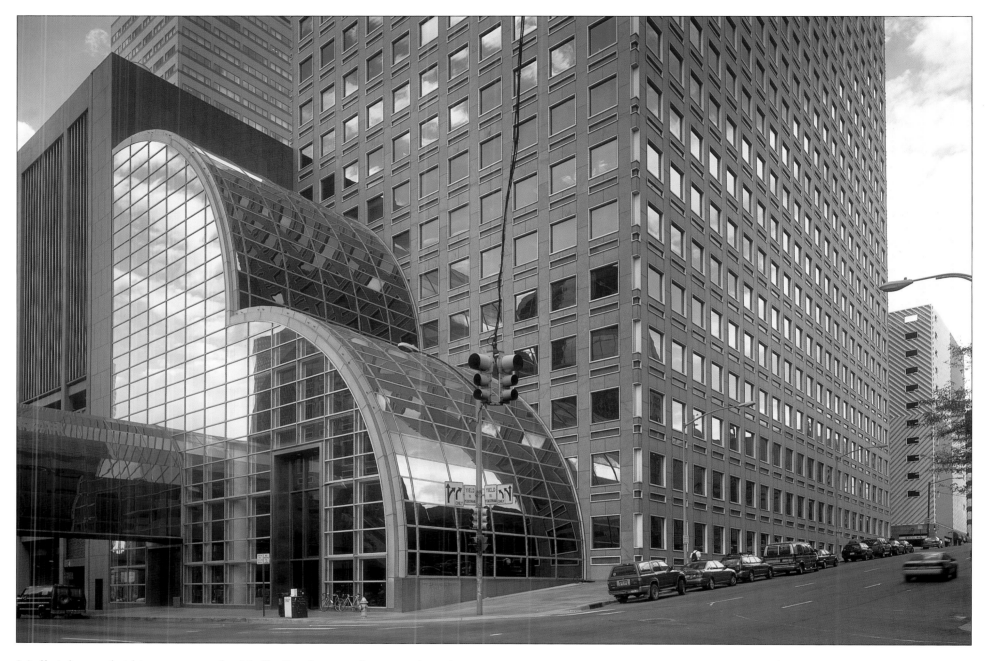

Moffat's last and riskiest venture, the Moffat Road, a treacherous railway line through the Rockies, cost him his entire fortune and his life. He committed suicide in 1911. The historic home on Lincoln, which his wife moved back into after he died bankrupt, didn't fare much better, as the entire block was cleared to make way for IM Pei's Mile High Center, built in 1955. The building is now called the "United Bank Tower."

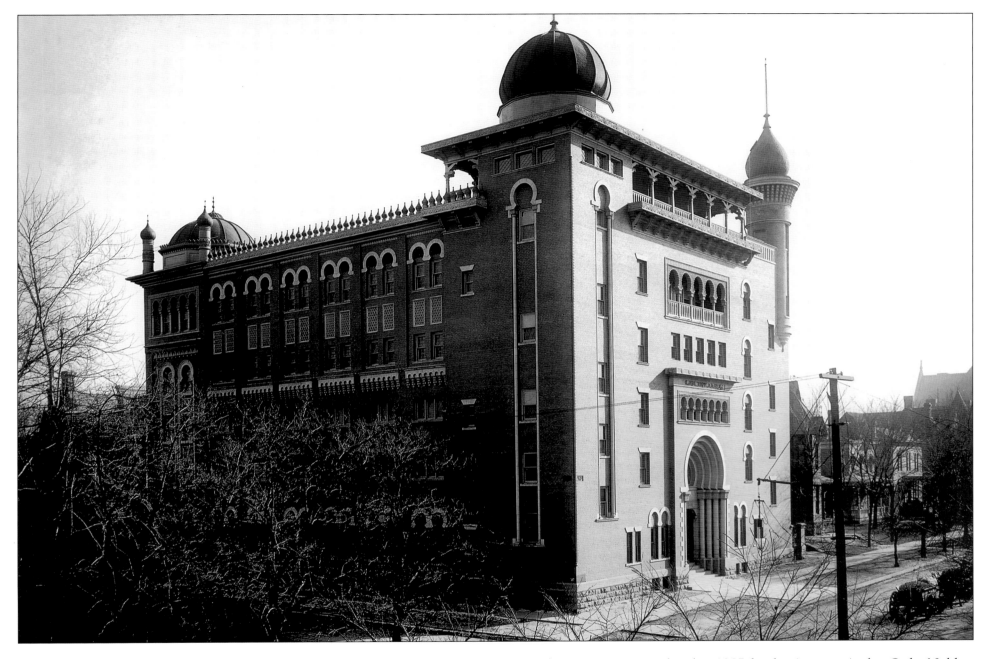

From the time it was completed in 1907 for the Ancient Arabic Order Nobles of the Mystic Shrine, a secret fraternal society, the El Jebel Temple was shrouded in mystery. Its mosque-like domes contrasted sharply with the rest of the red brick facade, and only society members knew what was inside.

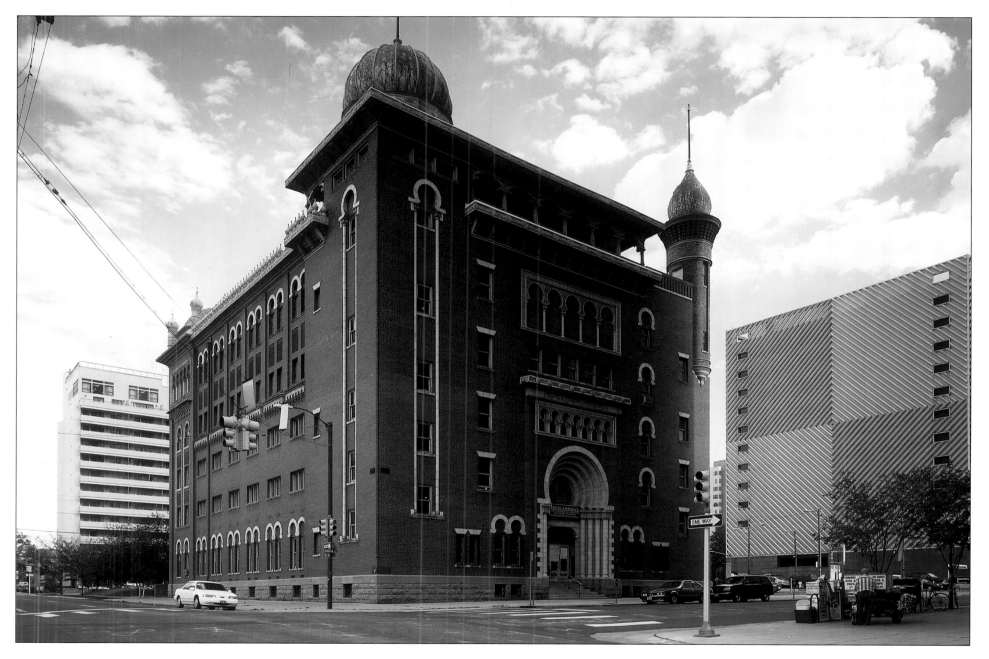

The El Jebel Shrine remained secret for nearly ninety years, until 1996, when the Eulipions, a theater group, purchased it. The interior of the building is rich in woodwork, filled with symbols and decorations of Middle-Eastern inspiration, including a large room whose ceiling resembles a Persian carpet. The Eulipions' purchase of the building—now referred to as the "Rocky Mountain Masonic Consistory"—saved it from certain demolition.

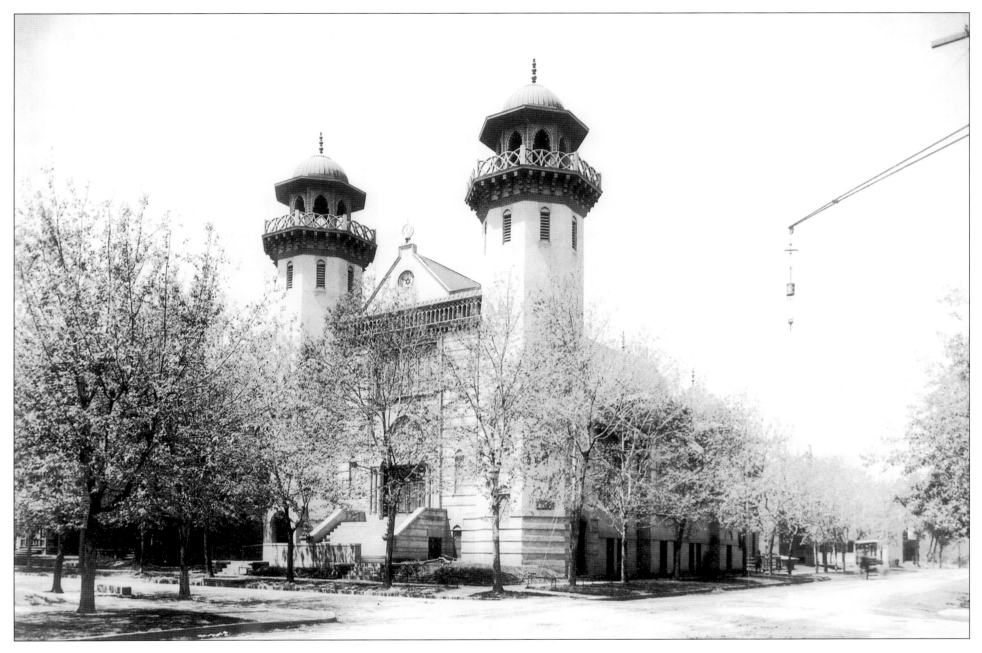

While prejudice and violence against Eastern-European Jews was commonplace in turn-of-the-century Denver, Jews of German descent, by comparison, did not fare badly. The city's largest Jewish congregation built this synagogue, Temple Emmanuel, in 1899 to replace their old temple. Stained-glass windows, Moorish-style towers, a vaulted chapel that seated 1,500, and a congregation that included respected businessmen and politicians allowed Emmanuel to fit in among the grand churches, including Trinity Methodist, that surrounded it.

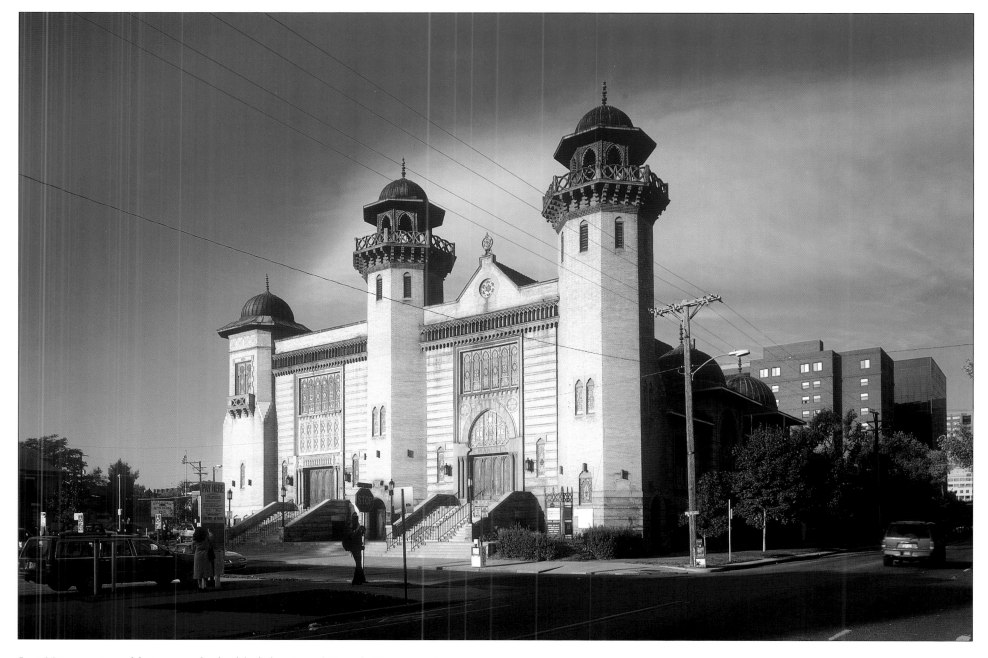

In 1924, a major addition nearly doubled the size of Temple Emmanuel, adding a third tower and a second front entryway. The congregation that once filled the building moved to a new location in the 1950s. It was home to several churches over the next three decades before being converted by the city into an events center.

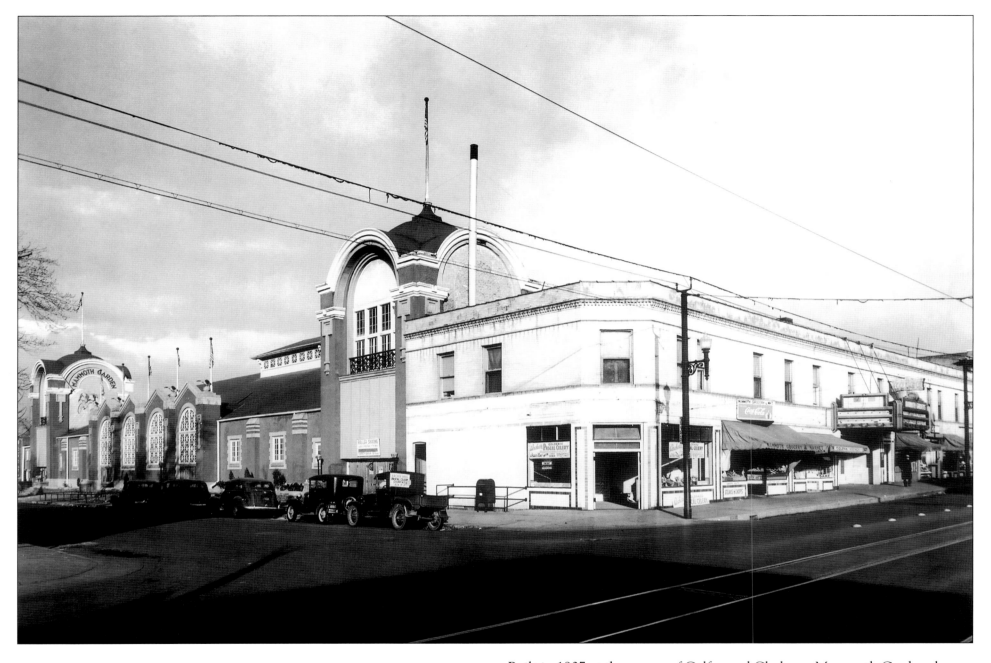

Built in 1907 at the corner of Colfax and Clarkson, Mammoth Gardens began its life as a roller-skating rink. Not long after, the Fritchle Automotive and Battery Company leased the 35,000-square-foot property as a factory to produce Fritchle Electrics, a successful brand of electric automobiles. By 1917, however, Fritchle had succumbed to competition in Detroit, and the building reverted to its recreational roots.

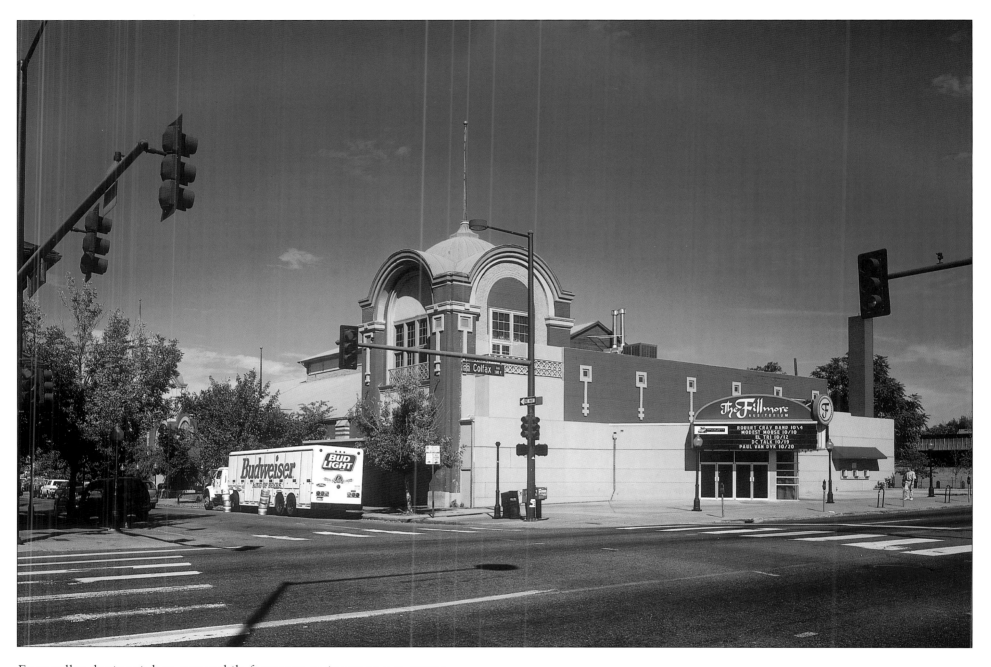

From roller-skating rink to automobile factory to casino to events center, Mammoth Gardens has seen a gamut of uses. In the late 1990s, concert promoter Bill Graham purchased the building, which had been vacant for several years. After a massive interior renovation, the Mammoth reopened as the Fillmore Auditorium, named and designed after Graham's two other famed concert halls of the 1960s. The Fillmore continues to draw large national acts and huge crowds.

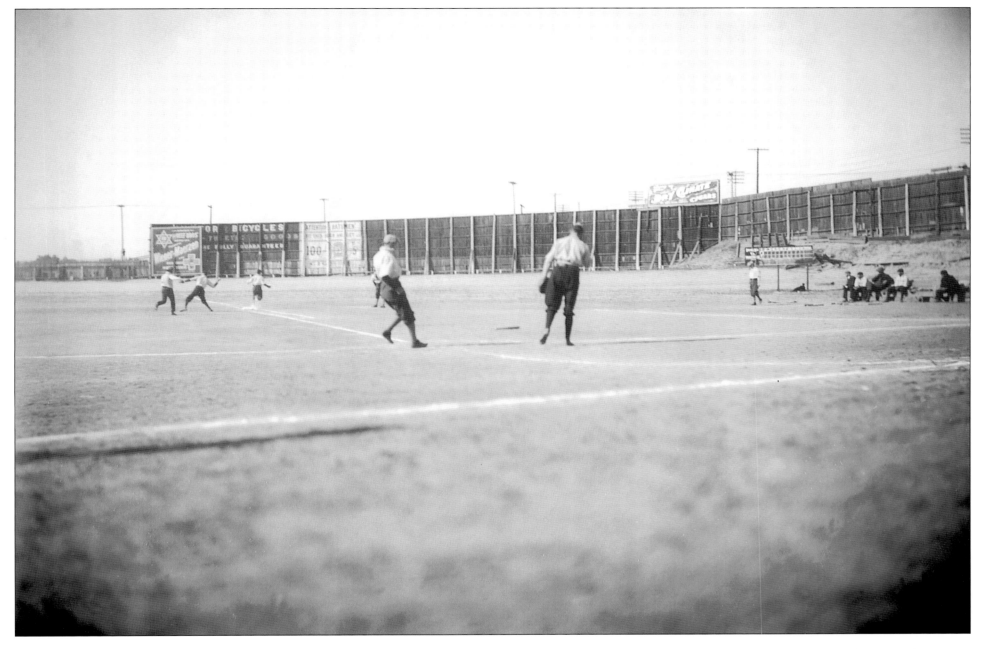

This photo, taken in 1900, shows a game in the first official season of Denver's professional baseball team, the Denver Bears. The Bears played at Broadway Park, winning three Western League pennants, until 1922, when they moved farther south to Merchants Park. Ten years later, the team went bust with the Depression economy, though they resurfaced again in 1947.

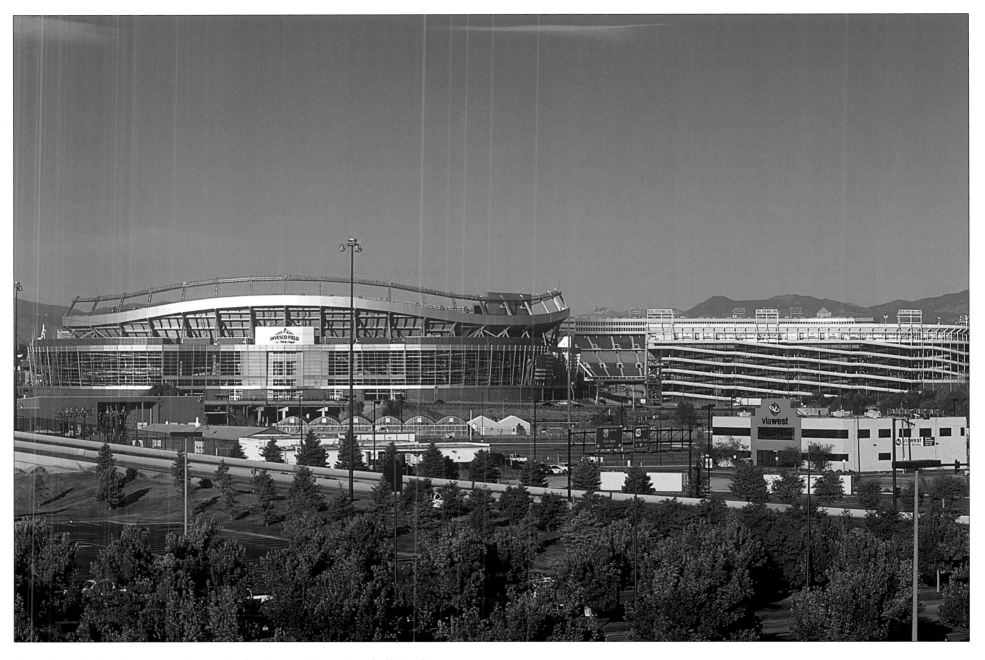

Broadway Park is long gone. In 1948, the Denver Bears Baseball Stadium was built to house the team on the site of a former garbage dump. The stadium was expanded in the 1950s to accommodate one of the original American Football League teams, the Denver Broncos, and renamed "Mile High Stadium." Mile High was expanded again in the 1970s, but is now scheduled for demolition, as a brand-new stadium was built for the Broncos in 2001.

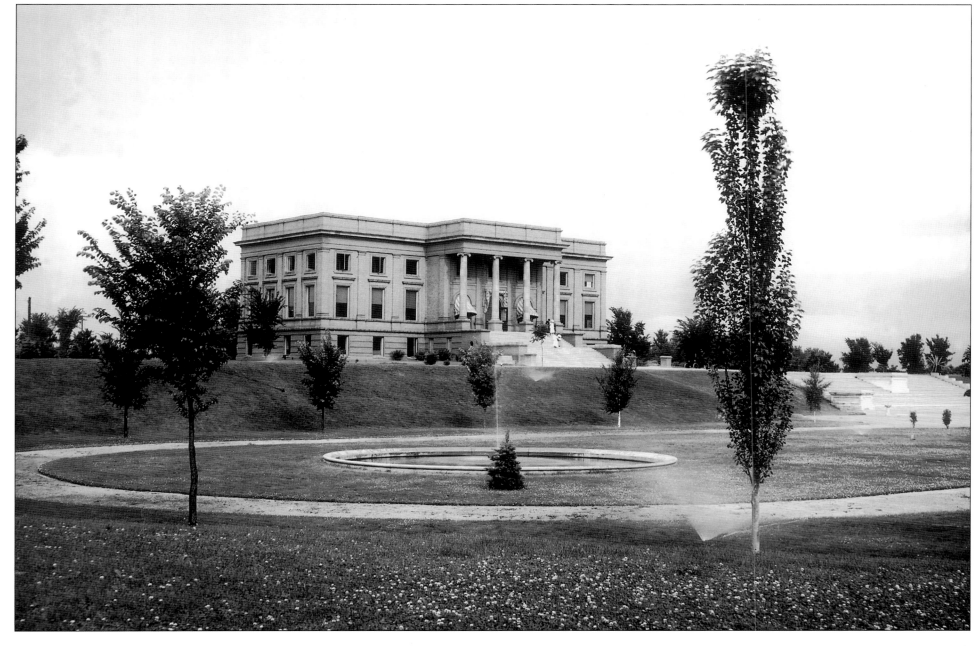

Like many of Denver's most significant structures, the Museum of Natural History was built in neoclassical style to accentuate its importance. The museum, situated at the eastern boundary of the beautiful, expansive City Park (which was also home to the Denver Zoological Gardens), was founded in 1900, though the main building wasn't completed until 1908. The park, with its big, looping drives, pretty lakes, gardens, and sculptures, was a fitting setting for the elegant Museum.

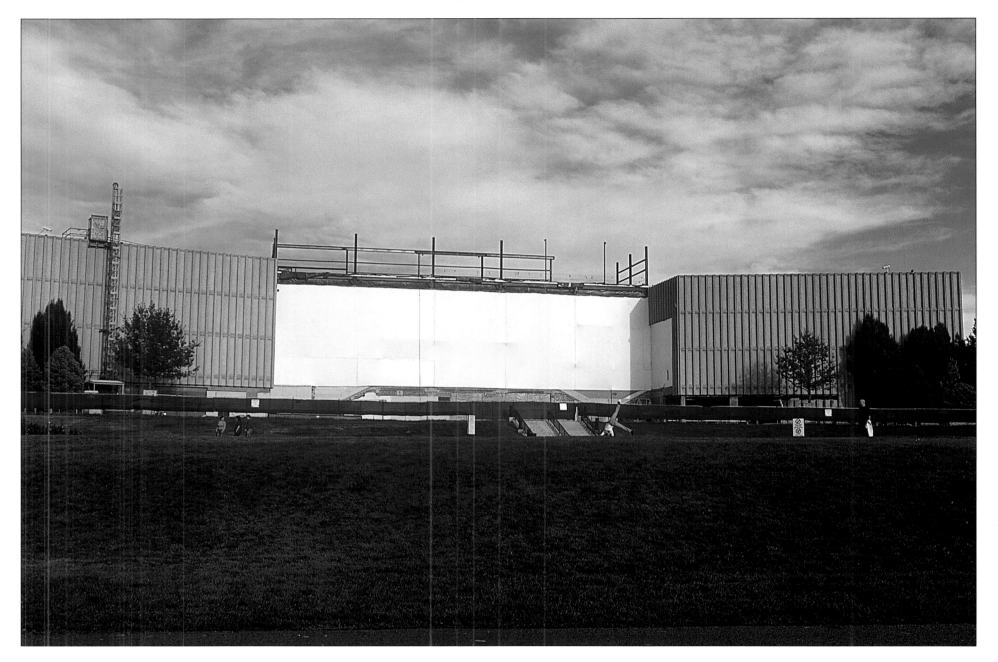

Over the years, the Museum of Natural History has undergone many changes, the most recent of which is its name. Now the Denver Museum of Nature and Science, the building underwent three significant renovations that have hidden the original structure behind glass and concrete, but which added an auditorium, IMAX theater, and several wings. As can be seen here, a fourth major renovation is currently under way. City Park is still a beautiful, well-manicured home for this facility, which has become Colorado's most popular and illustrious museum.

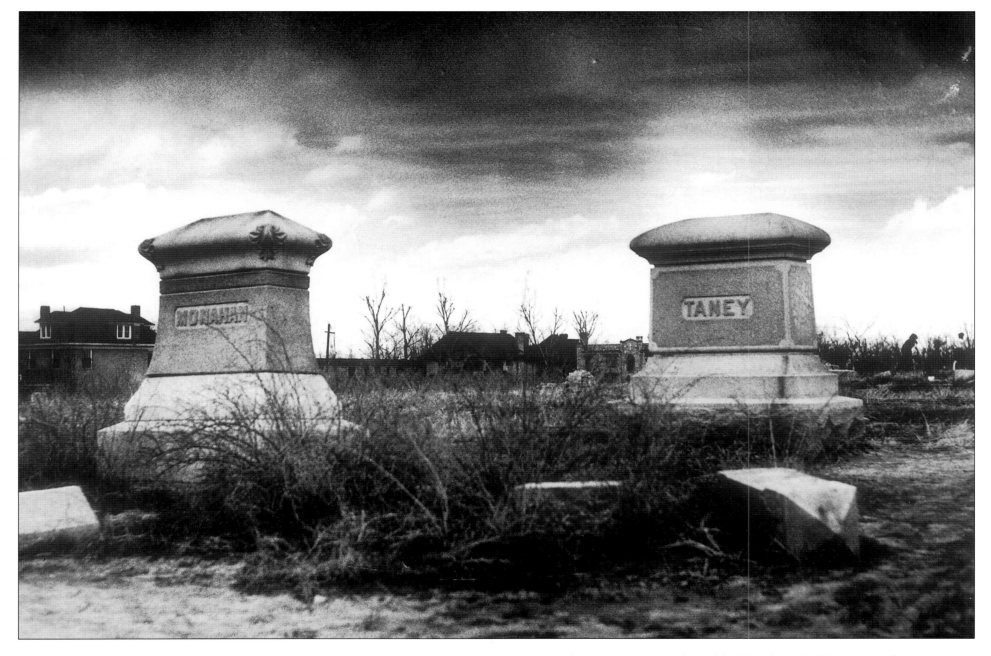

Mount Calvary Cemetery, a three-block lot bounded by York and Race Streets, was the Catholic section of Mount Prospect City Cemetery. Horace Tabor, one of the greatest contributors to the growth of early Denver, was buried here in 1899. Pictured here in 1937, Mount Calvary fell into disrepair with toppled monuments and overgrown weeds.

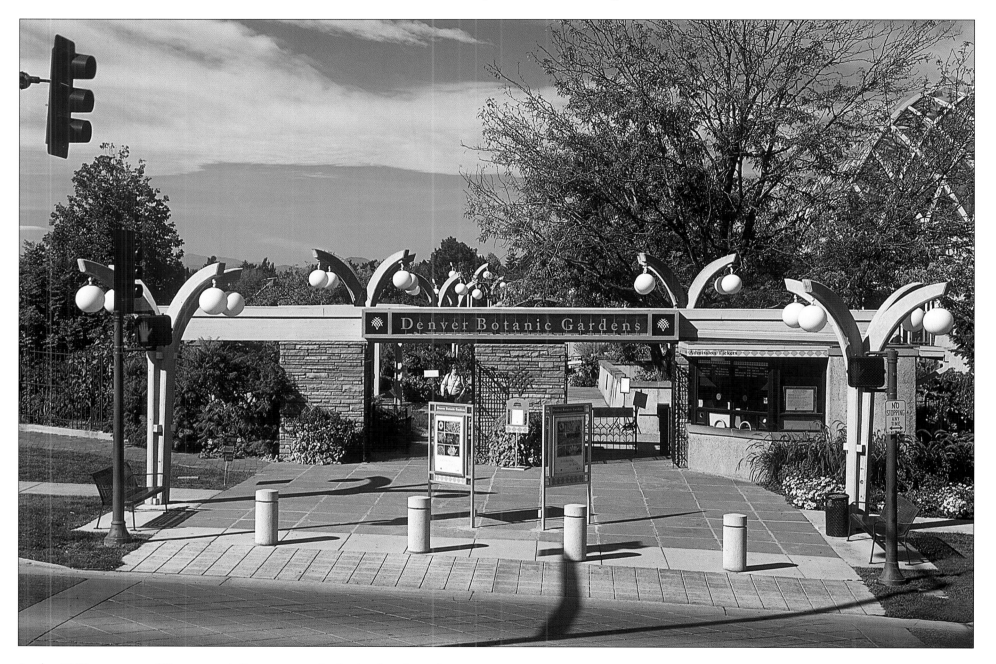

In the 1950s, a group of Denver socialite women who had a decade earlier founded the Colorado Forestry and Horticultural Association, began planting gardens on the city-acquired site of Mount Calvary Cemetery. Graves were moved to a new location, and the property became the Denver Botanic Gardens. Today the distinguished Botanic Gardens, at the northern extension of Cheesman Park, include the Boettcher Memorial Center, with its naturalistic waterfalls, and the elegant Botanic Gardens House.

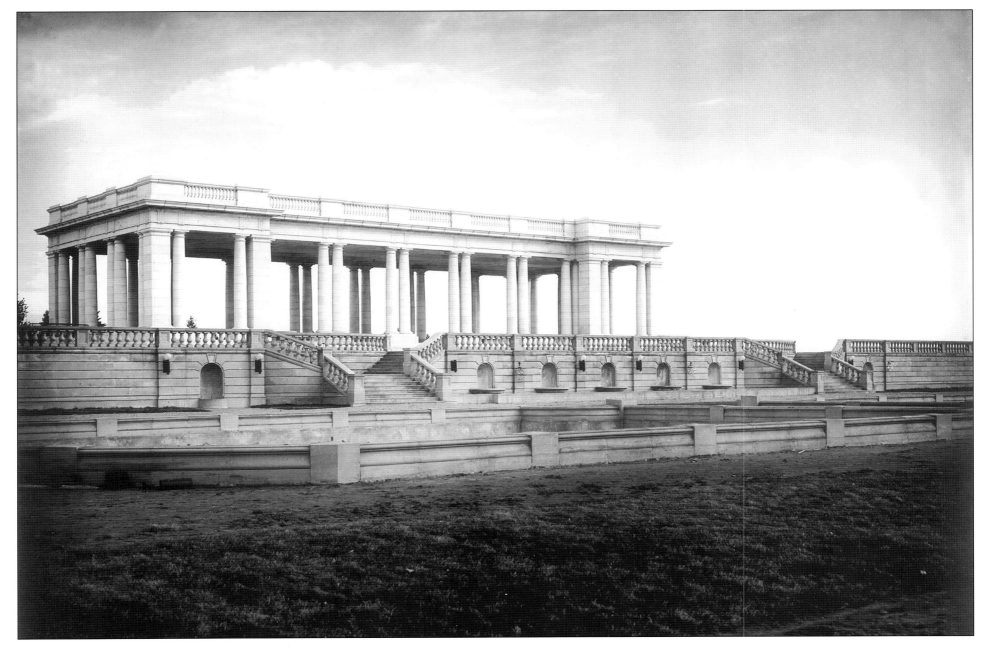

Separated from Congress Park as a memorial to Walter Scott Cheesman, the early tycoon who invested and made a fortune in various Denver dealings, Cheesman Park was one of the city's most beautiful recreational areas. The neoclassical Cheesman Memorial Pavilion, pictured here just after its completion in 1909, was placed at the head of the park.

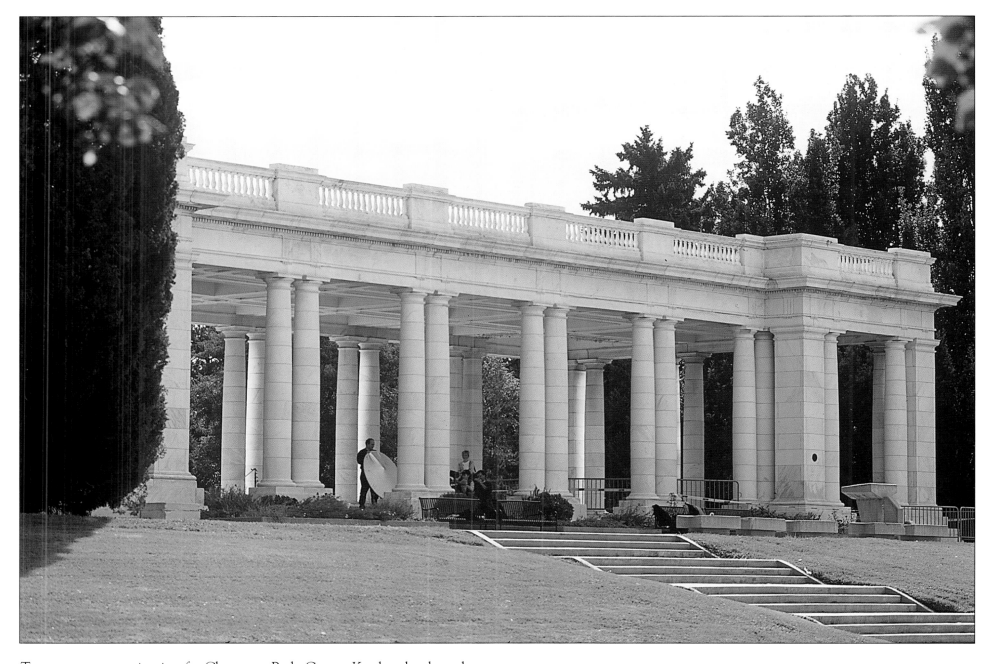

To ensure a mountain view for Cheesman Park, George Kessler, the shrewd planner of the late 1800s, set it on high ground. It is a plan that has paid off, as the Cheesman has been designated a National Register and Denver landmark. The park is a popular recreational destination, with beautiful gardens and a reflecting pool.

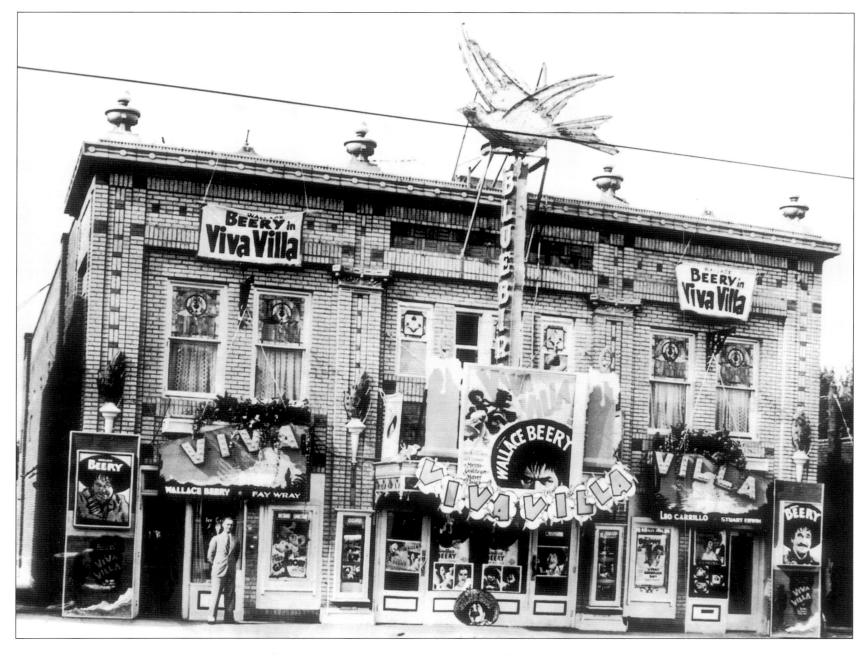

As the Great Depression took hold of Denver, the city's once abundant live theater scene began to dwindle, replaced by more economical movie houses. Harry Huffman, who saw the potential of moving pictures, began to acquire a number of theaters. He began with the Thompson on Colfax, pictured here shortly after Huffman renamed it the "Bluebird Theater." Within years, Huffman had purchased most of downtown's most popular theaters, earning him the nickname "Mr. Movies."

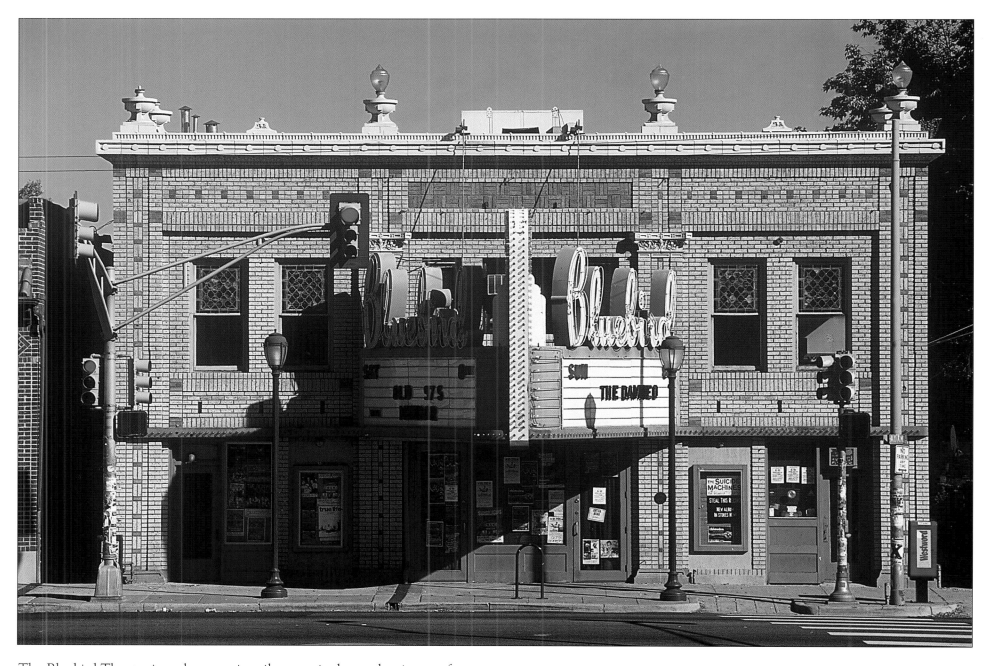

The Bluebird Theater is no longer primarily a movie theater but is one of the city's most popular concert destinations. Though many of the larger musical acts it once attracted have moved to the newer Fillmore Auditorium, the Bluebird's intimate setting and longevity have made it a musical mainstay in Denver.

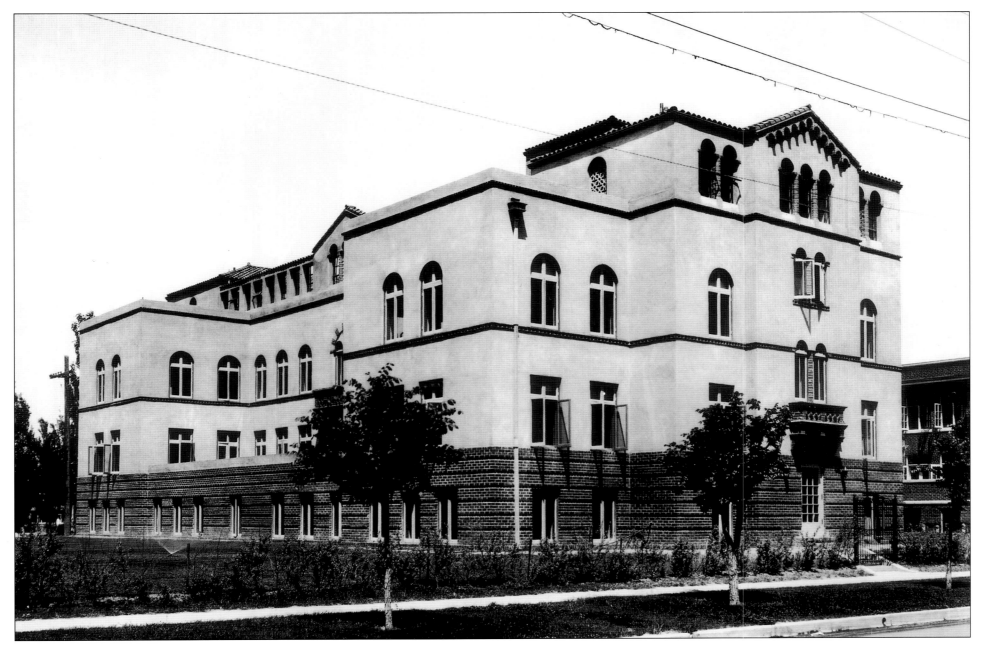

In the 1880s, tuberculosis was a motivating factor for many who moved to the high, dry climate of Denver. By the 1890s, TB had become somewhat of an epidemic, particularly among Jews who came from East Coast and European ghettos. After years of economic struggle, the National Jewish Hospital for Consumptives opened its doors. In 1927, NJH built and moved into this building on East Colfax to help accommodate a growing population.

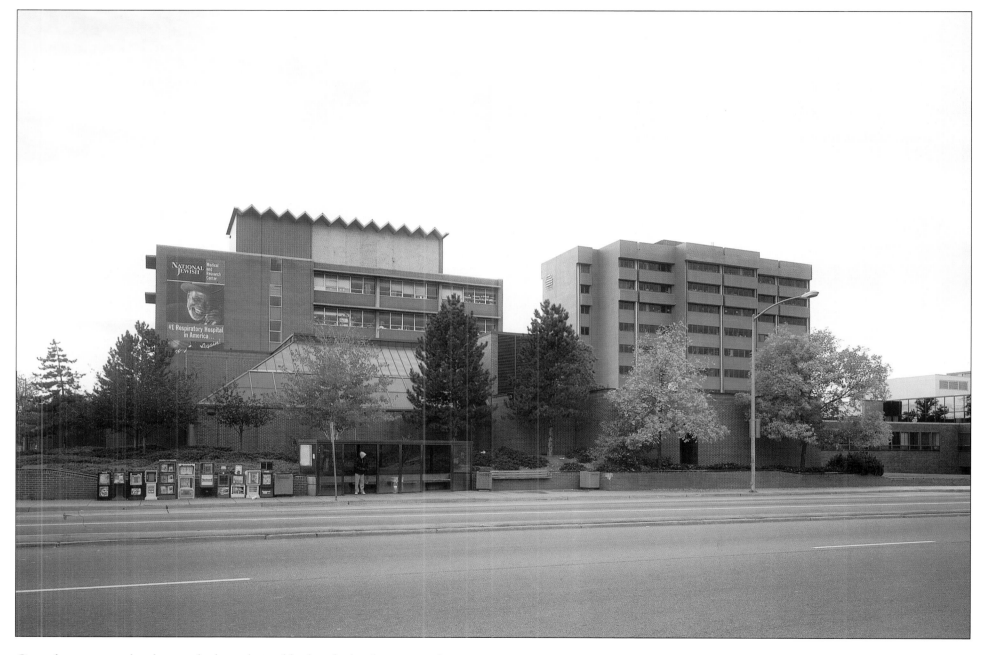

Over the years, as the threat of tuberculosis ebbed with the discovery of penicillin, the focus of the National Jewish Hospital and its counterpart, the Jewish Consumptive Relief Society, grew wider. National Jewish, which has grown into one of the most highly regarded institutions for respiratory disorders and research in the country, is open to people of all backgrounds.

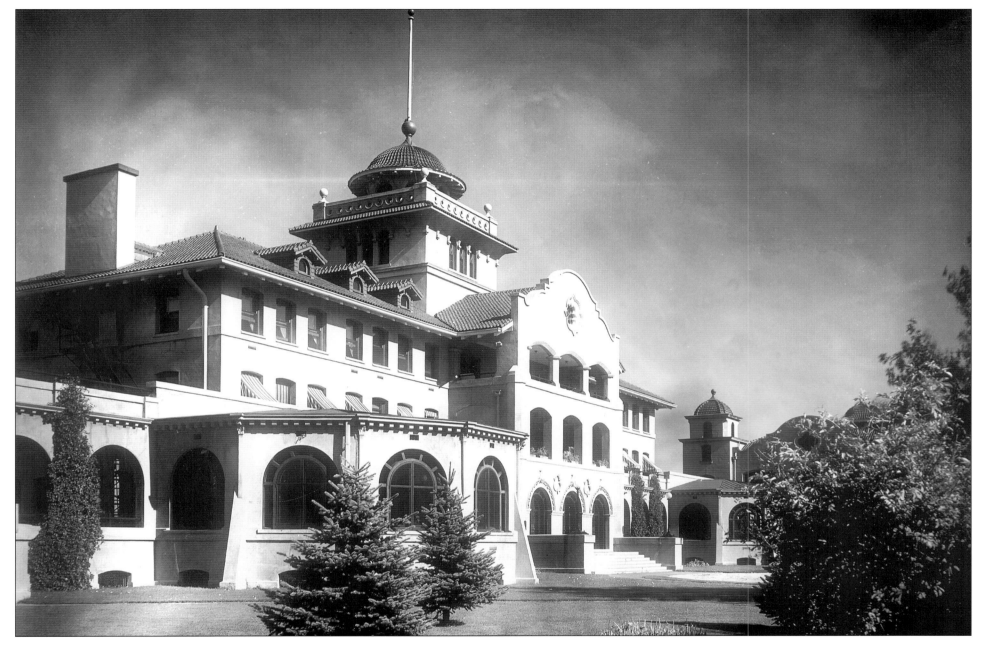

Before the introduction of penicillin, the tuberculosis epidemic consumed nearly thirty percent of Denver's population, including the mother of millionaire Lawrence Phipps, who endowed the building pictured here, the Agnes Memorial Sanatorium, in 1904. The building functioned as an institute for TB patients until 1938, when it was converted into an Army Air Corps technical school.

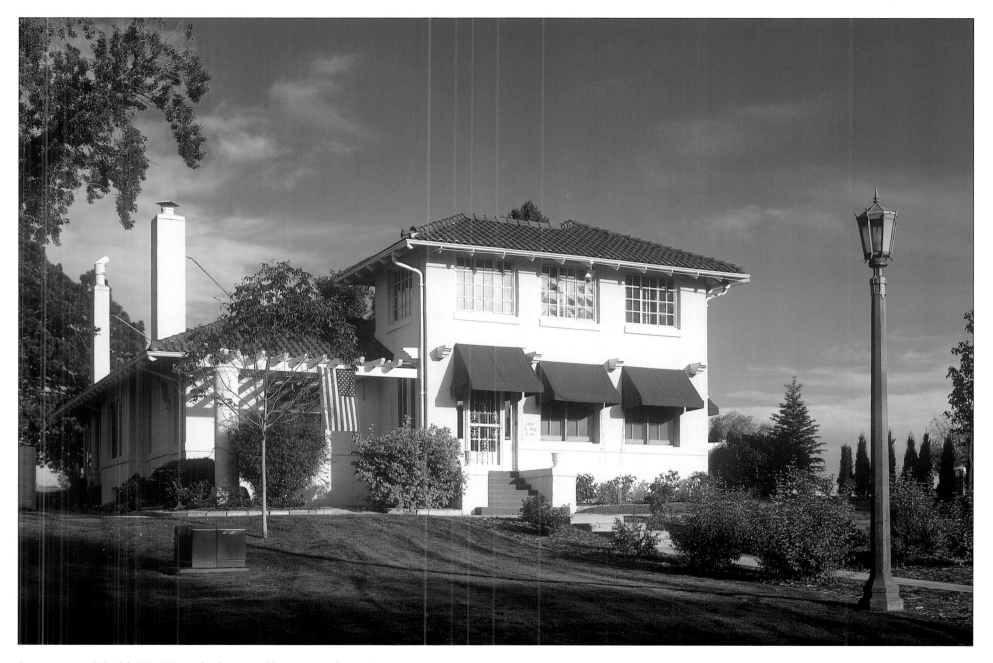

Just prior to World War II, in the hopes of bringing jobs to Depression-era Denver, the city purchased the Agnes Memorial Sanatorium and donated the 950-acre property, along with other land, to the army. The sanatorium was converted into Lowry Air Base, which brought life to the suburb of Aurora and continues to provide flight training and other skills to the men and women of the Air Force and to create thousands of jobs, both military and civilian.

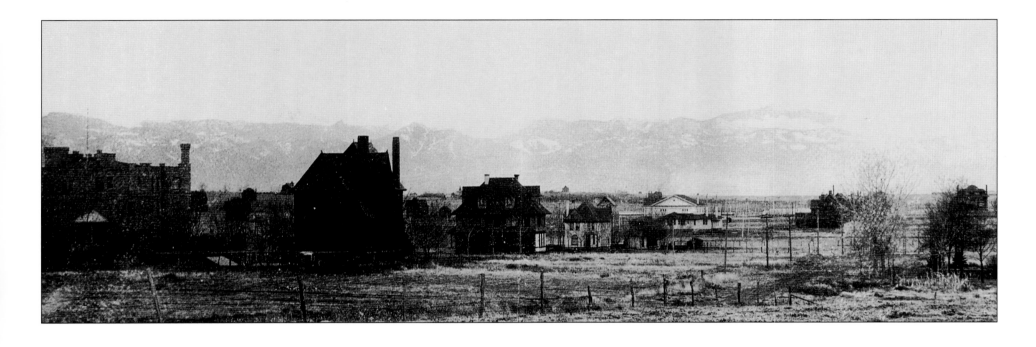

Above: In the 1880s, as streetcar extensions made possible the founding of suburban towns, Baron Walter von Richthofen was working tirelessly to promote his own development, the suburb of Montclair. Richthofen built his own grand castle and sunk a fortune into land in the hopes that Denverites would be lured out of the city. As can be seen in this 1904 photo, the idea of Montclair didn't take right away.

Right: In fact, although the town of Montclair officially became annexed by the city of Denver in 1902, it wasn't until the advent of the automobile many decades later that Montclair blossomed. Today, thanks to an aggressive preservation plan, Montclair is one of the premier residential districts of the city. Richthofen's castle still stands as a private residence and the symbol of a town that was a long time coming.

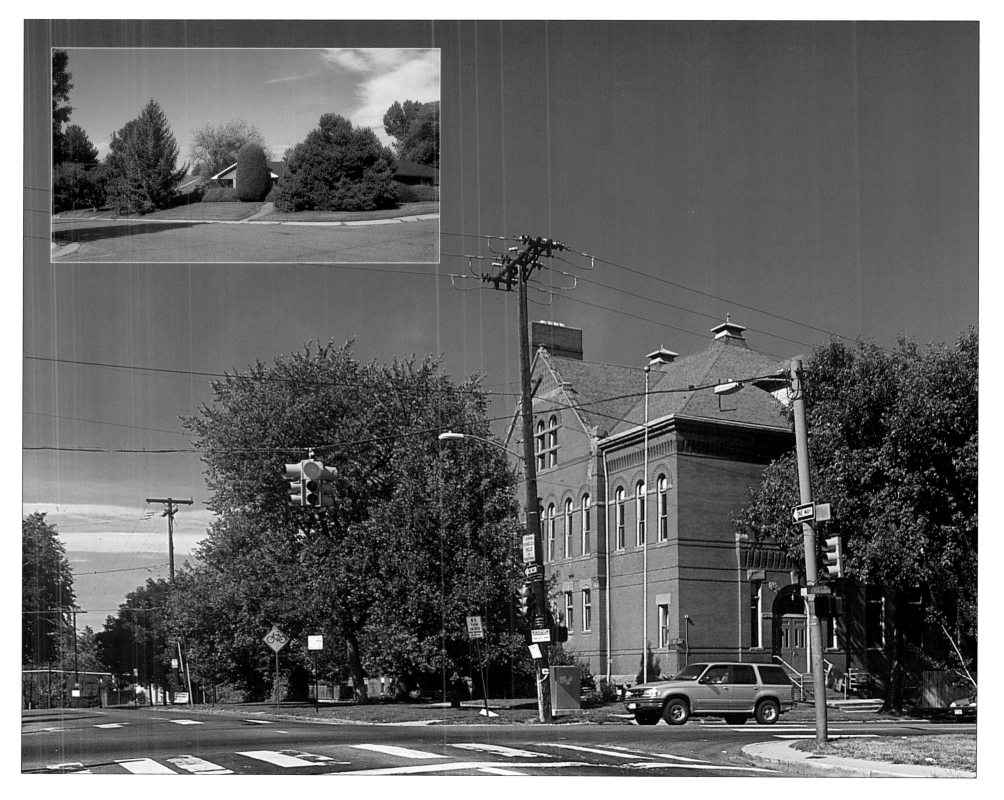

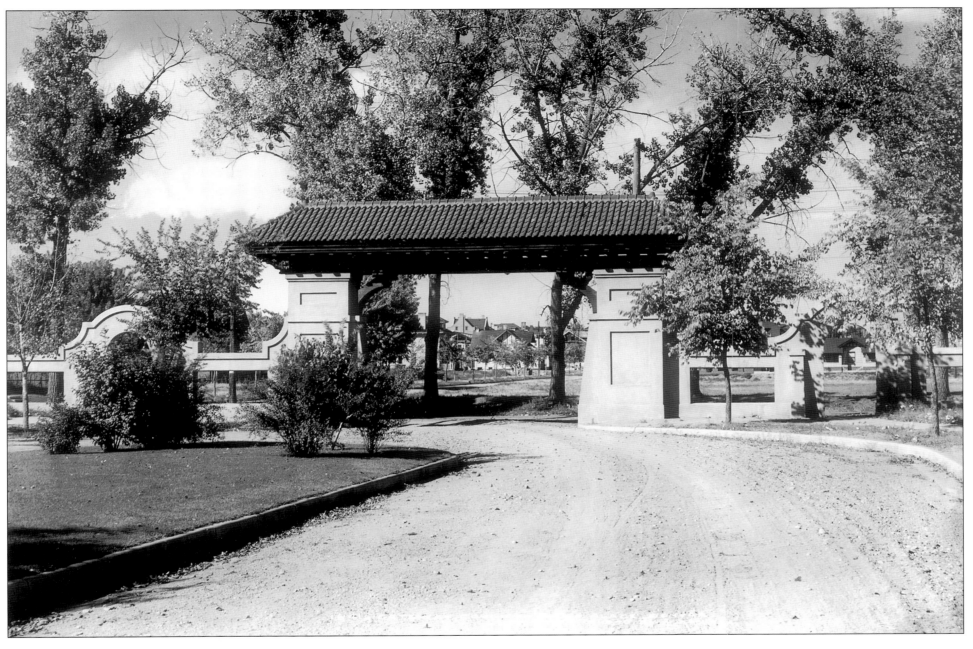

By the turn of the nineteenth century, Denver's elite had turned their eyes toward social recreation. Golf had become increasingly popular, and in 1901, several prominent enthusiasts converted an empty field south of the city into the Denver Country Club. Eventually, influential citizens, including Robert Speer, moved to the area north of the country club (once a racetrack), creating an elite residential district whose entrance is pictured above circa 1907.

The term "country club" now refers more to the beautiful, historical residential neighborhood north of the Denver Country Club, than it does to the club itself. Expensive, newer homes coincide with an array of historical residences in this impeccably landscaped suburb southeast of the city. Though most of the houses were built before 1940, there is almost constant renovation, which keeps the district invigorated.

Denver's park system was an important aspect of Mayor Robert Speer's vision of the "City Beautiful," and Washington Park was one of the most significant. The 160-acre area, built in 1889, included two lakes, including Smith Lake, photographed here circa 1920, and a vast open field called the "Great Meadow." The house of Eugene Field, famed author of the children's poem, "Wynken, Blynken, & Nod," was made into a branch library and relocated in the park.

A tranquil, residential community sprung up around Washington Park—a neighborhood of pretty, modest houses that has become increasingly trendy. Smith Lake is still a popular spot for sunbathers and outdoor recreation, and most of the original structures in the park, including Eugene Field's cottage and the 1913 Boat House (visible in this shot), are still present. Other historic landmarks include the Shelter House from 1912 and a sculpture inspired by Field's poem from 1919.

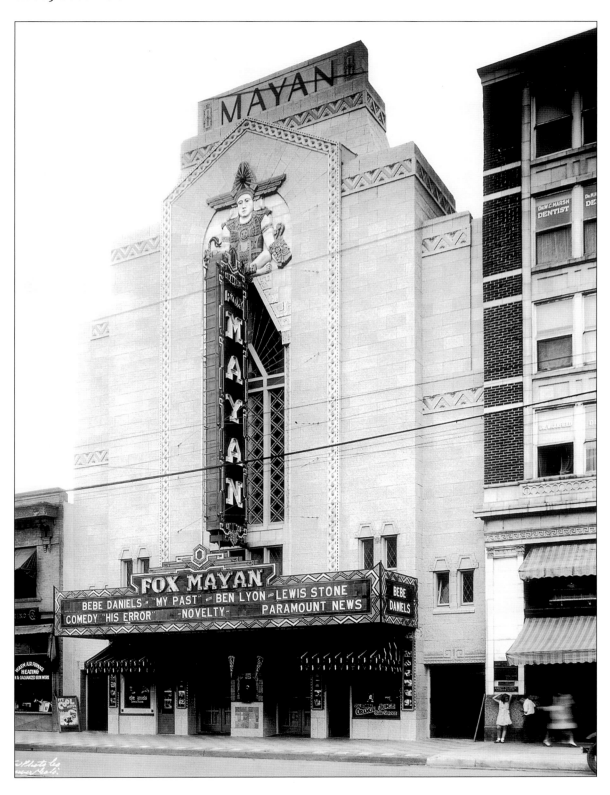

After the performance theaters of the early 1900s had given way to Depression-era movie houses, the movie houses themselves began to grow more ornate. This photo, taken in 1931, shows the Central-America-themed Mayan Theater, owned by movie king Harry Huffman a year after its construction had fully obscured the simple red brick of the earlier Queen Theater.

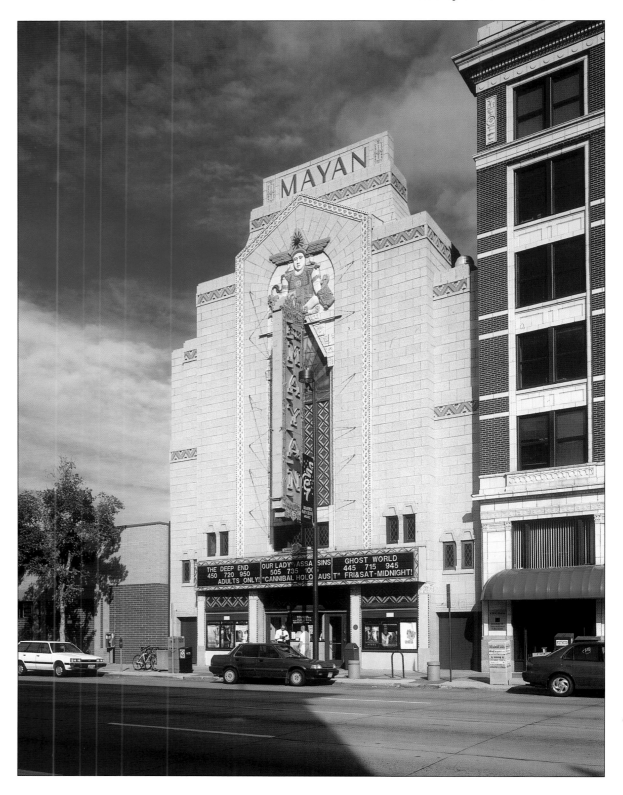

In 1984, the historic Mayan was rescued from demolition and restored. In 1987, the theater once again began showing movies. Its intricate facade and unique motif make it perhaps the most stunning survivor of Denver's movie-house era. Now protected as a Denver landmark, the Mayan is the city's premier theater for art-house and independently produced pictures.

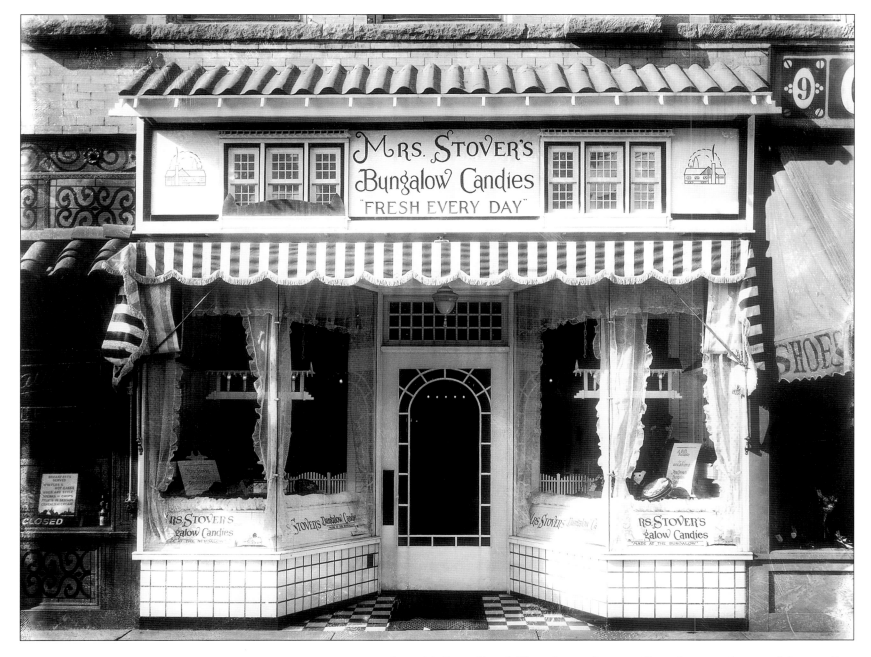

In 1923, Russell and Clara Stover began selling their candy out of this small store on Broadway Street. Their success grew well beyond the city limits, making Mrs. Stover's Bungalow Candies a model for Denver businesses, many of which were struggling against banks and businesses from the East Coast. Among a handful of other local start-up entrepreneurs were the Shwayder brothers, who founded a company in 1910 that manufactured trunks under the name "Samsonite."

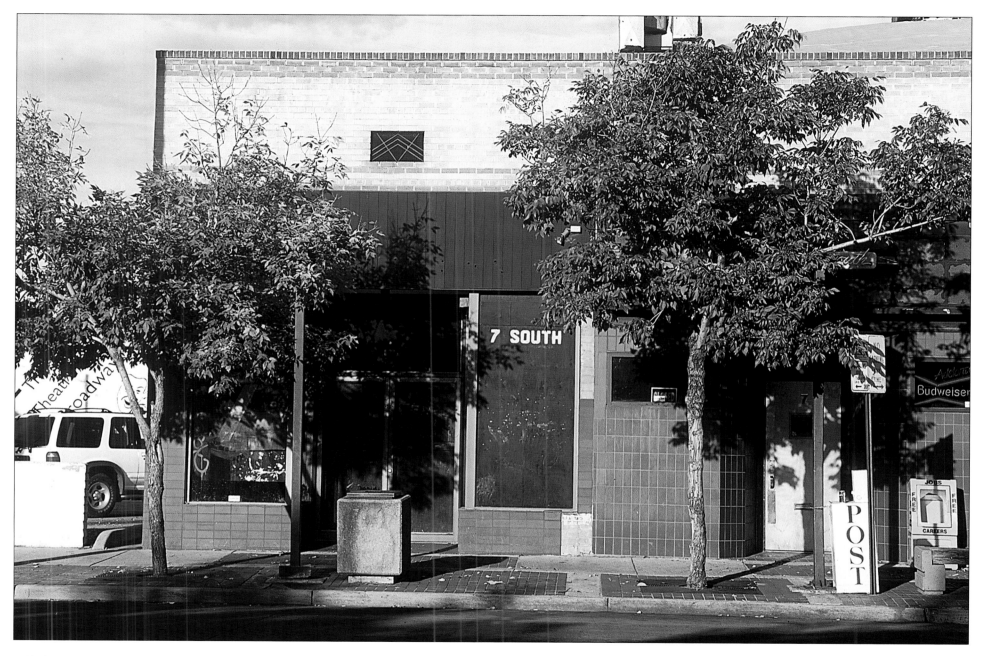

All that remains now is a row of local stores, including a video store. Mrs. Stover has long since moved her candy business, now known as "Russell Stover's," to larger headquarters, though there are still factories in Colorado. Samsonite, which manufactures all types of luggage and travel accessories, also continues to be an international leader within its industry. Denver is now home to many of the country's premier businesses, especially in the areas of technology and telecommunications.

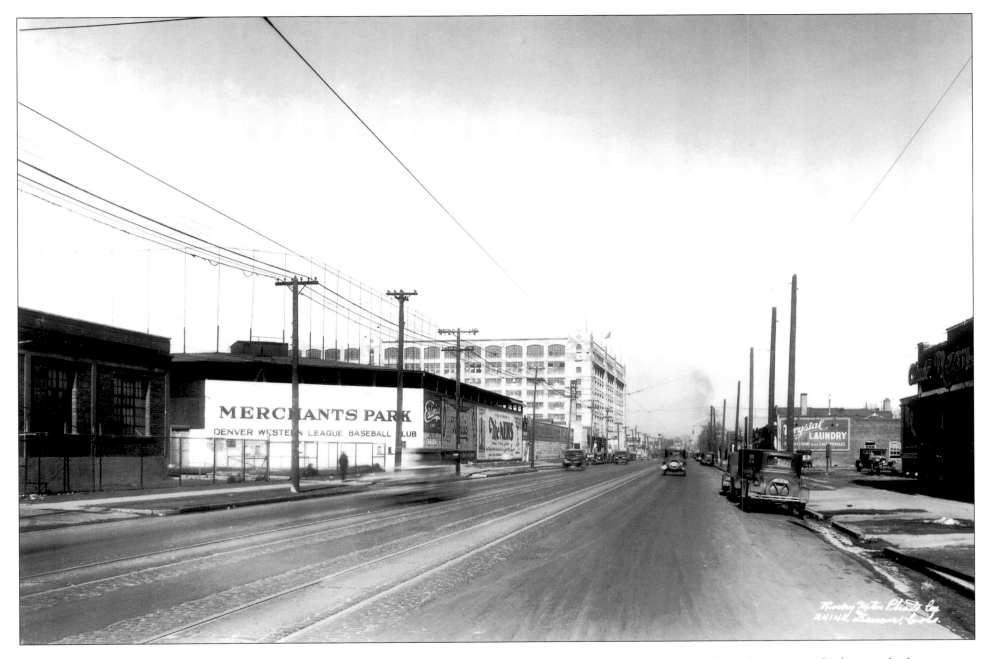

While Denver's cable-car system allowed expansion further south along Broadway, the advent of the automobile made travel outside the city center even more convenient. This photo, taken between 1922 and 1930, shows Merchant's Park, the second home of the Denver Bears baseball team.

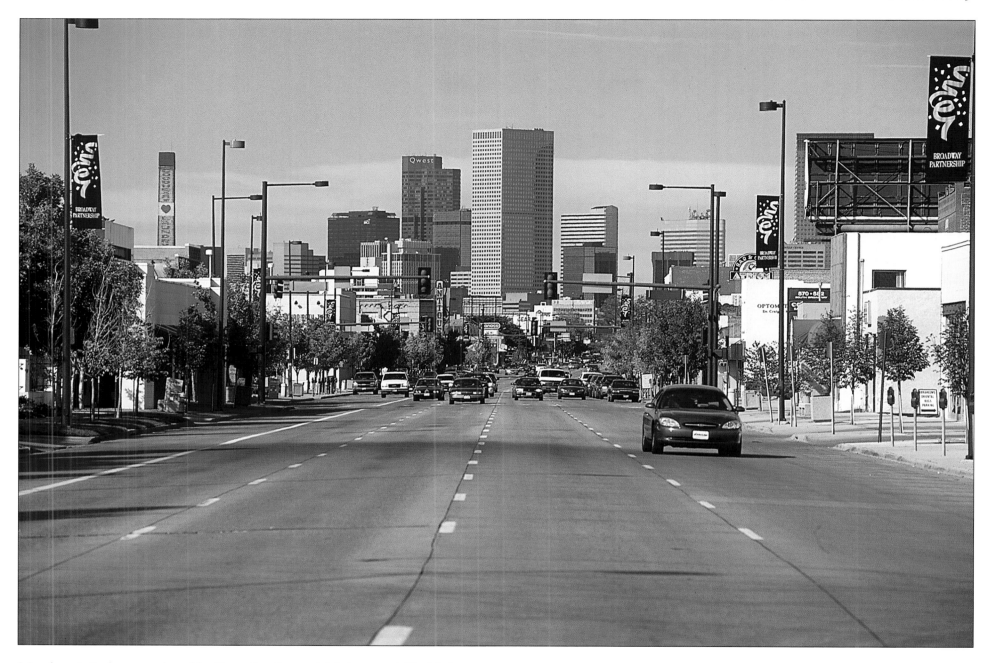

Merchant's Park was replaced by Bears Stadium, which became Mile High
Stadium in the 1950s. South Broadway today, because of the cable-car route
that once ran along it, is one of Denver's widest thoroughfares, affording a
unique view looking north toward downtown.

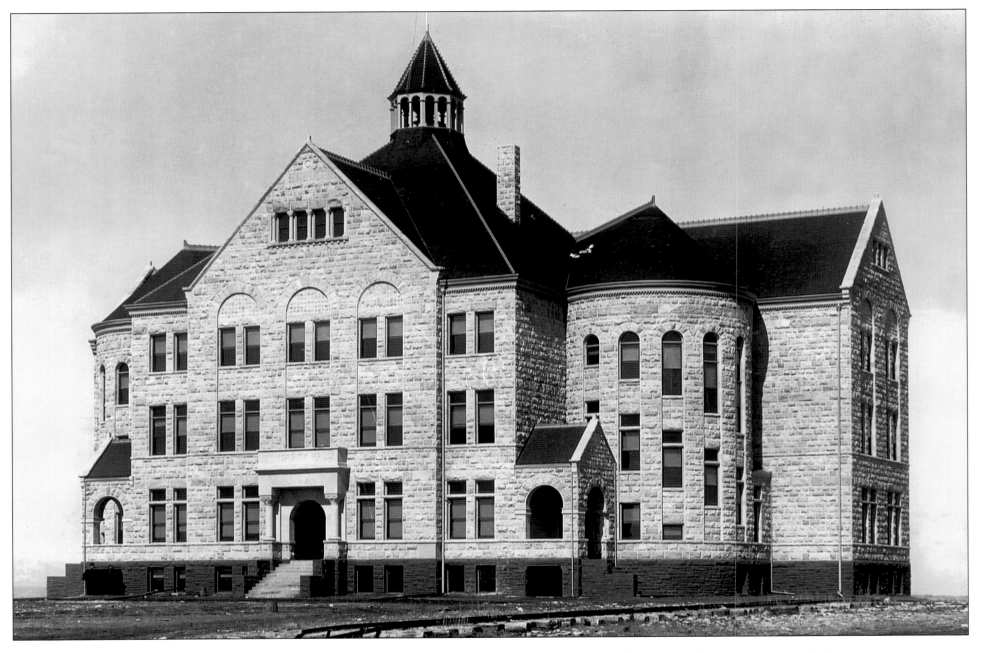

Denver University, the state's earliest institution of higher education, was founded in 1879 as the Colorado Seminary. Old Main, pictured here circa 1895, was the first building on the school's new campus in University Park. The structure was built in 1890, by Denver's first-licensed architect, Robert Roeschlaub, and was followed by the Iliff School of Theology in 1892 and the Buchtel Memorial Chapel in 1917, which was destroyed soon after in a fire.

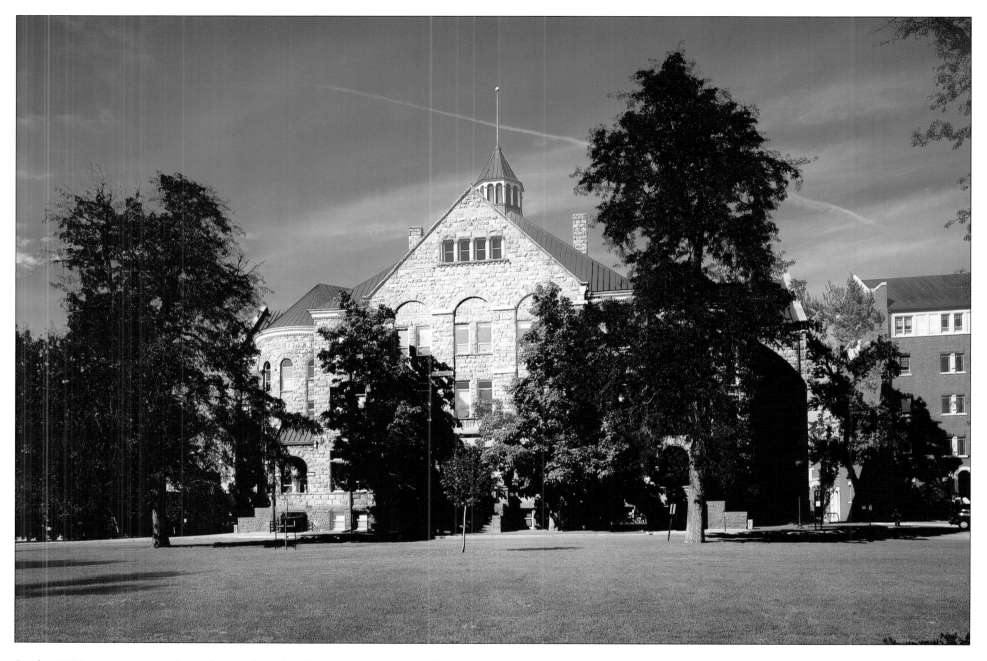

In the 1980s, competition from the combined colleges of the Auraria Campus forced Denver University to raise tuition fees and cut back programs, but the state's oldest institution for higher education is strengthened by a fine reputation and solid enrollment. Old Main, though it is now called "University Hall" and is surrounded by dozens of other university buildings and the bustling neighborhood of University Park, remains a primary facility for the school.

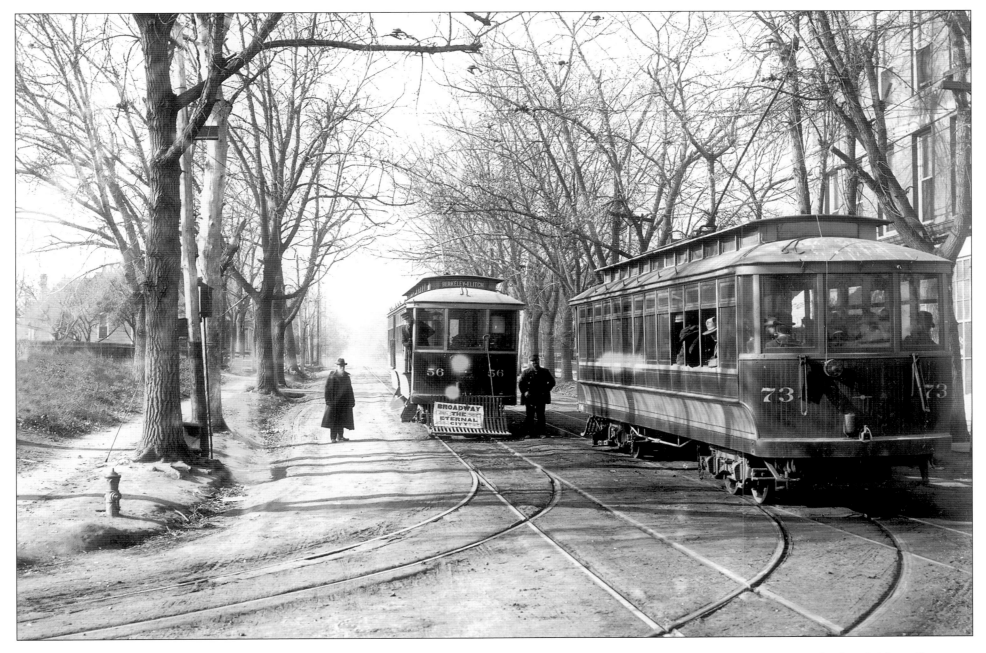

Not long after bridges and streetcars began crossing the South Platte River, rapid development began on the land northwest of Denver. A cleaner, less-crowded respite from the city across the South Platte was an enticement for many to move to the competing city of Highland. By 1890, six years before it was annexed by Denver, Highland was one of Colorado's largest cities, boasting over 5,000 residents.

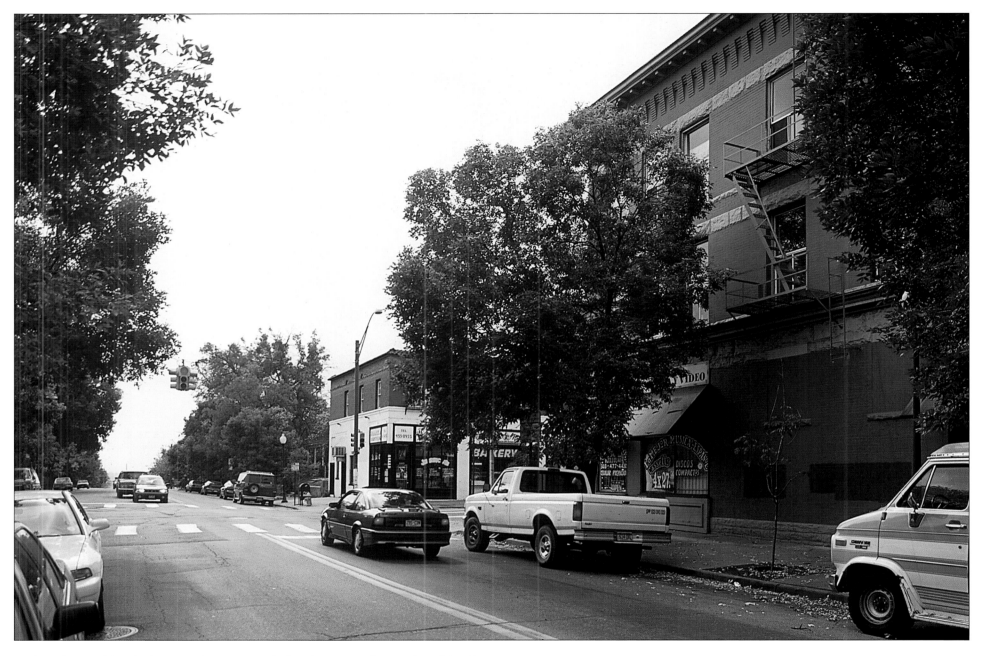

Today, the Highlands district of Denver includes the original city of Highland,
as well as Potter Highlands and Highland Park. Although the Highlands
suffered some degradation in the last decades of the twentieth century, an
urban renewal effort has restored some of the quaint, historic charm of the
place, and with its elevated views of the city, it is again becoming a popular
home for those wishing to combine the conveniences of city and suburb.

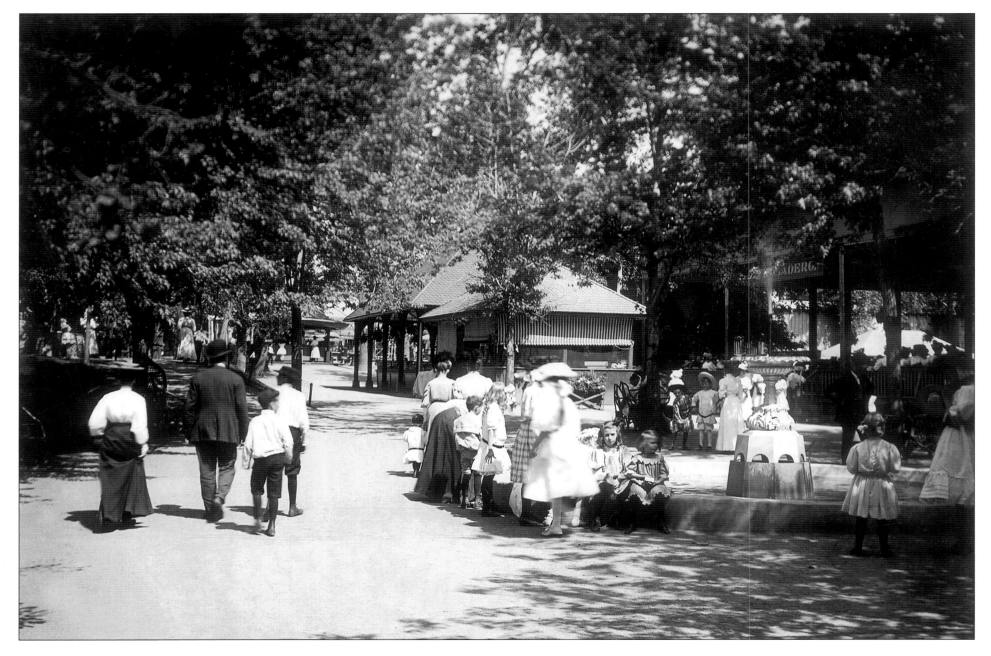

Opened in 1890 by John and Mary Elitch, Elitch Gardens was Denver's first amusement park. Elitch Gardens was built on the site of an apple orchard on Thirty-eighth and Tennyson, in the Highlands area of northwest Denver. Along with rides and games, the park offered a charming theater for summer-stock performances and some of Denver's earliest presentations of moving pictures.

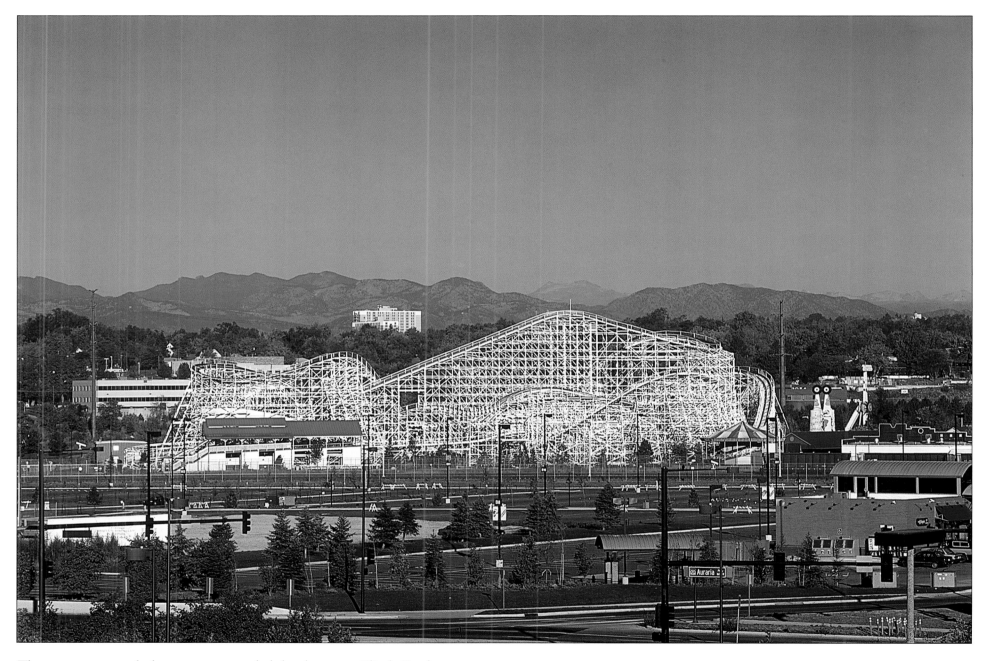

The amusement park that once surrounded the theater at Elitch Gardens
moved, in the early 1990s, to this location just south of Lower Downtown, on
the banks of the South Platte River. In the late 1990s, the park, which still
stands as Denver's oldest, was sold to a national corporation that owns theme
parks across the country. The Elitch Gardens theater still stands, though it is
currently unused, in northwest Denver.

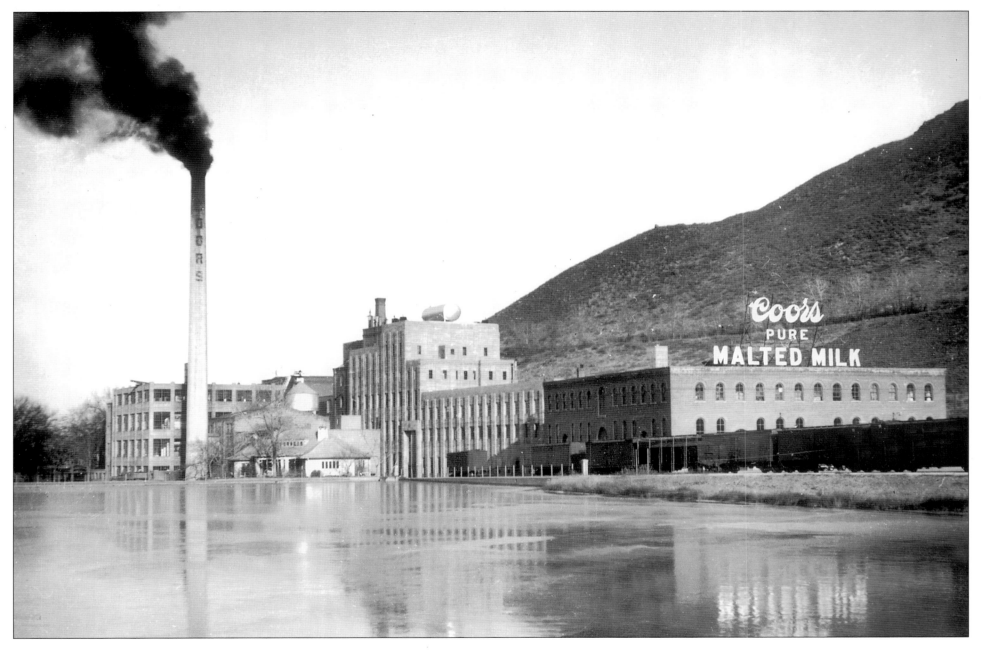

In 1873, Jacob Scheuler and Adolph Coors established a tiny brewery in Denver. The idea was hardly novel at the time, but unlike the dozens of other small beer manufacturers, the Adolph Coors Company grew by the early 1900s into this 3,400-acre plant, located west of Denver in Golden. The company continued to prosper, even through prohibition, when operations were switched to malted milk (note the billboard in this 1935 photo), butter, and even porcelain.

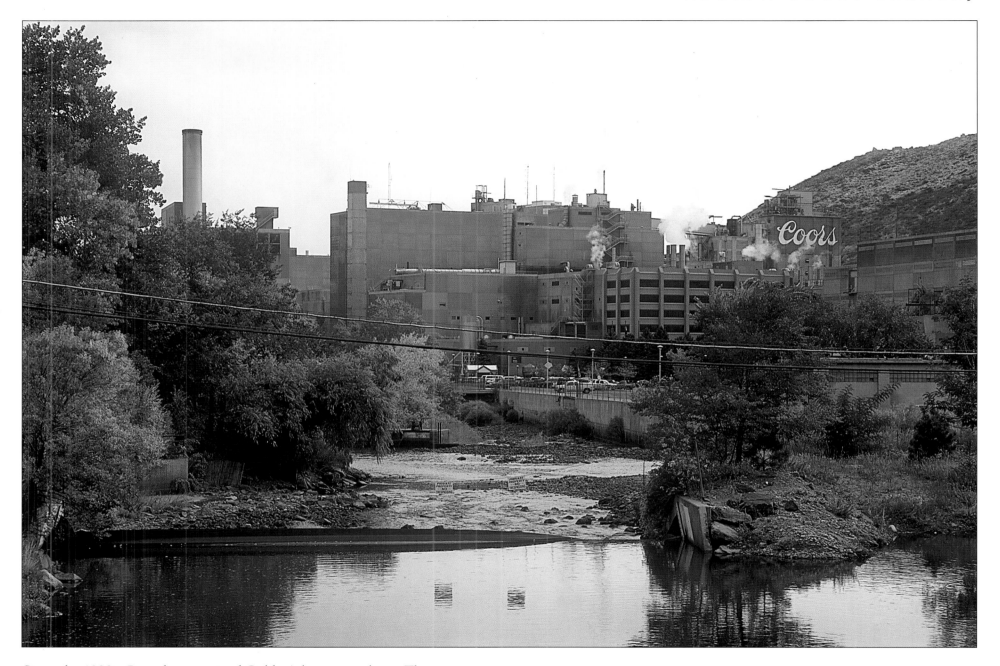

Since the 1930s, Coors has remained Golden's largest employer. The brewhouse, completed in 1934, is the oldest surviving structure of the facility, which was built in 1906. The company, one of the top beer producers in the world, still produces porcelain for commercial use, a practice left over from the prohibition era. The Coors brewery offers free tours, which include product samples, and has become one of the area's most popular tourist destinations.

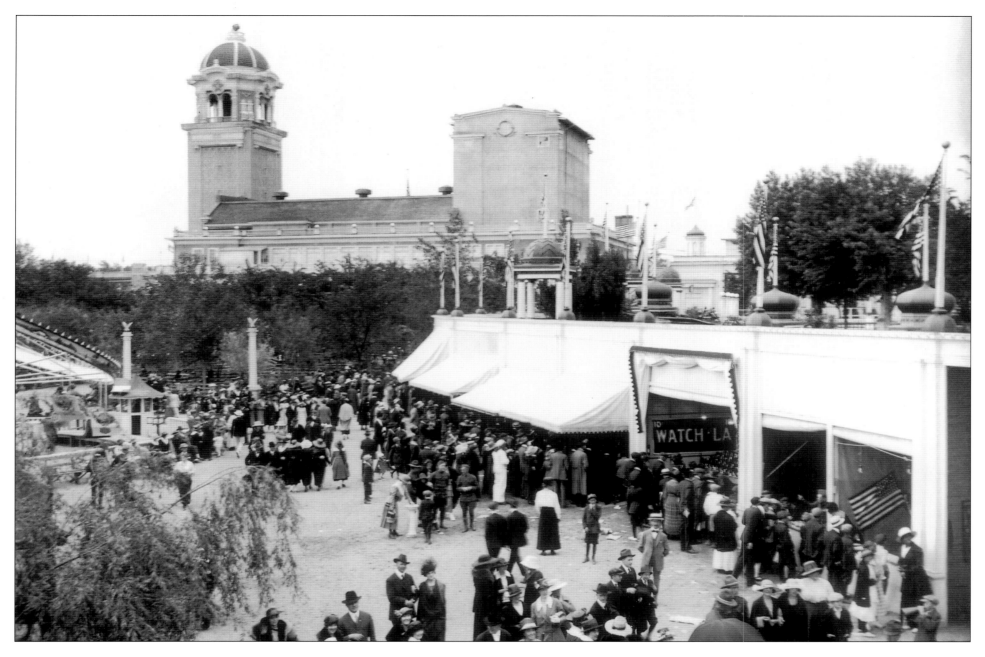

Lakeside Amusement Park, which wrapped around the thirty-seven-acre Lake Rhoda, opened in 1908, adjacent to Manhattan Beach Amusement Park. Lakeside, like Elitch Gardens and unlike Manhattan Beach, prospered through the years, luring traffic with its glowing 150-foot entrance tower and activities that included a roller coaster, skating, tennis, a theater, swimming, and a train that carried visitors around the lake.

No longer the grand attraction it was at the turn of the century, Lakeside Amusement Park, which underwent a major restoration in the 1940s, is nonetheless a popular theme-park destination. The park is also significant because it is still owned by the progeny of Ben Karsner, Lakeside's founder and builder, whose small-gauge train continues to haul park visitors on a tour around the lake.

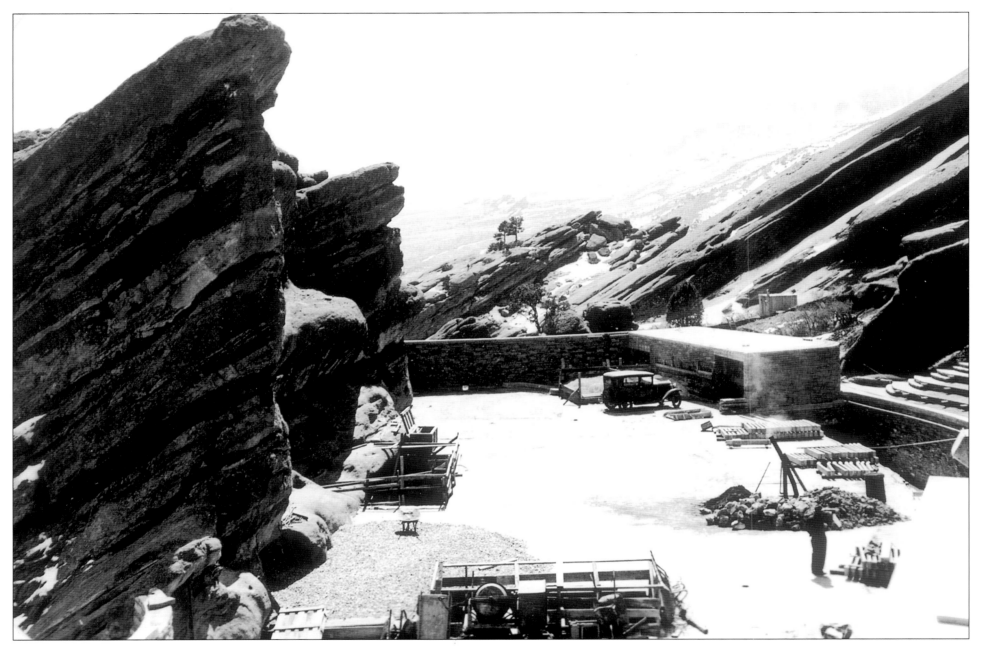

Through the 1920s, Denver accumulated property west of the city, including Red Rocks Park, which was acquired in 1928 and designated for use as a mountain park. Although Mayor Benjamin Stapleton envisioned the area as a scenic rock garden, his parks commissioner, George Cranmer, who had been inspired by an outdoor amphitheater in Italy, had other plans. Cranmer essentially dynamited Stapleton's rock garden to smithereens, installing in its place the amphitheater seen here under construction in 1940.

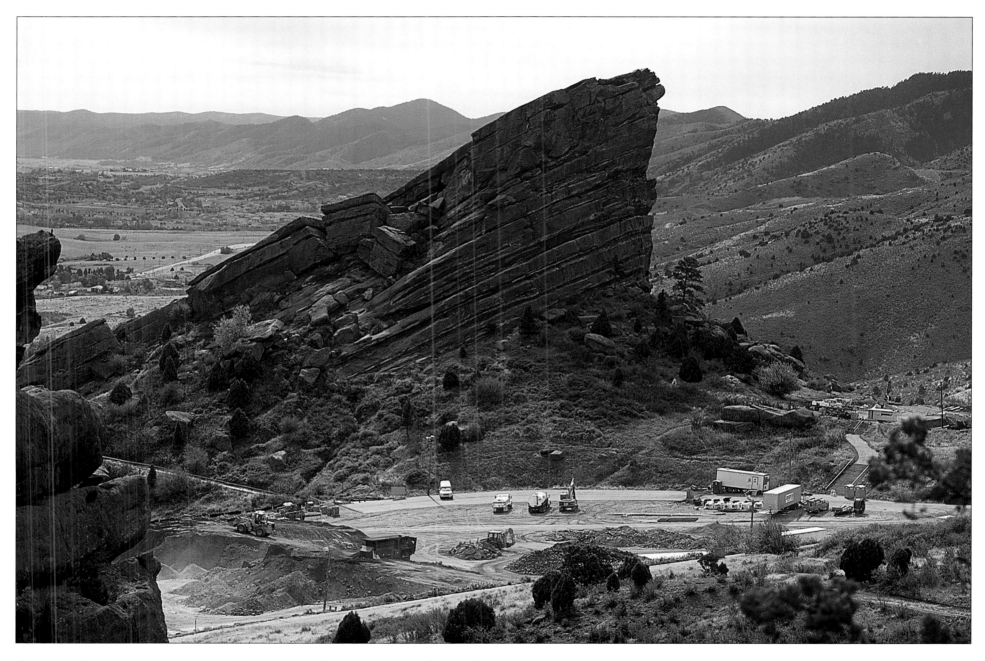

As any avid concert-goer can attest, there are very few music venues that rival Red Rocks Amphitheater. Ingeniously designed by architect Burnham Hoyt, the stage and seating at Red Rocks blend simply into the beautiful landscape overlooking downtown Denver. The amphitheater is currently being reconstructed and is closed to the public, but the near-perfect acoustics that bounce off the volcanically uplifted outcroppings ensures that this will be one of Denver's most dramatic attractions when it reopens.

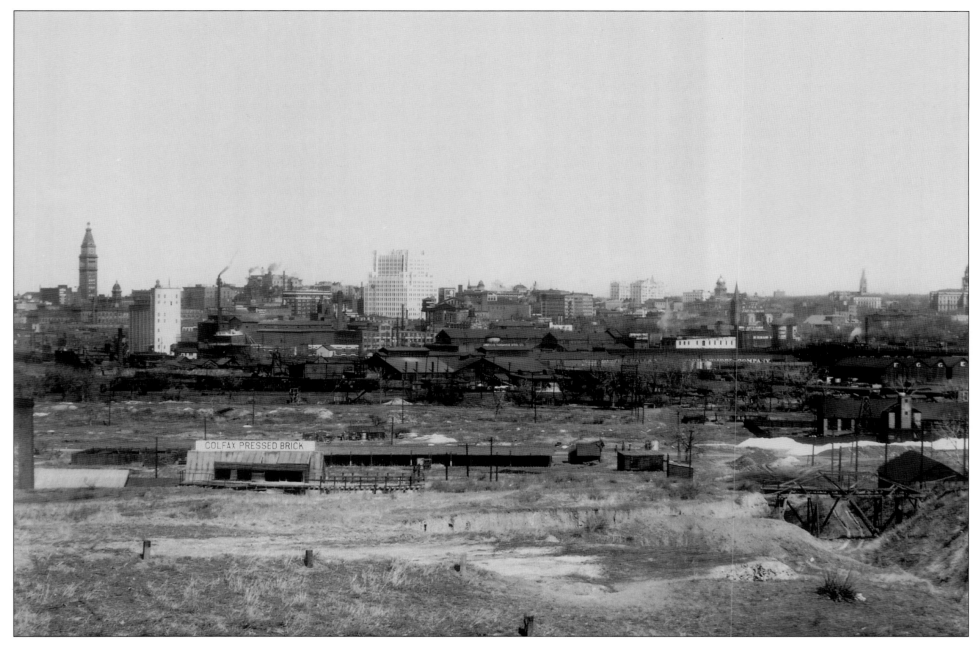

Denver's skyline in the early 1900s was dominated by the Daniels and Fishers Tower, the old City Hall, and the newly built Capitol Building. It was a place in the midst of evolution, one whose builders had already envisioned its future and made significant strides toward that vision. These adventurous pioneers dreamed of a future city, began building it as a reality, and then handed it off to new generations of dreamers.

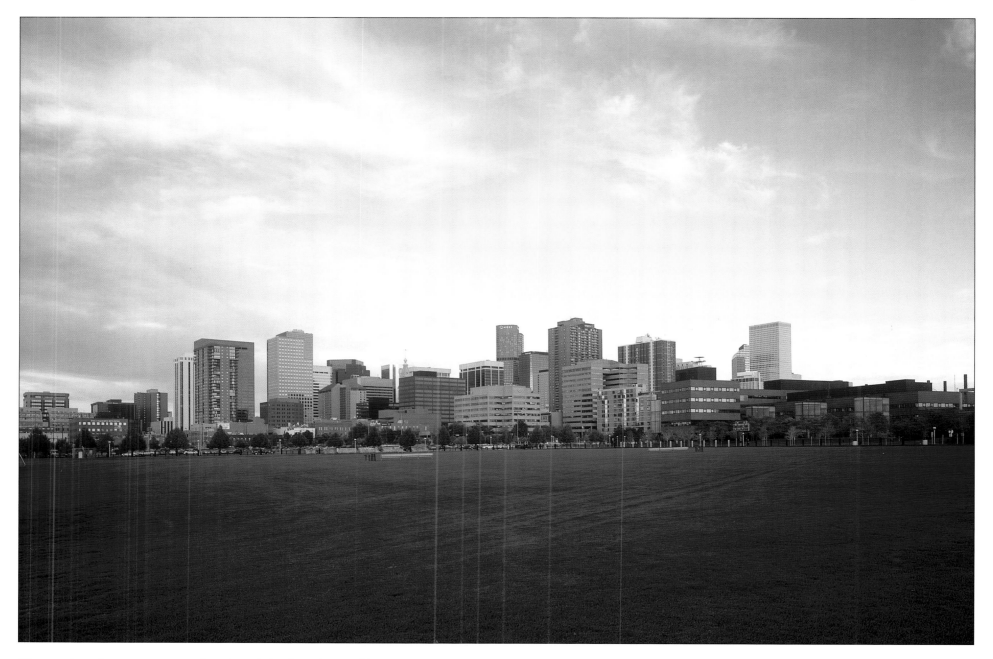

The city's earlier structures, either demolished or obscured by the skyscrapers that clamor for a space on the horizon, are no longer visible here; still, the scenes of yesterday are a part of Denver as it is today. With constant renovation, restoration, and new construction, the face of Denver seems to get younger as it grows older, but the city seems now to have a firmer grasp on the importance of history and the idea that, in many ways, the past is inextricable from the present.

INDEX